NEW YORK'S
Great
ART
MUSEUMS

NEW YORK'S *Great* ART MUSEUMS

TOURS

OF THE

PERMANENT COLLECTIONS

BY

ROBERT GARRETT

CHELSEA GREEN PUBLISHING COMPANY

CHELSEA, VERMONT

Library of Congress Cataloging-in-Publication Data

Garrett, Robert, 1949-
 New York's great art museums: tours of the permanent collections
 by Robert Garrett.
 p. cm.
 Bibliography: P.
 Includes index.
 ISBN 0-930031-13-X (alk. paper): $15.95
 1. Art museums—New York (N.Y.)—Guide-books. 2. Art—New
York (N.Y.)—Guide-books. 3. New York (N.Y.)—Description—1981
—Guide-books. I. Title.
 N600.G37 1988
708.147'1—dc19 87-35043
 CIP

CONTENTS

INTRODUCTION

MANY people are lost the moment they step inside an art museum. Even if you have visited a particular museum before, the sheer number of objects can be overwhelming. Ideally, every visitor could choose to have an informed friend at his or her side to introduce the collections and show the way. My hope is that this guidebook answers that need with words and pictures. The guide is meant as a resource, to be read at leisure and also taken to the galleries.

This book presents a series of walking tours of museum highlights. A guiding principle is that no tour should be longer than an hour or so. Looking at art is demanding. It's usually more rewarding to see fewer objects rather than attempting to rush through galleries as if they were tracts of real estate. Visitors can use this book to design their own tours, abridging the routes or wandering off the track as they please.

Art museums as we know them today took a very long time to develop. In ancient Greece, it wasn't only the devoutly religious who visited temples. Tourists could enter to admire the statues and paintings if they gave an offering to the local gods.

In Europe, royalty, the aristocracy, and the Church assembled the early art collections. In the seventeenth century, it was possible to visit Versailles and its paintings and to watch the splendid exhibitionist Louis XIV as he dined in his palace. Gentlemen were required to have plumed hats and swords, which they could rent from a concierge.

But it wasn't until the French Revolution that a museum threw open its doors to a vast public. The Louvre, formerly a royal palace and the first national art museum, opened in 1793 on the anniversary of the monarchy's fall. Most days the museum was reserved for artists to study and copy great

works of the past. On public days crowds came in force, accompanied by droves of enterprising prostitutes. Museum-going had arrived.

Nowadays visiting an art museum is a great democratic experience. Something of the sacred revives in us when we go to see art, and something of the carnival too. A phenomenon of the past couple of decades is the blockbuster temporary exhibit. This guidebook focuses on the permanent collections of New York City's art museums, in the belief that they represent a kind of "quiet" blockbuster on display year in and out.

Why these particular objects? These highlights are not a curator's choice, although many of the paintings and sculptures would figure prominently on any curator's list. I selected objects because of their significance in art history, their beauty, or because they had some special tale to tell. Some objects are quite modest. Seen firsthand, an object communicates a direct sense of the artist who made it. Sometimes an object is surprisingly smaller than expected from photographic reproduction; often the hand of an artist is visible in brushwork or the touch upon sculpture.

Subjectivity was an obvious factor in the guidebook. I believe in approaching art passionately. I enjoy hearing people with opinions and idiosyncracies, if they are not overbearing, and I have allowed my own voice to come through. You will notice that I have given comparatively little space to art of the last several decades. I have favorite contemporary artists, but I also freely admit to preferring the long view of history. Given an afternoon at the Metropolitan Museum, I am more likely to head off to see Egyptian art or European paintings than art of the 1980s.

This book, then, is like a tour guide leader in a gallery— it has its own personality. It does not pretend to be an exhaustive or comprehensive survey. Anyone wishing to learn in more depth about the collections can turn to the numerous publications of the museums themselves. The guide is a beginning and an aid. The real adventure is going and looking.

Most of the museums are described in single tours, the notable exception being the Metropolitan, the greatest of New York's great art museums. A curator at the Met once wittily referred to the museum as the only building in

Manhattan that impresses horizontally. The Metropolitan occupies 1.5 million square feet of space, and its collections span more than five thousand years of human history. It can swallow you alive if you attempt to encompass its galleries in one or two visits. This guide's strategy is to present tours of three major areas: Egyptian Art, Greek and Roman Art, and European Paintings (including 19th Century Paintings and Sculpture). Briefer introductions are offered to a number of the Met's other departments, with a separate tour of the Cloisters.

One rather full tour takes in the Museum of Modern Art, and in addition, there is a brief description of its Sculpture Garden. The section on MOMA emphasizes the lives of the modern artists, simply because they are so interesting, and because their struggle has become a part of how we see ourselves. The Frick Collection, Brooklyn Museum, Guggenheim, and Whitney Museums each have their own sections.

Finally, it's worth mentioning the Pierpont Morgan Library at Madison Avenue and 36th Street, although its exhibit policy disqualifies it from the guide. Aside from a few examples, selections from its great permanent collection of drawings, manuscripts, and books are only sometimes displayed. For the traveler and the native New Yorker, the Morgan Library's chief attraction is its temporary exhibits. For information call 212-685-0610.

NOTE ON EXHIBIT CHANGES

Shifts in exhibits of permanent collections tend to be glacial. You should find most objects where this guidebook locates them. Even so, collections are "permanent" only in the sense that a museum owns the objects or has them on long-term loan as promised gifts. Museum displays are subject to change. Galleries occasionally close for renovation or reinstallation, or the mounting of a special exhibit. Also, objects are sometimes removed for conservation or to go on temporary exhibit elsewhere. Typically, major paintings and sculpture are returned to their customary galleries. If you are planning a special trip to see a particular object, it is a good idea to call the museum ahead to see if it is on view.

FIFTH AVENUE AT 82ND STREET
NEW YORK, NY 10028
TELEPHONE: 212-879-5500

HOURS: *Tuesdays, 9:30–8:45; Wednesdays–Sundays, 9:30–5:15. Closed Mondays and December 25, January 1, and Thanksgiving Day.*

ADMISSION: *$5 suggested for adults, $2.50 suggested for students and senior citizens, free for members and children under 12 accompanied by an adult. Some admission fee is required, but you may pay more or less than amount suggested.*

GETTING THERE: *By bus, southbound on Fifth Avenue, northbound on Madison Avenue. By subway, Lexington Avenue trains 4, 5, 6 to 86th Street. Parking garage at 80th Street and Fifth Avenue (parking fees begin at $7.50 for one hour).*

RESTAURANT: *Cafeteria-style service and beer and wine. In a separate section, meals served by waiters; for reservations, call 570-3964.*

GIFT SHOPS: *Located off Great Hall. Books, museum catalogs, and bulletins, postcards, posters, Christmas cards, children's publications, and a wide range of gifts including porcelain, glassware, jewelry, and decorations in silver and gold, and facsimiles of museum art.*

SPECIAL EVENTS: *For recorded concert and lecture information, call 744-9120. For Concert and Lecture Office, call 570-3949.*

TOURS: *Gallery tours daily, information at Visitors' Center in Great Hall. Audioguide cassettes can be rented in Great Hall near entrance to Egyptian Art, at the Uris Center for Education on the ground floor, and near special exhibits.*

MEMBERSHIP: *$60 and up annually ($25 for students, $100 for dual membership, and $30 for non-NYC area members). Benefits include calendar, museum bulletins, discounts on museum merchandise, free members' lectures, announcement of special subscription programs for children.*

LIBRARY: *Open to graduate students and qualified researchers.*

THE METROPOLITAN MUSEUM OF ART

T HE Metropolitan Museum is the largest art museum in the Western Hemisphere and, so goes the boast, the most comprehensive anywhere. The Louvre is deeper in Italian painting, the British Museum has the Elgin marbles, but no other museum can match the Metropolitan as an encyclopedia of world art.

The museum was founded in 1870 by New York civic and business leaders who wanted to promote public uplift and edification. It was first quartered in a former dancing school at Fifth Avenue between 43rd and 44th Streets and later in a manor house on West 14th Street. The building program in Central Park began in 1880, and the Beaux Arts façade and entrance on 82nd Street was completed in 1905. The palatial façade sums up the museum's original democratic aspirations, which have been resoundingly fulfilled. This is a people's palace, and the approximately four million visitors yearly to the Metropolitan make it New York's most popular (if not overpopulated) tourist attraction.

The Metropolitan's first director was Luigi Palma di Cesnola, an Italian-born adventurer and soldier who fought for the Union during the Civil War and as American consul to Cyprus became a voracious amateur archaeologist. Before being hired as director, he had smuggled a collection of mostly second-rate Cypriot artifacts past Turkish governors of the island and sold it to the Metropolitan. In the early days, Cesnola's limestone statues

METROPOLITAN MUSEUM
FIRST FLOOR OVERVIEW

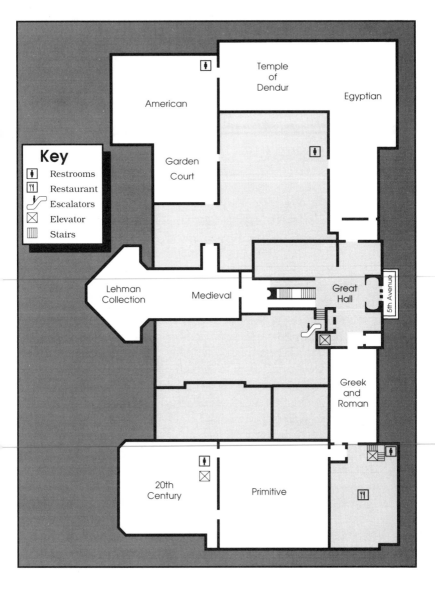

METROPOLITAN MUSEUM
SECOND FLOOR OVERVIEW

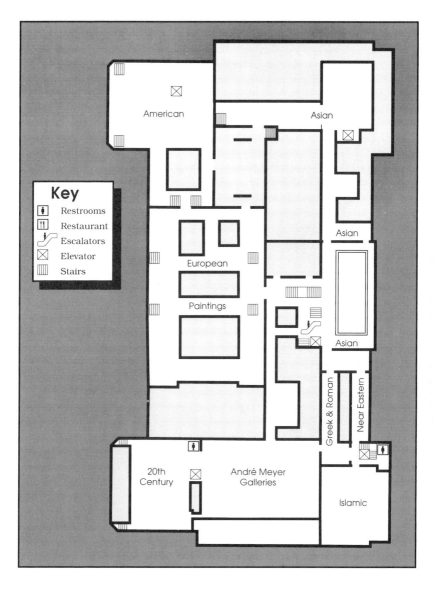

formed the backbone of the museum's antiquities collection. Today, they smile sweetly at visitors in a corridor that leads to the restaurant.

In Europe, Napoleon added to the Louvre's art at the turn of the nineteenth century simply by plundering treasures from countries he defeated. The Metropolitan had no Napoleon, but it did elect financier J.P. Morgan as president in 1904, and that was almost as good. Instead of stealing tradition, Morgan bought it. The Metropolitan's primary holdings until Morgan's era consisted of plaster castings of European sculptural masterpieces, which were gradually replaced with original art.

During Morgan's time, Metropolitan archaeologists began to dig at Luxor in Egypt, when the Egyptians were still allowing foreigners to claim half of whatever they found. Among the Metropolitan's greatest early donors was Mrs. Henry O. Havemeyer, wife of a sugar refinery tycoon. Her childhood friend from Philadelphia was the artist Mary Cassatt, who advised her to buy Impressionists and also Goya and El Greco. The financier Robert Lehman was the greatest donor of art in recent years, and his collection is housed in its own wing. Like most great museums, much of the Metropolitan's enormous permanent collection is in storage. In the past two decades, the Metropolitan has vastly expanded its gallery space. The last phase of its ambitious building program, a wing housing European sculpture and decorative arts, is scheduled to open in 1989.

EGYPTIAN ART

THE art of ancient Egypt is an elaborate exercise in wishing that was sustained for some three thousand years. The wish was for life to continue after death. Other peoples have believed in an afterlife, but the Egyptians were astonishingly dogged in the provisions they made for their well-being in the next world. The theme of Egyptian art is that you *could* take it with you. At first, only a pharaoh could expect an afterlife, although it was believed common people who were necessary to the king could share in it. Eventually, an afterlife separate from the king was possible. The rulers and bureaucrats of ancient Egypt outfitted their tombs with the needs and comforts to which they were accustomed and took precautions to ensure that their families and servants would join them beyond the grave. The death-denying art in the Egyptian galleries constitutes a robust portrait of life in an ancient land.

As you enter the galleries, you might do well to keep in mind how the ancient Egyptians oriented themselves. The Nile flows from south to north, the sun travels from east to west. Each September the Nile overflowed its banks, depositing rich silt and giving life. Every day the sun god Ra was born again and went to its home in the west. The utter simplicity of these two axes of river and sun explains much about the Egyptian insistence on the order and permanence of existence itself.

Orienting yourself in these galleries, if not so perfectly simple, is child's play compared to finding your way around some other departments in the museum. The galleries in recent years have been completely reinstalled and are ar-

EGYPTIAN ART TOUR
FIRST FLOOR

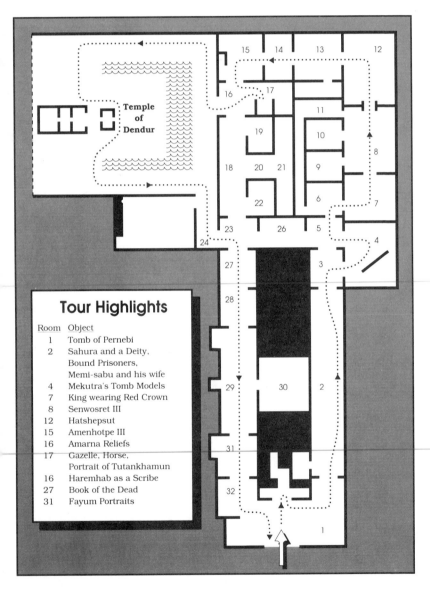

Temple
of
Dendur

15 14 13 12

16 17

19 11

10

8

18 20 21 9

22 6 7

23 26 5

24 4

27 3

28

Tour Highlights

Room	Object
1	Tomb of Pernebi
2	Sahura and a Deity, Bound Prisoners, Memi-sabu and his wife
4	Mekutra's Tomb Models
7	King wearing Red Crown
8	Senwosret III
12	Hatshepsut
15	Amenhotpe III
16	Amarna Reliefs
17	Gazelle, Horse, Portrait of Tutankhamun
16	Haremhab as a Scribe
27	Book of the Dead
31	Fayum Portraits

29 30 2

31

32

1

ranged for the most part chronologically. The layout is roughly in the shape of a horseshoe, with the Temple of Dendur in its own wing off to the one side of the horseshoe.

Greeting you at the entrance to the galleries are **Merti and his Wife**, tomb statues from the Old Kingdom (ca. 2350 B.C.) of an aristocratic couple poised at the threshold of their new life in the underworld. Behind them is the Tomb of Pernebi, an Old Kingdom building (ca. 2415–2375 B.C.) purchased from the Egyptian government in 1913 and transported here from the desert cemetery of Saqqara in northern Egypt.

Tomb of Pernebi. The door at the left leads to a room with a small opening through which you can view the statue chamber that once held a statue of a royal courtier named Pernebi. The central door leads to the chapel. At the rear of the chapel is a false door through which the spirit of Lord Chamberlain Pernebi would have come from his burial place below ground to enjoy food offerings left for him.

Tomb robbers in antiquity scoured this building of portable treasures, and nothing of Pernebi's physical being was found by modern excavators except a skull and a leg bone. His image, however, is everywhere. We see him sculpted at each side of the main doorway, facing the entrance to his tomb. In the chapel, above the false door, he is depicted at his leisure inside the tomb, as if glimpsed through a window. He also appears on the walls of the chapel, accepting food and drink from his retainers and relatives. The carved and painted wall reliefs show traces of their once brilliant colors.

The Egyptians had themselves portrayed as a kind of insurance policy against death. If anything happened to the tomb owner's body, his spirit could reside in the painted images, statues, and statuettes inside his tomb. Nobles such as Pernebi hired priests to visit their tombs and recite magic words to bring them to life so that they could enjoy the material pleasures depicted on the walls. The magic was also contained in the inscriptions carved on the walls. The inscription on the lintel of Pernebi's false door calls upon the god Osiris, ruler of the dead, to provide "bread and beer on New Year's . . . and every festival."

Over the centuries, such inscriptions became ever more

numerous and complicated and included lengthy testimonies to a deceased person's virtues, lists of protective spells, and litanies of wants and needs. The grasping quality of Egyptian funerary art is not so difficult for us to understand from a modern perspective. It's the human impulse to cover all bets and cross both fingers tightly.

Enter Gallery 2 to the right of Pernebi's tomb.

The small **Lion God** (ca. 3100 B.C.) guarding the entrance to the gallery dates from the dawn of Egyptian

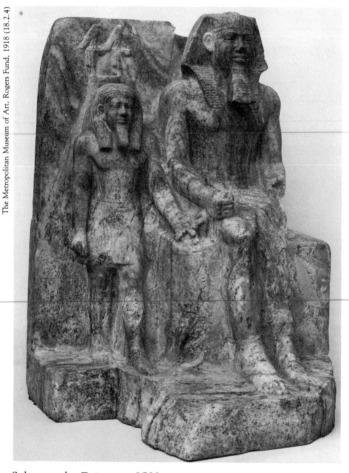

Sahura and a Deity, ca. 2500 B.C.

history and might have been a votive offering of an early king to a god. Later dynasties would transform the mighty beast into a sphinx, a god with the human head of a pharaoh and an animal body. Here, the lion is rendered simply and almost abstractly in hard quartz. At first glance the creature strikes us as almost cuddly, but we sense hidden power in its sphinx-like crouch.

Look for the next several objects behind the display glass that runs the length of Gallery 2.

It's been said the Egyptians valued permanence so highly that their art hardly changed for three thousand years. The formal, block-like style of the statuette **King Sahura and a Deity** (ca. 2487–2473 B.C.) illustrates that observation. History as measured in transient events held little interest for the Egyptians. They stressed permanence and continuity in their art as a way of ensuring stability. Although small in scale, this sculpture has a monumental feeling, a sort of "oomph" that belies its size. Sahura, an Old Kingdom ruler, is accompanied by a nome, or god representing one of the provinces of Upper Egypt. The god is handing Sahura an ankh, the hieroglyphic symbol of life.

Two **Bound Prisoners** (ca. 2400 B.C.) once knelt in an Old Kingdom pyramid temple at Saqqara. This pair of sculptures represents traditional foreign enemies of Egypt, reassuringly depicted in defeat. They are desert tribesmen, depicted with careful attention to racial characteristics and individuality that is typical in depictions of foreigners but otherwise unusual in Egyptian art. Gloating, it seems, makes for potent artistic inspiration.

Memi-sabu and His Wife (ca. 2360 B.C.) lived in a time when bureaucrats such as Memi-sabu, steward of the king's property, built more elaborate tombs than before. The couple lock their arms around each other in a rigid pose that, in its formality, looks a bit like a time-out-of-mind version of Grant Wood's *American Gothic*. The convention for portraying couples in Egyptian art was to depict a wife with her arms placed around her husband. But here, steward Memi-sabu has put his hand over his wife's breast and heart. While Egyptian women were generally unequal in political power, funerary art such as this indicates respect and affection between the sexes. The gesture may also show that husband and wife shared the tomb, which

wasn't always the case. Best of all for Memi-sabu's wife, she here has the expectation of everlasting life beyond the grave.

In Gallery 4 are the painted wooden funerary models from the tomb of Mekutra, a chancellor of King Mentu-hotep II.

Mekutra's Tomb Models (ca. 2009–1998 B.C.). During excavations in 1920 in western Thebes, archaeologist H.E. Winlock had all but concluded that Mekutra's tomb was barren, having been cleaned out ages ago by thieves. But someone from his party discovered a hidden chamber down a back corridor. When Winlock got there he shone a light through a crack in the wall.

"The beam of light shot into a little world of four thousand years ago, and I was gazing into the midst of a myriad of brightly painted little men going this way and that," wrote Winlock, who later became Metropolitan Museum director.

What Winlock saw was a small army of replica servants whose job was to serve Mekutra faithfully, laboring on his estate and sailing his boats up and down the underworld's version of the Nile. The Metropolitan owns thirteen models, and others from Mekutra's tomb are in the Cairo Museum. Preserved in their dry desert vault, they are in mint condition and offer an intimate look at daily life in ancient Egypt.

Upon entering the gallery you will see a large model of a servant woman, trim and alert, bearing meat, duck, and bread for Mekutra. On the near side of the gallery are models that give a doll's-house view of a cattle stable, slaughterhouse, granary, brewery, and bakery, and a syca-more-tree studded garden walled off from the outside world. Models of the lord's fleet are located on the other side of the gallery. Mekutra himself is shown on several of the boats, sometimes with his son. On one boat, powered downstream against the wind by oarsmen, Mekutra sits in the bow, pressing a lotus flower to his nose and listening to a singer. On another, the captain of the boat is reporting to him, and one can surmise that Mekutra is on a business trip, perhaps to inspect a harvest for the king or some equally important afterlife errand.

The Metropolitan Museum of Art, Museum Excavations, 1919–20; Rogers Fund, supplemented by contributions of Edward S. Harkness (20.3.1)

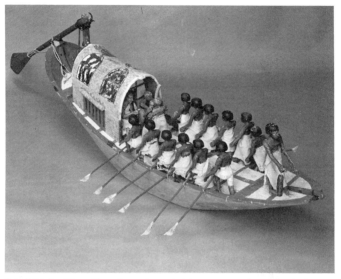

Model of a Travelling Boat from Mekutra's tomb, ca. 2000 B.C.

Nobles such as Mekutra counted on the magic of wall paintings and statues, and increasingly in this period (ca. 2000 B.C.), they also looked to the more tangible enchantment of three-dimensional models. For magic to work, details must be right. A servant on a sporting boat has just hauled in a fish, not a tiny one but a whopper, and on another boat a sailor is properly vigilant for sandbars. In the granary, an overseer stands by the door, eternally watchful, as bosses will be, that no one leaves early. Even the cattle, with bovine instinct, know how to die. One has just been killed in the slaughterhouse, and its tongue lolls out as if to prove the job was well done.

Exit left to Gallery 5, walk a few paces through Gallery 6, and turn right into Gallery 7.

Here you will find a superbly preserved wood sculpture, **King Wearing the Red Crown** (ca. 1962–1928 B.C.). The pose of the man with a walking stick, who may represent a king named Senwosret I, is a familiar convention but played out here with such vitality it appears the figure will reach the afterworld in his very next stride. A few

paces away at the center of the gallery, the **Stele of Montuwosre**, from the same period, is another example of a convention rendered with vigor. The stele, or slab of stone, depicts the steward Montuwosre seated at his funeral banquet with food offerings piled up to the point of toppling.

In Gallery 8 are two small, highly expressive sculptures of Senwosret III. **Sphinx of Senwosret** is directly before you as you enter, and a fragment showing the face of the king is behind it and to the right.

Senwosret III (ca. 1878–1843 B.C.) is a quartzite fragment. This has been called the first realistic portrait in

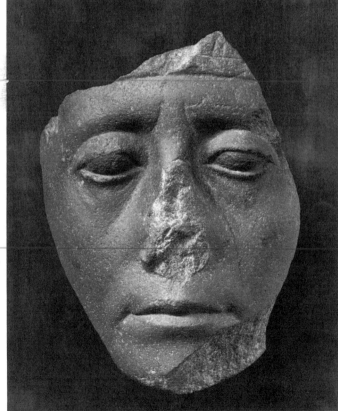

The Metropolitan Museum of Art, Carnarvon Collection, Gift of Edward S. Harkness, 1926

Senwosret III quartzite fragment, ca. 1800s B.C.

world art. Senwosret was a renowned strongman who con-
quered Nubia, Egypt's traditional enemy to the south, and
put down an independent-minded nobility. Previously,
pharoahs were endowed with the attributes of the gods
whose intermediaries they were. Although Senwosret was
worshipped as a god in his time, for some reason he has
chosen to be shown as a mortal who bears responsibility for
his people. Some modern observers look at Senwosret and
see a brooding, inward, careworn individual, although it is
equally possible to see him as brutish and stubborn. In this
face you can guess at what it takes to wield total power
successfully, and at what price.

Near these portraits is a display case full of fascinating
small tomb objects of the period, including an **amethyst
amulet** in the shape of a turtle and two **magic wands** to
protect the deceased from evil spirits. A **board game** with
"jackal and hound" pieces would have helped while away
the afterlife and must have been played much like modern-
day Parcheesi. A blue faience **hippopotamus** is decorated
on its surface with lotus blossoms, the vegetation of its
marshy home. Hippos were considered menacing, not
cute, in ancient Egypt. In his day, such a hippo's efficacy as
a good-luck charm lay in the reversal of his power to harm
by the act of rendering his image; often, such tomb figures
were purposely broken to neutralize their harmfulness.
(You might want to take a detour to Gallery 9 nearby to see
another hippo, popularly known as **William**, the unofficial
mascot of the Metropolitan. William got his name from an
affectionate article on him in *Punch* magazine, which was
reprinted in a 1931 Metropolitan *Bulletin.*)

Near the center of Gallery 8 is the **Pectoral of Senwos-
ret II** (ca. 1897–1878 B.C.), a stunning piece of Middle
Kingdom jewelry. It was apparently a gift of King Senwos-
ret II to his daughter Princess Sithathoryunet, who was the
sister or half-sister of Senwosret III. The 372 bits of pre-
cious stone, inlaid in gold cloisonné, form a design of
hieroglyphs that can be read as a wish for eternal life. The
recipient of the wish is Senwosret II, whose name is con-
tained in the cartouche, or oval ring, flanked by falcons.
Prominent in the design are a scarab that pushes the sun
disc through the sky, two protective serpents that encircle
the sun, and a pair of ankhs that holds the whole together.

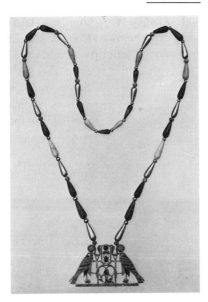

Pectoral of Senwosret II,
ca. 1897–1878 B.C.

The Metropolitan Museum of Art,
purchase, Rogers Fund and Henry
Walters Gift, 1916 (16.1.3)

Below the cartouche is a figure representing the god of millions, holding the bent reed that means "year." On its arm is a tadpole, the symbol for 100,000. Taken as a whole, the design reads: "May the sun god grant Senwosret II hundreds of thousands and millions of years of life."

Gallery 12, straight ahead, contains monumental statuary of Hatshepsut found near her funerary temple at Deir el Bahri in western Thebes.

Queen Hatshepsut (1503–1482 B.C.). Hatshepsut, stepmother of Tuthmosis III, was Egypt's great pretender. She ruled briefly as co-regent with the boy, who was the illegitimate son and heir of the dead king Tuthmosis II, and then took full power and named herself queen. What followed was one of the more bizarre public relations campaigns in the history of art. The royal portraits Hatshepsut commissioned of herself depict her as a man, in male dress and often wearing the stiff ceremonial beard of a king. The reaction of her people to this masquerade has gone unrecorded by history.

The finest sculpture of Hatshepsut, in white limestone, is known as the "White Queen." Here Hapshepsut wears a pharaoh's headdress and male kilt, but her delicate features and body are obviously female. She's an attractive young

woman, serene, ladylike, and perfectly at ease in a man's world.

At the far end of Gallery 15 is the **Head of Amenhotpe III**, a limestone bust, and the exquisite **Amenhotpe III as a Sphinx,** a small, perfectly preserved, blue faience sculpture that depicts the New Kingdom pharoah as a lion-man whose outstretched arms support wine offerings to a god. Amenhotpe III (1417–1379 B.C.) is portrayed as a rather baby-faced pharaoh, and his soft features fit the historical consensus of his personality. His predecessors had won all the important battles, and Amenhotpe's talent was to enjoy Egypt's unprecedented prosperity. He was an art connoisseur and also a bit of a braggart who claimed to have been a mighty lion hunter in his youth. Portraits of Amenhotpe in later life show him as a fleshy monarch whose athletic interests appear to have been focused on the banquet table.

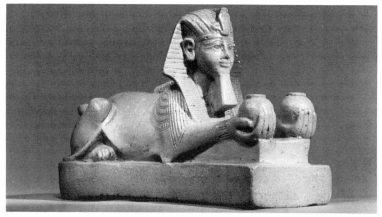

Amenhotpe as a Sphinx, ca. 1417–1379 B.C.

Amenhotpe III married a commoner named Tiye, who is said to have wielded uncommon influence over him. A fragment of polished yellow jasper may represent **Queen Tiye,** or at least Tiye's mouth. The ripe, full lips resemble other portraits of her. Whoever the woman portrayed was, her sultry expression suggests she may have gotten her own way on more than one occasion.

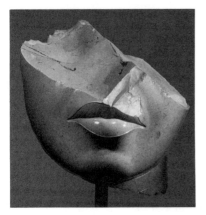

Queen Tiye (?) fragment,
ca. 1417–1379 B.C.

The Metropolitan Museum of Art,
purchase, Edward S. Harkness Gift,
1926 (26.7.1396)

Gallery 16 contains the wall reliefs commissioned by Akhenaton, son of Amenhotpe III, who ruled Egypt with his queen, Nefertiti.

The **Amarna Reliefs** (ca. 1373–1362 B.C.). The pharaoh Akhenaton was either an enlightened individualist or a wild eccentric, depending on your interpretation of history. For the brief interval of his reign, he diverted the flow of ancient Egypt's politics, art, and religion. He abolished the state god Amun-Ra, erased this god's image from temples near and far, and worshipped instead the Aton, or disk of the sun, an oddly literal deity. His own name he changed from Amenhotpe IV to Akhenaton, or spirit of Aton. As the capstone of his official heresy, he moved from Thebes and built a new capital in an unsettled area of middle Egypt. His royal city was located at what is now Amarna, from which the Metropolitan's twenty-five painted wall reliefs take their name.

Aton was a warm and loving god, judging from a hymn written in Akhenaton's time, and perhaps by him, that has been compared to the Old Testament's Psalm 104 for its consoling repetitions on the theme of divine providence. The picture that emerges of the man himself is far more confused. As seen in the Amarna reliefs, he has a long, hollow face and a sharply jutting chin. Sculptures in other museum collections depict the pharaoh as a sort of freakish praying mantis, an elongated figure with wide hips and swelling breasts. Some historians have suggested he adopted androgyny to identify himself with some male-female creation deity. It has also been theorized he suffered a

degenerative physical deformity or even underwent a sex change. The reasons behind his religious zealotry are likewise uncertain. Perhaps his conversion to a directly approachable god can be likened in its secular spirit to the Protestant reformation of medieval Europe. However, Aton was only approachable by the king himself; everyone else had to pray to Akhenaton. And so when Akhenaton died, his one-man reformation died, too. His temples were knocked down, and the small and easily portable building blocks carted off for use as construction fill elsewhere. Many of the Amarna reliefs were found in the 1930s at the temples of the Ramesside kings, across the Nile from Akhenaton's vanished city.

Contrary to the changeless traditions of Egyptian art, the Amarna reliefs celebrate the here and now, this moment and no other. Instead of aristocrats posing timelessly, a court scene shows Akhenaton's daughters as one of them playfully flips her kid sister's braids to one side. Horses toss their heads, harpists pluck their instruments with long curled fingers that have just played a note, servants fairly quiver after throwing themselves at the feet of their royal

The Metropolitan Museum of Art, Gift of Norbet Schimmel, 1985 (1985.328.2)

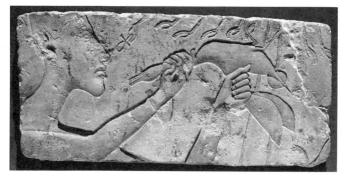

Sacrificing a Duck, mid-1300s B.C.

masters. One of the most arresting images is of **Akhenaton Sacrificing a Duck** and raising up his offering for Aton's approval. He is just now breaking the bird's neck with a twist of his wrist. The sun's rays beam down, depicted as surreally animate, little caressing hands. One little hand clasps an ankh that is about to touch the king on the nose.

Gallery 17 contains such sprightly objects from the period as an ivory **gazelle** and a **horse**. A particularly lively portrait of an unidentified woman, probably a princess, adorns a **Canopic Jar** (in the center of the gallery) which once held the viscera of the deceased. Also in this gallery is a small stone portrait of **Tutankhamun** (ca. 1357–1352 B.C.), the nephew of Akhenaton. After succeeding his notorious uncle, the boy-king changed his name from Tutankhaton to wipe out the embarrassing connection to Atonism.

Although King Tut is beloved in our own day, owing to the romance of his tomb treasures surviving intact, his early death makes him but a footnote in the perspective of dynastic history. General Haremhab, Tutankhamun's deputy, was the strongman who ruled behind the scenes and established the old order that Tutankhamun's uncle had upset.

Go back through Gallery 16, and you will find the life-sized sculpture of Haremhab, near the door that leads to the Temple of Dendur.

Haremhab as a Scribe of the King (ca. 1350 B.C.). Literacy was highly esteemed in ancient Egypt, for words had such power that they could perpetuate life itself. Haremhab was following a centuries-old convention in posing as a cross-legged scribe. His round paunch is a symbol of affluence and respectability. On his lap is a hymn to Thoth, the god of writing, and the general looks up from the scroll absorbed in thought. It was a form of self-flattery for this man of action to appear in the guise of a soft intellectual, yet we know that underneath that meditative gaze is a personality as solid as the granite from which the sculpture is made.

Go through the doors of Gallery 16 to the Temple of Dendur. The temple is a gift of the Egyptian government in thanks for America's role in saving ancient monuments threatened by flooding caused by the construction of the Aswan Dam. The temple faces east, as it did on its original site, and stands at the same distance from a pool of water as it once did from the Nile.

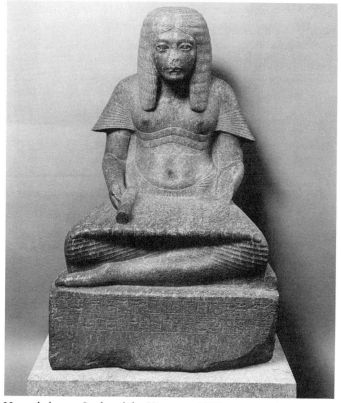

Haremhab as a Scribe of the King, ca. 1350 B.C.

Temple of Dendur (ca. 15 B.C.). The Roman Emperor Augustus, who visited occupied Egypt once during his life, built this small temple to charm a recently conquered people. The temple was dedicated to the goddess Isis and to two sons of a Nubian chieftain who were honored as gods after drowning in the sacred Nile. Augustus, a genial but shrewd politician, was already spending huge sums to build new shrines and restore old ones in Rome, so this temple in the south of Egypt was but a variation on a favorite propaganda ploy. Augustus is represented repeatedly on the temple walls in the guise of a pharaoh, making offerings and mingling familiarly with Egyptian gods.

Go to the temple's north side (on the Central Park side of the museum wing). Carved in relief to the left of a door, you see Augustus in pharaoh's costume, giving the temple

deed to the goddess Isis, who stands to the right of the door. The deed is a land grant represented hieroglyphically by a field with three reeds. Isis, a mother-god of Egyptian religion, can be identified by her crown of a sun disk between cow horns. Behind her is her son Horus, falcon-headed sky-god and personification of kingship. The gods are positioned on the right, as if emerging from the inner sanctum at the back of the temple to invite Augustus inside.

If you walk to the front of the temple's gate, you can peer into the dim recesses of the inner sanctum, off limits to the museum visitor now as it was to the average Egyptian back then. The sanctum once held a cult figure of a god, which each morning the temple priests cared for and fed and each evening put back to bed.

Above the gate is a carving of the sun, the god Ra, with two cobras, representing north and south Egypt, and falcon wings to propel the sun through the sky. The carvings on the temple exterior, once painted in vivid reds, yellows, and black, are in sunken relief, which helped protect the images from erosion and also highlighted them in the desert sun. The lower areas of the gate are embellished by the graffiti of nineteenth century travelers.

In Gallery 23, a row of **shawabtis** (ca. 380–342 B.C.) stand at attention. Such small servant figures were traditionally placed inside tombs and were supposed to spring to life in the hereafter to do the bidding of the deceased.

In Gallery 27 are two examples of the **Book of the Dead**, a term for the scrolls placed inside or near a coffin to get the deceased into the next world and guarantee happiness ever after. The custom developed out of the Middle Kingdom convention of writing spells on the inside surfaces of coffins. In the New Kingdom, spells were written on papyrus scrolls and buried with the mummified body of the deceased.

Each "book" was an anthology of spells, old and new, which varied according to the inclinations of the noble buying it and the scribe he commissioned to produce it. A seemingly inexhaustible supply of magic texts could be

mixed and matched freely, in a patchwork of styles and grammar. Modern Western thought tends to search out one logical answer or explanation to a phenomenon. The ancient Egyptians believed that many different answers to death were possible, and they piled up answers to increase the potency of the magic.

The scrolls on display in this gallery are unrolled Mikado-like across one gallery wall. Both scrolls were done for a priest named Imhotep who was buried at Meir, middle Egypt. They date from the early Ptolemaic Period (ca. 350–250 B.C.) and are late examples of their kind. The piling up of spells and guarantees is especially insistent in the longer of the two scrolls. You can follow the text translations beginning at the right. The deceased is assured that he will not die and will not have to work in the hereafter. He is protected against crocodiles, shown in full retreat in one of the illustrated vignettes that run in a continuous band above the text. One spell prevents him from being conveyed eastward instead of westward, which would hardly do at all since a soul was supposed to go west to its home just as the sun does every night. Another spell, in an especially neat bit of magic, is intended for use if the previous spells failed. In this event, the deceased could become a bird and fly into the hereafter.

As you walk through Gallery 28, you will see on the left a beautifully preserved wooden statuette of **Anubis** (ca. 332–330 B.C.), the dog-headed god of mummification, arms raised dutifully to ward off evil.

The **Fayum Portraits** (2nd century A.D.), in Gallery 31, make a startling coda to a collection whose pervasive theme is fixed and timeless. It's something of a rude awakening to come upon these wonderfully candid portraits. Found at the site of a thriving Greek community at Fayum in north Egypt, the portraits are Greco-Roman in their realism but Egyptian in their intended function. The portraits were painted on small wooden tablets and wrapped into place on mummy coffins, thus assuring that the features of the person inside would live on. The Greek or Roman portrait artists used encaustic, tinted wax liquified

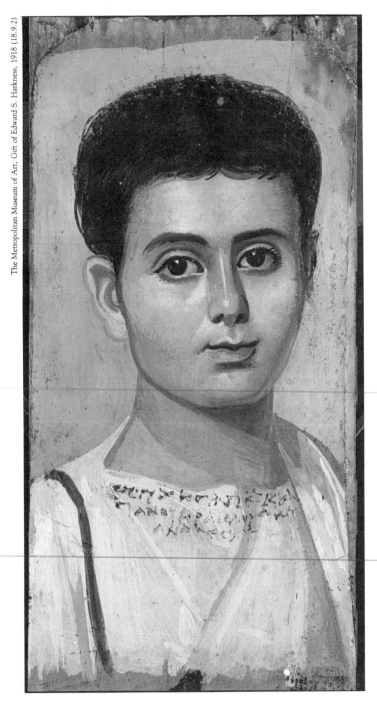

Portrait of a Boy Fayum Portraits, 2nd century A.D.

by heat. The technique, and the dry climate, account for the freshness of the colors. The exact ethnic identity, or mixtures of identities, of the people portrayed is a puzzle for scholars. Anyone who has ever people-watched in a Middle Eastern cafe will find the Fayum portraits utterly familiar.

GREEK AND
ROMAN ART

THE gods of Mount Olympus could never let well enough alone. In Homer's epics, they give advice, scold, and meddle. They paid attention, and divine interest was what a civilization in its childhood needed. Man became the measure of the universe, and the art of Greece and Rome begins with this guiding principle.

Nowadays, the nearest equivalent we have to the gods of the classical world are movie stars, pop singers, and martyred politicians. This is a bit of a comedown, to be sure. We can't really count on our idols, but it's important to note that the ancients didn't always rely on theirs either. By the fourth century B.C., the Greeks' literal belief in their gods had generally changed to a fascination with mythology for its allegorical beauty. A favorite aphorism about classical art says that as the gods became more human, humans became divine. Both the gods and the people you will encounter in these galleries make for splendid company.

The Greek and Roman department is arranged by material rather than chronology, which means you will be making some rather dislocating leaps in time. It's best to begin with Greek vase painting, if only because it plunges you immediately into the world of gods and heroes, not to mention satyrs forever lusting after the maenads with whom they dance.

Go up the escalator, located at left behind the Great Hall. On the second floor turn right and, after walking a few paces, right again. Straight ahead is the first gallery, containing South Italian red-figure vases.

GREEK AND ROMAN ART TOUR

Great Hall

First Floor

No.	Object
5	Kouros (Statue of a Youth)
6	Old Peasant Woman / Aphrodite
7	Roman Portraits
8	Room from a Villa at Boscoreale
9	Etruscan Art
10	Wounded Warrior
11	Sleeping Eros / Herakles
12	Cycladic Art

Second Floor

No.	Object
1	Painting of a Marble Statue
2	Sleep and Death by Euphronios
3	Panathenaic Prize-Amphoras
4	Sepulchral Vases

Pots were produced in enormous quantities in antiquity, and, somewhat like the car industry nowadays, their sale reflected the economy of a region. Attica, the city-state of Athens, dominated the vast foreign market for more than a century. When Athens was defeated in the Peloponnesian wars at the close of the fifth century B.C., the Greek colonies in South Italy took up some of the slack in vase painting. This first gallery is given over to provincial vase painting. Possibly because it just misses being first-rate, much of it is irresistible.

The **Painting of a Marble Statue** (4th century B.C.). The blank, white surface of most ancient sculpture today is a function of time and a figment of modern taste. The Greeks painted their statues, and here an artist in a workman's cap demonstrates how it was done. He is applying tinted wax to a statue of the man-god Herakles, who can be identified by his lion pelt and club. A helper at left heats up iron rods that will be passed over the marble to melt the wax so it can be brushed. Zeus and Nike, goddess of victory, observe the process from above. Herakles himself steals up to the scene, and his bashful demeanor suggests that even an ancient god could feel intimidated in the presence of art.

The flowering of Attic vase painting is on display in the next gallery.

Sleep and Death Lifting the Body of Sarpedon (ca. 515 B.C.). It is not true, as some have suggested, that this treasure arrived one day at the Metropolitan in a hatbox. For one thing, it's too big to have fit into one. In 1972, the museum announced that it had purchased this calyx-krater, or bowl to mix wine and water, from an old collection in Beirut. The price was reportedly one million dollars. The krater is by Euphronios, a famous sixth century B.C. artist whose pots were especially prized by the Etruscans who lived north of Rome. The Italian government has long maintained the krater was stolen from an Etruscan tomb and sold through a middleman to the Metropolitan, although the charge has never been proven.

Euphronios was a master of the red-figure technique, which had developed only a few decades before. In this technique the figures are left in the clay color, which turns

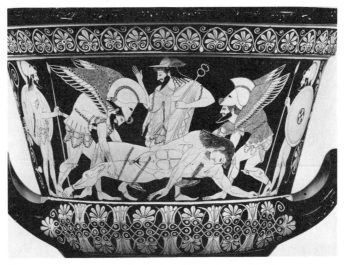

Sleep and Death Lifting the Body of Sarpedon, ca 515 B.C.

red when fired, and the background and highlights are painted with a solution or "slip" of clay and water that turns black. Euphronios was able to control the gradations of color, from black to reddish brown to red, by diluting the slip.

Greek artists were the first to take credit for their work, and both Euphronios and the potter Euxitheos have signed their names. The characters portrayed in this scene are also identified by name tags inscribed near each figure. Sarpedon, the mortal son of Zeus, has just been killed at Troy. Hermes, the conductor of souls, depicted at center, oversees the removal of the body to Olympus. Sleep and Death heft the corpse, which is still gushing blood. Greek physicians of the era were only just discovering how the human skeleton and muscle system worked, and in art Euphronios was a pioneer in detailing anatomy. As museum curator Dietrich von Bothmer has pointed out, Euphronios here has tipped Sarpedon's body on its side as if to show off his knowledge.

Located near this calyx-krater is **Youth Singing and Playing the Kithara**, an amphora by the Berlin painter, an anonymous master whose name derives from another amphora of his in the Berlin State Museum. Red-figure paint-

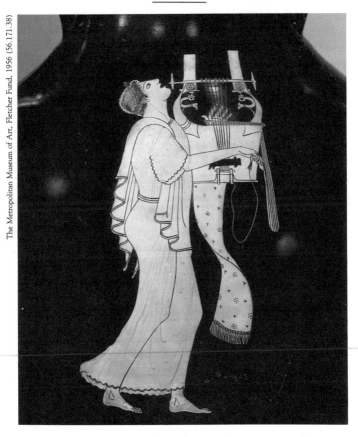

Youth Singing and Playing the Kithara, 5th century B.C.

ing is often compared to modern stage lighting, and no-where is the dramatic impact sharper than in this spotlit moment in time. A musician moves to the rhythm of his song, and as he rocks back and forth the decorative sash hanging from his instrument ripples against a limitless black background. "Ecstacy" is a Greek-derived word for standing outside oneself, which would seem to describe the infinite delight of this singer.

Straight ahead, through the next gallery, is the muse-um's collection of **prize-amphoras** awarded to athletes at the Panathenaic Games, which took place at Athens from the sixth century B.C. and into the period of Roman imperi-al power.

On the front of each trophy is a depiction of Athena, patron goddess of Athens and the games, who is always shown as a warrior with her pet owl. On the reverse is a depiction of the particular event, such as running or wrestling. The winners got to keep the amphora and the forty liters of oil each one held. In the **Foot Race** (ca. 530 B.C.), the sprinter in last place is a beardless youth who is being shown up by his elders.

The Greeks loved to play. Games were held at Athens and at Olympia and throughout Greece. In our minds the playfulness of the Greeks is linked to their nobility, although exactly how it influenced their innovations in political thought, philosophy, and science is difficult to say. By contrast, the Romans over the centuries invented ever more varied and perverse gladiatorial sport. Blood sport eventually came to Greece, and a number of cities built amphitheaters to hold Roman-style gladiatorial games. In Athens, however, a second century A.D. philosopher named Demonax was able to veto such amusements, preserving by a shred the Greek ideal of good sportsmanship.

As you walk to the stairway and elevators, you'll see several **sepulchral vases** (ca. 7th century B.C.), very early funerary monuments whose geometric designs show the deceased flanked by women mourners who are tearing their hair. The vases are bottomless. Offerings to the deceased, perhaps wine, were poured through the vases to the grave below.

On the first floor, enter the gallery immediately to the right of the staircase.

Kouros (Statue of a Youth) (late 7th century B.C.). This statue, one of the earliest surviving Greek marbles, looks like it is stirring from a dream. The Greeks, who had traveled to Egypt as mercenaries, seem to have known of Egyptian art. The Egyptians wanted permanence, and so had their images carved into stone block. This Greek youth appears to have freed himself from one. He stands on his own, and unlike most Egyptian statues he is nude, with a body that shows the sculptor's budding interest in how muscles looked. Statues like this one often were placed on

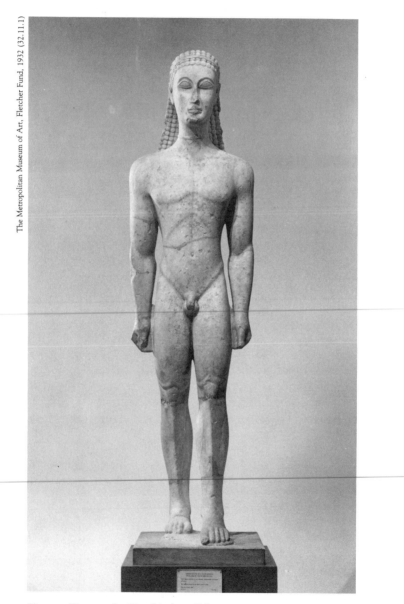

Kouros (Statue of a Youth), late 7th century B.C.

graves or dedicated to the gods. The youth might even be a god himself, because for the Greeks the distinction between man and god was especially slender in this period.

At the entrance to the next gallery is a marble grave relief of a **Girl with Doves** (ca. 450–440 B.C.), a fresh and unsentimental memorial to early death. In the following gallery are grave reliefs from the fourth century B.C. In one relief, a deceased man grasps the hand of a relative, a gesture demonstrating the firm bond of memory of the living for the dead.

In the next gallery is an **Old Peasant Woman** (ca. 2nd century B.C.), from the Hellenistic age (the period marked by the death of Alexander the Great in 323 B.C. and the

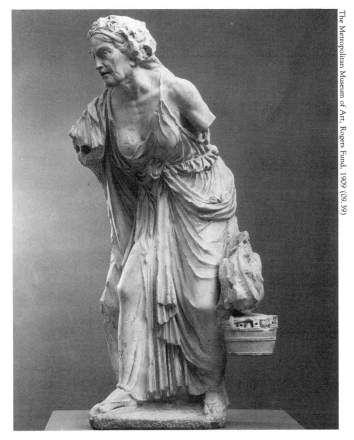

The Metropolitan Museum of Art, Rogers Fund, 1909 (09.39)

Old Peasant Woman, ca. 2nd century B.C.

colonizing of the East in the following three centuries). Art has come down from Mount Olympus, and ordinary people are portrayed realistically. The old woman, carting her chickens and fruits or vegetables, is bent and tired from her hard life. Perhaps we shouldn't be surprised that the Greeks could deal so graphically with aging. The hero of Homer's *Odyssey* came back from his travels so old and worn even his wife didn't recognize him.

In this gallery along with the *Old Peasant Woman*, which is thought to be a Greek original, are Roman copies of Greek sculpture.

Aphrodite, a Roman copy of Greek original (ca. 300 B.C.), depicts the goddess of love pausing at her bath. Aphrodite was one of the most copied subjects in ancient art. The Greeks copied their own art, but the most prodigious copiers of Greek originals were the Romans, who felt

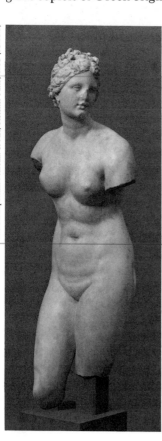

Aphrodite, ca. 300 B.C.

culturally inferior to the Greeks. During imperial times, they plundered original art wholesale from Greece and brought it home, but duplication was more practical and widespread. The date of this Aphrodite refers to the period of the original. This Roman copy was done about three centuries later, possibly by a Greek artisan working for the Romans in Italy.

Even the original upon which this Roman copy was based was itself a variation on an earlier statue. The prototype was an Aphrodite fashioned about 350 B.C. by the Greek sculptor Praxiteles, who placed his goddess in a cult shrine at Knidos, in what is now southwestern Turkey. Pliny the Elder praised the work in an early piece of art criticism, adding to the artist's already considerable fame. Because Praxiteles' Aphrodite has long since been lost, we must rely on Pliny's word and the art of the copiers to know what it was like. What's interesting about the platonic ideal of female nudity is how it has played out through the ages. The great Victorian thinker John Ruskin, accustomed to the ideal contained in classical marbles and bone-white castings of them, was surprised to discover on his wedding night that his wife had hair on her body. Apparently he did not recover from the shock of a real woman's body, for he never consummated his marriage.

In 79 A.D., Mount Vesuvius erupted, burying the provincial Roman town of Pompeii and neighboring coastal resorts. Nature's unkind swipe preserved an excellent if random sampling of paintings from classical antiquity, a medium almost completely lost to us. In 1903 the Metropolitan purchased at auction wall paintings from excavations of resort villas at Boscoreale and Boscotrecase. It's one of the largest collections of Roman painting outside Italy. The first set you encounter, in the Roman Portrait Gallery that follows the gallery containing Aphrodite, is the **Woman Playing the Kithara** and other enigmatic figures from Boscoreale. Fragments of decorative **Paintings from Boscotrecase** are displayed in the corridor leading from the Roman Portrait Gallery to the museum restaurant. Perhaps the most impressive paintings are those from the **Bedroom from a Villa at Boscoreale**, which is easy to miss if you are unfamiliar with the museum. Go through

the Roman Portrait Gallery and make an immediate right before the Great Hall. The architectural vistas of these paintings display an illusion of space, light, and shadow that was lost to painters until the Florentines bettered it during the Renaissance. You may wish you had a telescope to bring you closer to the charming still life of fruit at the far end of the bedroom.

Roman Portraits. They didn't shy away from facts, these world-beaters, and when the empire came crashing down around them the faces the Romans presented could be painfully frank. Most Roman portraits were probably done by hired Greek sculptors, but the no-nonsense attitude of soldiers and civil servants is what comes through. The image of Roman rulers was sometimes idealized or softened, as you can see by looking at the emperor **Caligula**, one of history's great sadists who ruled from 37 to 41 A.D. He appears innocuous enough, if not exactly sweet-tempered, in a bust near the center of this gallery. By contrast, the monumental bronze of **Trebonianus Gallus**, in one corner of the gallery, is a study in the lack of grace under pressure. The third century A.D. emperor reigned for two years during Rome's age of anxiety, when rulers were frequently killed in battle or skewered by the Praetorian Guard, and he was himself assassinated by his troops. His monstrously mock heroic body is out of sync with his small brutish head. A few paces diagonally away are three **portraits of men** from the same epoch, two of whom might make obvious candidates for a therapist's couch today. Gibbon describes the middle of the third century as a "melancholy calculation of human calamities." The Franks invaded Roman Spain, the Goths sacked Athens, and the Alemanni crossed the Po River to Ravenna before being turned back. Roman provincial generals mutinied one after the other. Civil war broke out in Alexandria. In Sicily bandits and slaves looted the estates of Roman senators. Famine and disease swept the empire. Romans turned to mystery cults and deeply fatalistic philosophy. Less than a century later, the emperor **Constantine** converted to Christianity before his death in 337 A.D. You can see a bust of him in the opposite corner of the gallery, raising his eyes to heaven and away from worldly trouble.

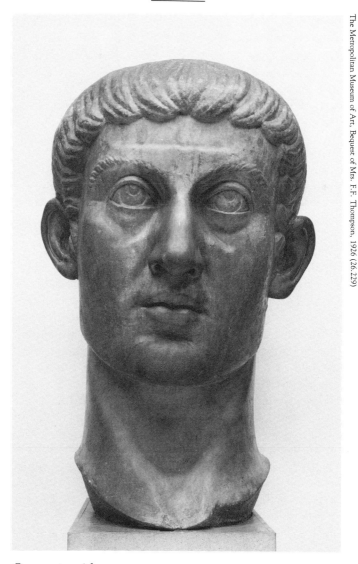

Constantine, 4th century A.D.

Etruscan art at the Metropolitan is located in a gallery which can be entered at the far end of the Roman Portrait Gallery.

Etruscan Art. No one knows for certain how the Etruscans arrived in Italy. But one theory is that small groups of fortune seekers came by land and sea over several centuries. They were lured by the mines and farmlands of what is

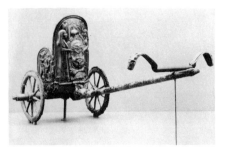

Etruscan Chariot,
6th century B.C.

now Tuscany and established themselves as metalworkers and weapons suppliers to the ancient world. In the sixth century B.C. they controlled north and central Italy, including Rome. In the next three centuries the better-organized Romans, and the Greeks in southern Italy, defeated them in key battles. Absorbed into Roman culture, the Etruscans left behind scant writing, and most of our knowledge of them comes from their tombs in northern Italy.

An Etruscan **chariot** (late 6th century B.C.) was a tomb offering rather than an actual war machine. Chariots were not used in battle anymore, and this one is a nostalgic reference to the early transport of such legendary heroes as the Greek warrior Achilles, who seems to be the subject here. In the main design his mother is giving him a fanciful shield and helmet; the designs on either side show him fighting, and driving a chariot pulled by winged horses. Smaller objects in this gallery demonstrate the Etruscan gift for metalwork, including a **centaur** and a candelabrum finial of a **Wounded Warrior and Companion**, both located near the center of the room. The Etruscans adopted Greek mythology and imitated Greek art, but their angular, elongated, "orientalized" way with form is still a puzzle. Perhaps it reveals their contacts, or their own origins, in the East. Like the Vikings who settled in the British Isles, or the pioneers and miners who opened the American West, the Etruscans must have come from hardy stock. A strange vigor is the hallmark of their art.

In the next gallery, the **Wounded Warrior Falling Backwards** has been stabbed in his right armpit, but you'd never know it from the gaze of cool nobility on his face.

This is a Roman copy of a bronze by the famous fifth century B.C. Greek sculptor Kresilas. The bronze original had the warrior falling backwards, but the marble copy is positioned upright. The statue embodies an ideal that even the Greeks must have found impractical in real life—the gift for looking great just before you fall on your behind.

At the entrance to the next gallery is a life-sized **Sleeping Eros** (ca. 200 B.C.), the son of Aphrodite, known to us today as Cupid. This wonderfully observant Hellenistic sculpture, possibly made on the island of Rhodes, shows the pudgy little boy all tuckered out from his hectic schedule.

Most of the objects in this gallery are small, and it would be a shame to overlook them by hurrying past. Two display cases, against the wall on the right as you enter, contain a wide assortment of household gods and votive offerings. **Athena** (ca. 5th century B.C.) and **Herakles** (ca. 6th century B.C.) are displayed prominently. These two small bronze gods were once placed in cult temples and private shrines.

Herakles, the son of Zeus by a mortal woman, was one of the most popular gods of ancient Greece. Pindar called him *heros theos*, a heroic god-man, or what in modern English we would call "superman." According to legend, the goddess Hera, the jealous wife of Zeus, forced Herakles to obey Eurysteus, the king of Tiryms, who assigned him such labors as battling Amazons and bringing back the three-headed dog Cerberus from the gates of the dead. The first labor was to kill a lion ravaging the Greek countryside. The lion's skin was impervious to arrows, so Herakles, with the help of the goddess Athena, knocked the beast senseless with his club and then strangled it. Herakles is customarily depicted wearing the magical pelt of the dead lion. The beefy little bronze figure brandishing his club here is shown totally nude, which could mean that he has just reported for his first day of work.

Near the center of this gallery are objects from the Geometric Period (ca. 8th century B.C.), including a **centauromachy**, a pair of bronze figures which may represent Herakles fighting a centaur. The horses from this period look Picasso-like to modern eyes for their economy of form. Perhaps the most wonderful object in the grouping is the

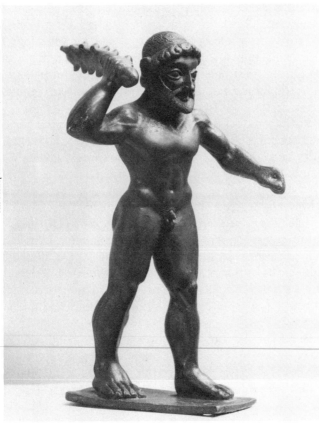

Herakles, ca. 6th century B.C.

statuette of an **Armorer Making a Helmet** (ca. 7th century B.C.), which evokes to the core the energy and industry of a man bending over his task. An actual helmet from the same period as the statuette of the helmet-maker is on view in a display case at the door as you are leaving the gallery.

In the next gallery are the doll-like marble figures from the islands of the Cyclades in the Aegean Sea.

Cycladic Art (3rd millenium B.C.). Brancusi and other modern sculptors were instinctively drawn to these simple, reductive, elegant forms from prehistory, as if to long-lost relatives. Cycladic statuettes once lay in graves, possibly to guard the dead. Traces of paint on the faces of figures in

other collections indicate they were intended to have eyes. Even without paint, none of the faces seems blank. Despite the self-containment and repose of these figures, we feel they are awake and ever watchful.

Most Cycladic figures are female, fertility goddesses in all likelihood. Male figures are rare enough, but even more rare is the depiction of a musician such as that in the Met's collection. The harpist has abandoned himself to his music, throwing his head back (like the kithara player on the Berlin painter's vase in the gallery upstairs). Perhaps this earnest little man is singing for a goddess who protects the dead. Historian George Hanfmann has suggested an analogy to Orpheus, who descended to the underworld and

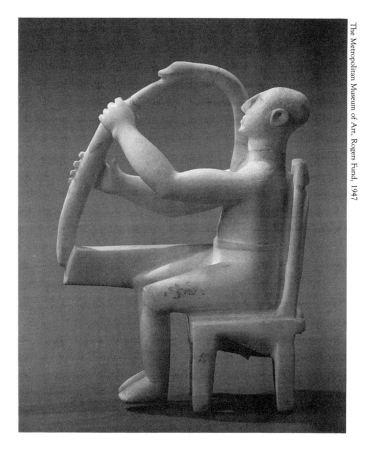

The Metropolitan Museum of Art, Rogers Fund, 1947

Harpist, 3rd millenium B.C.

played so charmingly for the ruler of the dead that he returned alive. The musician's fingernails are perfectly rendered, a detail we find startling but somehow appropriate. It's precisely the sort of small point the gods would notice.

EUROPEAN
PAINTINGS

PICTURES tell a story. For many of us, this invitation to a tale well told is what the experience of visiting a museum is all about. In the Middle Ages, paintings told the story of human beings in relation to God. As the centuries passed the story shifted to humankind. The Metropolitan's vast collection of European paintings is arranged by country and period, but this highlights tour will follow the broader theme of religious art that gave way to secular art.

From the Great Hall go up the main staircase. Begin in Gallery 3, with a key painting from the workshop of the medieval master Giotto. If you then retrace your steps and enter Gallery 23, you can proceed through the galleries in a generally clockwise direction and end up in the eighteenth century—back where you started. The Met's holdings of nineteenth century European paintings are in a separate wing nearby.

Giotto di Bondone (ca. 1266–1337) was famous in his own day, lavishly praised in the first histories on Italian art by the writers of Florence where he lived. After his death, when theorists began to speak of the coming of a Renaissance, he was singled out as a precursor of the new age. In the 1350s, the poet Boccaccio declared the artist had captured the truth of nature so well that those who saw his paintings mistook them for reality. His great achievements were to simplify and unify the narrative of a picture, and to persuasively render figures in space. But Giotto was also intensely interested in the inner beings of those figures. The faces of his saints, so grave and purposeful, tell us that these were people with thoughts and emotions.

EUROPEAN PAINTINGS TOUR
SECOND FLOOR

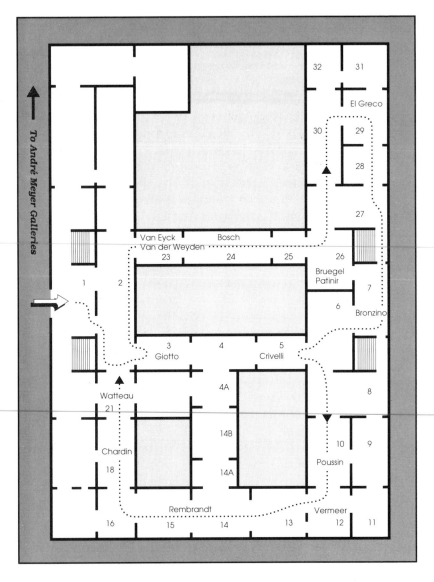

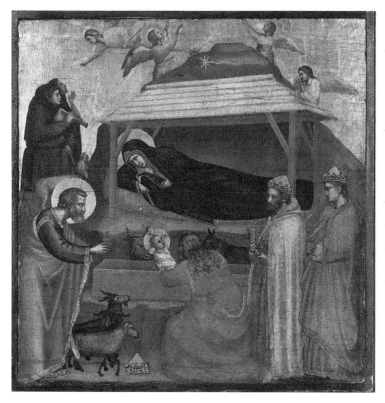

The Metropolitan Museum of Art, John Stewart Kennedy Fund, 1911 (11.126.1)

Giotto *The Epiphany*, ca. 1320

The Epiphany by Giotto. To instruct the faithful and to give glory to God, these were the duties of the medieval artist. The gold leaf backdrop here, as elsewhere in early Christian art, represents the light of God. Giotto's nativity scene, painted about 1320, has the drama and weight of faith made visible. One of the kings has put aside his crown, dropped to one knee and lifted the Christ Child out of His cradle. It's an audacious act for several reasons. Giotto is so convinced of the power intrinsic to this scene, and in his own talents, that he has allowed the king to turn his back to viewers of the painting. The naturalness of the motion and the way the king's body defines space in three dimensions are departures from the conventions of medi-eval painting. Then, too, this stranger's hoisting of the baby has startled Joseph, whose body language expresses the anxiety of a parent. Heaven is close at hand in this

picture, but Giotto firmly understands this world and all the players in it. At left, a dog responds to the magnitude of the event with doggy curiosity, cocking its head at the angels above.

In Gallery 23 are works by the two princes of fifteenth century Flemish painting, Jan van Eyck and Rogier van der Weyden.

The Crucifixion and **The Last Judgment** by Jan van Eyck (active by 1422, died 1441). Only God in heaven can number the hairs on the heads of all mankind, but the vision of Jan van Eyck represents a splendid if merely mortal attempt. The Flemish artist recorded all the universe in these two mighty little panels: heaven, hell, and

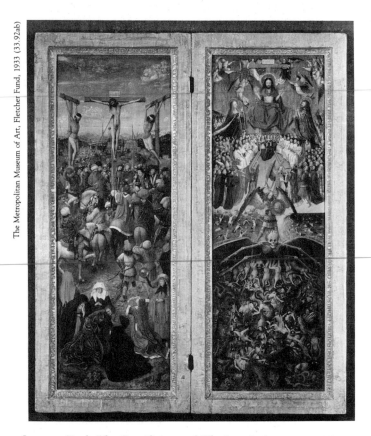

Jan van Eyck *The Crucifixion* and *The Last Judgement*, 1425–30

the world of man. The gem-like brilliance of Van Eyck's colors, and the precision of his illusionism, is a measure of his faith in the meaning and unity of creation. Van Eyck keenly observed everything, near and far. He painted, with equal virtuosity, stones on the ground, snowy mountain crags, the fur trim on the turbans of the fashionably dressed sinners who taunt Christ on the Cross, and the glistening ornamentation on the armor and shield of the Archangel Michael who is sending the damned straight to hell.

The sixteenth century biographer Giorgio Vasari called Van Eyck an alchemist, and until recently it was thought the artist was the inventor of oil painting. Other artists had begun to use oil as a binder of pigment. Although Van Eyck did not invent the medium, in a manner of speaking he did perform alchemy with it. These two panels are among the earliest surviving paintings attributed to Van Eyck, dating from about 1425–30, and with them he has already achieved a technical mastery that astonishes us to this day. He combined tempera, which is color mixed with egg yolk, with linseed oil. The key to his technique was that he applied his blend of pigment and oil in thin translucent glazes one upon the other. The amount of pigment in each glaze was successively less, and this layering allowed him to build a glowing, jeweled surface. It is not known what kind of brushes he used, but some must have been so fine that they held only one hair.

The gold frames holding these paintings are the originals, and upon the frame of *The Last Judgment* is the biblical inscription: "I will also set the teeth of beasts upon them, with the passion of the serpents of the dust." The artist has interpreted those words with harrowing zeal. Monsters rip and mangle the flesh of the damned in a hell that is well populated by clerics and kings, it being a special delight of artists in the Middle Ages to visually confirm that the first shall be last. In the middle of the painting, you can see the dead being called to judgment from land and sea. Heaven above presents us with a group portrait of the elect, dominated by the even rows of white-robed Old Testament prophets.

Looking at this calm and joyous assembly, one thinks, irreverently, of Huckleberry Finn's opinion of heaven as a

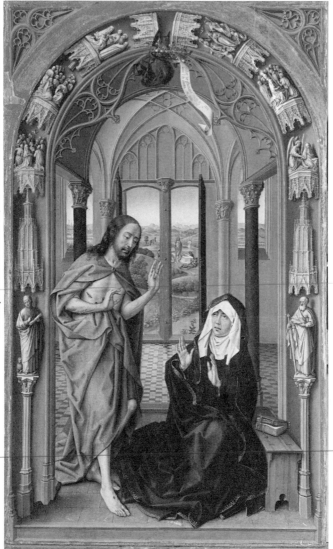

Rogier van der Weyden *Christ Appearing to His Mother*, 15th century

church service for the boringly well-behaved. Yet one of the elect seems unaware of any heavenly etiquette. At the upper left of the painting, a naked soul flings his arms up in unbridled happiness. Van Eyck has drawn attention to him by outlining his tiny figure against the blue of the Virgin Mary's robes. It's pleasant to contemplate this sinner who can't get over his great fortune.

Christ Appearing to His Mother by Rogier van der Weyden (ca. 1400–1464). The medieval mind loved a good story, and some of the best plot twists were simply made up. Nowhere in the gospels does it say that Christ visited Mary after the Resurrection. Rather, medieval artists were inspired to depict this scene by a popular text on the life of Christ by an anonymous Franciscan monk, once thought to be Saint Bonaventure, whom modern scholars call Pseudo-Bonaventure.

As an aid to devotion, and a spark to the imagination, the text purposely embroidered the narrative of the New Testament. Among the homespun details we learn from Pseudo-Bonaventure is that Christ preferred His mother's cooking to the food of angels. Pseudo-Bonaventure also wrote that Christ's first act after rising from the dead was to go see His mother, who was waiting tearfully for Him. Recovering from the surprise of Christ's actual appearance, she embraced Him and, true to maternal instinct, "looked intently and earnestly at His face and at the scars on His hands and asked whether all the pain had gone."

In Van der Weyden's interpretation of this apocryphal event, Mary is dressed in the habit of a nun and is seated in a Gothic building. In the landscape behind the building, the Resurrection is taking place. The sculpture in the Gothic arch, which illustrates Mary's life in storybook fashion, lacks the polychrome that was customary. Van der Weyden himself is said to have taken commissions to color church sculpture, even after he had become one of Christendom's most famous artists. His decision to depict the carvings in this painting as stone gray is a theatrical device that heightens the emotional impact of Christ's miraculous meeting with Mary. The artist's own particular miracle is to have made the two figures look like sculpture come to warm-blooded life.

In Gallery 24 is **The Adoration of the Magi**, an early painting by Hieronymus Bosch (active by 1480, died 1516). We search this picture for clues about the latter Bosch, the Bosch of bizarre visions and unearthly delights, with the fixated curiosity that we might bring to the scrutiny of an early photograph of a future president or assassin. An indefinable air of stupefaction hangs over this scene, as if the participants aren't entirely sure why they are there. If you peer closely at the landscape in the background, you'll see the fruit of Bosch's peculiar genius beginning to bud. A man with a dagger menaces an old woman, and birds pick clean the carcass of an animal.

The Flemish painter Joachim Patinir (active by 1515, died 1524) is considered the first landscape painter, an assessment confirmed by the vast earth and sky that dwarf the figures in **The Penitence of Saint Jerome**, Gallery 26. Patinir was so enamored of landscape that he reportedly supplied backgrounds to other artists. Pieter Bruegel the Elder was aware of Patinir's paintings, but Bruegel, whose patronage was secular, was free to cut loose from religious narrative in his grand landscape on view in the same gallery. We've come a long way from the realism of Giotto, whose view of nature was strictly guided by a belief in God.

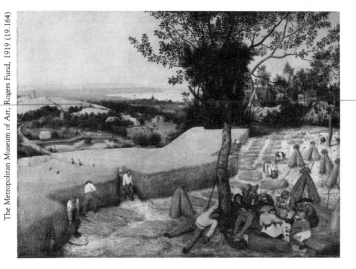

Pieter Bruegel the Elder *The Harvesters*, 1565

Bruegel's world view, detached and panoramic, is that of a humanist.

The Harvesters by Bruegel (active by 1551, died 1569). This painting is one of five that survive in a cycle of six, or perhaps twelve, illustrations to the seasons that the artist did on commission for Niclaes Jonghelinck of Antwerp. Church sculpture and illuminated manuscripts had linked the cycle of the months to the life and labor of peasants, but Bruegel here makes nature itself the hero. The unharvested wheat forms a bold diagonal in the foreground; a haywagon trundles across the valley in the middle distance, toward swimmers who skinny-dip in a pond; and boats are visible in a harbor near the hazy horizon. The village church seen through the trees is a reminder of God. Curiously, just at that moment when God's role in landscape has diminished, landscape becomes more godlike and expansive than before. Bruegel wants to include everything in this painting and nearly does. This ripe summer scene breathes contentment and acceptance, and it is a very deep breath.

For El Greco (1541–1614), born Domenikos Theotokopoulos, the truth existed in how the eye and imagination of the artist chose to see it. He wasn't the only painter of the epoch to embrace this new definition of art, but he was certainly the most daring. The Met's rich selection of his paintings is on view in Gallery 29.

In his youth on the island of Crete, he was a painter of Byzantine icons. He moved to Venice, then Rome, and in 1577 at age thirty-six, to Toledo in Spain. The recent discovery of El Greco's annotations in the margins of two books on art and architecture indicates that he thought of himself as an intellectual rather than a mystic. According to El Greco, an artist who slavishly followed Renaissance ideals of proportion and perspective was "a donkey covered with lion's skin." His own distortion of form was rooted in Mannerist theory prevalent in Rome, which proclaimed the freedom of style and artifice, and his intense colors owe much to Venetian painting.

You can get away with a lot when you're good, and as a superior painter in the provincial city of Toledo El Greco let his style take him where it would. Yet he was a man of his time, not a rebel. El Greco cultivated the right church

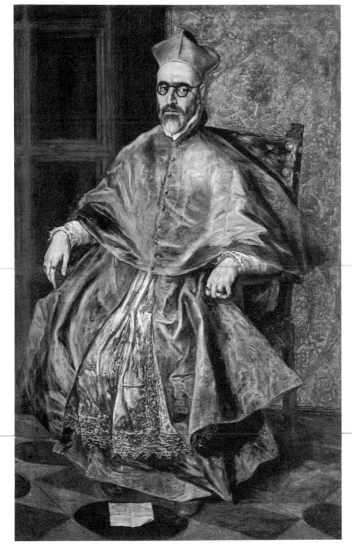

El Greco *Portrait of a Cardinal*, ca. 1600

officials for patronage. He was a servant of the Counter Reformation in his art, and if his personal beliefs differed from the official line, he was unlikely to have said so out loud. Although not the crazed mystic who has been sometimes imagined, no one today would deny the artist's deeply metaphysical turn of mind. Among the famous paintings in this gallery are **View of Toledo**, an anthem to the elemental power of nature; the **Vision of St. John**, a glimpse of the Apocalypse in a painting that was part of an unfinished commission at El Greco's death; and his mesmerizing *Portrait of a Cardinal*, discussed below.

Portrait of a Cardinal by El Greco. The identity of the scarlet-robed churchman in this striking and frightening portrait is unknown. Three cardinals of the Spanish Inquisition are possible, Guevara, Quiroga, or Rojas. All three served as Inquisitor Generals, or chief administrators of the tribunals charged with enforcing morals and cleansing Spain of Jewish, Moorish, and Protestant tendencies.

The opinion of the average museum-goer, that it would be dangerous to hire this man as a babysitter, is understandable on the visual evidence and also historically correct up to a point. Savagery is relative in history, which is to say that when this portrait was painted, circa 1600, a less virulent Inquisition had long since replaced the holocaust of the late fifteenth century, when thousands of accused heretics had gone up in flames. By one estimate fewer than three people a year in the sixteenth and seventeenth centuries burned at the stake throughout Spain and its territories. Fines, prison, and parading in the *auto-da-fe*, the festival-like public confessions of faith, were the far more common penalties.

Nonetheless it is fair to say, as Cervantes did in *Don Quixote*, that the Inquisition was effective at pressing the truth from the bones of the accused. The methods of torture were relatively conventional for the times. Water torture was used, during which water was forced down the throat; victims were also bound to a rack equipped with cords that tightened around the suspect's body. The church fathers of the sixteenth century recommended torture as a final resort in prompting confession. Cold-blooded detachment was the order of the day.

The cardinal in this painting looks like an intelligent,

even cultured man, which fits the profile for the educated elite of Spain's church hierarchy. Certainly we can read in his staring eyes a personality not prone to compromise. His left hand is twisted in an odd claw-like gesture, and a piece of paper lying at his feet forms a cryptic punctuation. The shallow, Byzantine-like backdrop, half gold and half darkness, could be interpreted as a symbolic division between the light of religion and the darkness of the human mind. We cannot be sure what this cardinal thought of his portrait, although we do know that churchmen of the Inquisition considered fear an excellent weapon in protecting the faith. It's possible he was well pleased.

Three rooms away, in Gallery 7, is another of the Metropolitan's famous portraits. It must be seen by anyone even remotely interested in social rank. **Portrait of a Young Man** by Agnolo Bronzino (1503–1572), the foremost Mannerist painter of Florence, offers a tidy visual definition of class. Some have it, some don't, and everything about the unidentified aristocrat in this painting from about 1540 says that he does. A decade or so before the portrait was painted, Baldassare Castiglione's *Book of the Courtier* described the ideal noble as someone who could hunt, swim, jump, run, throw stones, and vault on horseback. The book advises against competing with anyone of lower birth, warning that "one must be well nigh sure of winning, else he ought not to enter in, because it is too unseemly and too ugly a thing, and quite without dignity, to see a gentleman defeated by a peasant, especially at wrestling." It seems evident the young man in this portrait did not wrestle with peasants.

Although you are moving now on this walking tour away from religious art and into the secular age, you shouldn't resist the temptation of backtracking to see the small, precious painting by the fifteenth century Italian artist Carlo Crivelli (active by 1457, died 1495). The Crivelli is located in Gallery 5.

Madonna and Child by Crivelli. This painting is ripe with Christian symbolism, whose meanings were understandable to educated believers. Above the Virgin and Child is an apple, symbol of Original Sin, and a gourd,

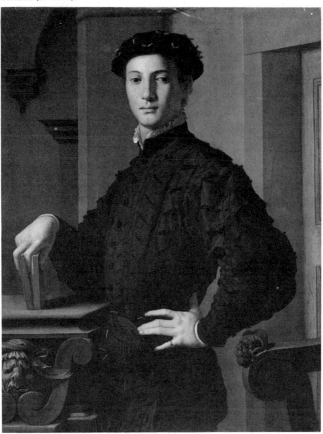

Agnolo Bronzino *Portrait of a Young Man,* ca. 1540

symbol of the Resurrection. (The gourd is associated with Jonah, whom God "resurrected" from the whale and in a later episode shaded with an enormous gourd.) The Christ Child's pet goldfinch forecasts His later Passion, since the goldfinch made its nest among thorns. The fly that has landed on the ledge is a symbol of the corruption and evil that was defeated by Christ. This picture is complete in itself, referring as it does to the past, present, and future. It is also wonderfully painted. The flickering, individual brushstrokes coincide with the modern taste for "painterly" style, and in our own age of disbelief, we are captivated.

Turn right out of Gallery 5, and two galleries away, in Gallery 10, you will find **The Rape of the Sabine Women** by Nicholas Poussin (ca. 1594–1665). Poussin was a high priest of painting in his day, who looked to classical antiquity for ideal beauty and harmony of form. His art aimed high, and if the grandeur of this painting rolls right off our backs today, it can at the very least tell us something about human nature as revealed in the history of art. Poussin arranged the composition of this violent scene so flawlessly that it appears frozen and static. We feel we might walk into it and admire the statue-like participants without bodily harm to ourselves. It is a stunning picture in its way and an illustration of the perils of the orderly mind that must put things exactly in their place.

Bruegel's *The Harvesters* gave us an expansive view of the world and the people in it. Coming now to the paintings of Johannes Vermeer (ca. 1632–1675), what we see is a luminous private universe. Vermeer was almost entirely forgotten after his death, until his rediscovery in the mid-nineteenth century. Nearly a quarter of the fewer than forty paintings by Vermeer that exist are on public exhibit in New York, at the Metropolitan and the Frick Collection. The Met's best known Vermeer is in Gallery 12.

Young Woman with a Water Jug by Johannes Vermeer. He was, as art historian Kenneth Clark put it, a "hoarder of contentment." Although he was a member of the local artists' guild, he made a precarious living as an art dealer selling work by other people. He was unwilling to part with his own paintings, and one of the few contemporary references to him is the diary entry of a French art collector named Balthasar de Monconys who was turned away: "At Delft I saw the painter Vermeer who had none of his works to show me. . . ."

Vermeer refined the Dutch love of home life to a kind of perfection. To help him do this, he almost certainly used a camera obscura, which projected an image through a double convex mirror and lens onto a surface as an aid to copying. Vermeer seems to have begun using this early version of a camera in 1658, a few years before he painted *Young Woman with a Water Jug*. He arranged the composition of this painting with a geometric rightness that re-

Johannes Vermeer *Young Woman with a Water Jug*, ca. 1660s

minds us of Mondrian, but what we find most seductive is the silvery tone of his cool light. Vermeer achieved his seamless surface by applying paint in small dots, mimicking the effect of his primitive imaging machine. Like a modern camera, his antique device focused most sharply on one plane, leaving background and foreground in softer focus. The technique fitted what little we can discern of the artist's temperament. The scene Vermeer has painted looks oddly untouchable, perfect but out of reach.

The Metropolitan's paintings by Rembrandt are in Gallery 14 and 15. In 1961, the Met paid $2.3 million for Rembrandt's *Aristotle with a Bust of Homer* (Gallery 15), at the time a record for a painting. It would be appropriate if that purchase price, and Rembrandt's status today as a blue chip Old Master, should come to mind as we approach the

painting. Money, fame, and art are the subjects of the painting itself and are also the intractible themes of Rembrandt's life.

Aristotle with a Bust of Homer by Rembrandt (1606–1669). Aristotle wears a gold chain that he must have gotten as a form of payment from his student and patron Alexander the Great, whose profile is visible on the medallion hanging from the chain. Aristotle's left hand, tucked in the shadows, hooks the sparkling gold. His right hand is placed on the head of the poet Homer, which is cast in light. The daydreaming philosopher seems to recognize the primacy of poetry over gold, of art over worldly success. That's the straightforward interpretation, which you are free to take if you are inclined to moral optimism. Anyone who prefers ambiguity should consider that Homer's wonderfully animate face looks quizzical, almost comically so, and that the bust of the poet is mute as well as blind.

The Metropolitan Museum of Art, purchased with special funds and gifts of friends of the Museum, 1961 (61.198)

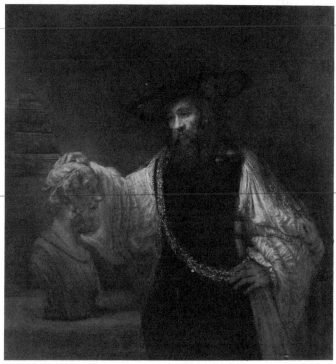

Rembrandt *Aristotle with a Bust of Homer*, 1653

Success soured for Rembrandt in his middle age. He completed this painting of Aristotle in 1653 for the Sicilian nobleman Don Antonio Ruffo, at a time when his reputation as a portraitist was waning in the north. Three of Rembrandt's four children had died, as had his wife Saskia in 1642. In 1656, he became insolvent and auctioned off his property. That Rembrandt squandered money is a matter of record and also part of the myth of the artist as tragic hero who helps to bring about his own downfall. His extravagance in buying medallions, antique weapons, and artworks was one expression of his profligacy. Rembrandt loved to play dress-up, and the garments that Aristotle is depicted as wearing came from the artist's own vast wardrobe of exotic costumes. The bust of Homer was doubtless inspired by one or another of the twenty-eight busts of Roman emperors he was forced to auction off.

In his revisionist biography, the American scholar Gary Schwartz describes Rembrandt as an arrogant character not always to be trusted in his business or private life. Whether this is true, and even if it is, his self-portraits remain extraordinary examples of personal inquiry. The tradition of self-portraiture did not exist in Rembrandt's time, yet he portrayed himself at an average of twice a year throughout his career. Writer Ambrose Bierce defined a celebrity as someone who is famous for being well-known. The greatest temptation with Rembrandt today is to similarly view him as a "great" artist and leave it at that. In the Metropolitan's **Self-Portrait** from 1660, we see a man with a bulbous nose and eyes that won't look away. It is the face of failure, and the artist's inability to offer excuses for himself stops us in our tracks.

As you walk from Gallery 15 back to the landing above the main staircase, you will go through several galleries of eighteenth century painting. Many museum-goers find the surface charm of the period perfectly resistible, yet it would take a viewer with an especially steely heart to breeze past **Boy Blowing Bubbles** by Jean Baptiste Chardin (ca. 1699–1779), located in Gallery 18. Chardin began his career as a sign painter, a stylish one by all accounts, and he was successful at everything he touched. His greatest

love was still life, common objects invested with a fine solemnity. In this painting, he illustrates the proverbial idea that life is as transient as a soap bubble. Chardin's image is at once sober and charming, and enduring in a manner that contradicts its message.

In Gallery 21, adjacent to Gallery 18, is **Mezzetin** by Jean Antoine Watteau (1684–1721) in which a comedic stage character named Mezzetin sings of unrequited love. In the glimmering light of a lush garden, the statue with its back turned to Mezzetin might be mistaken for the woman he is longing for. It's a wonderfully theatrical painting, a portrait of melancholy and gentle irony.

ANDRÉ MEYER GALLERIES

There are two entrances to the André Meyer Galleries, the wing devoted to nineteenth century European paintings and sculpture. The main approach to the galleries is through Greek and Roman Art; if you are at the landing above the main staircase, the quickest way is to walk down the Recent Acquisitions corridor and straight ahead.

If you enter the galleries from the side, you will see the Metropolitan's paintings by Francisco Goya (1746–1828), including his famous allegory on the innocence of childhood. It's a fitting introduction to the dawn of the modern era.

Don Manuel Osorio by Goya. Goya painted this portrait of the Count of Altamira's son in 1780s, but though the painting predates the nineteenth century we sense in it a turn of mind that defies its chronological niche. As a court painter, Goya was perfectly adept at the brilliant rococo style of the day. In England, Gainsborough was painting aristocrats as if they were mannequins without a thought in their heads. Goya looked inside his own head when he painted his aristocrats. The thoughts that came out on canvas cast a strange shadow behind the silvery promise of the Age of Reason.

The caged birds in the painting are symbols of innocence. The cats wait to pounce upon the magpie, a bird that in Christian symbolism stands for the soul. Since the dreaming boy in his bright red suit is tethered to a pet magpie by a string, we can assume the child himself is in jeopardy.

At the heart of the André Meyer Galleries is the Met's collection of Impressionists and Post-Impressionists, including nearly thirty paintings by Monet, and an abundant selection of paintings by Renoir, Pissarro, Cézanne, Van Gogh, and others. These paintings are in the large central gallery. In the galleries ringing this one are the predecessors and contemporaries of the Impressionists.

At the main entrance to the galleries (a short walk from the entrance at which the Goya painting is hung), are the paintings of Jacques-Louis David and Jean-Auguste Ingres, high priests of the academic style against which the Impressionists rebelled. The acolytes of this style, who once reigned in the French Salon exhibits which were the products of official taste, have been banished to the outer ring of the André Meyer Galleries. The Royal Academy of Painting and Sculpture had been founded under Louis XIV and sponsored the first Salon in 1667. A hallmark of academic painting was a smooth finish that concealed traces of brushstrokes. Compare the licked surface of a David or Ingres painting to the separate touches of pure color in a landscape by Monet, and you have an idea how odd the Impressionists looked in the early days to their contemporaries.

Turner, Constable, Delacroix, and Courbet are well represented just outside the central gallery, and if you continue walking counterclockwise you will go through the galleries containing the Barbizon School painters and the symbolists Klimt and Moreau.

Auguste Rodin has a large gallery to himself, or nearly so: in the protean marble and bronze forms on display, Rodin can be seen, figuratively speaking, wrestling with the spirit of Michelangelo.

The galleries devoted to Degas, located to one side of the main entrance to the André Meyer wing, will be discussed last.

The Impressionists got their name during their first group exhibit of 1874 from a hostile critic who used the term in ridicule. They later adopted the label themselves, despite its vagueness that never quite described the various artists associated with the group. Any definition of Impressionism would have to include the importance of the play of light and the recording of immediate experience. Renoir

had been the first of the group to see shadows as broken color rather than outlined areas of black and gray. Monet was the purest Impressionist. He once said that he wished he had been born blind, gaining sight so that he could paint objects without knowing what they were but rather as light itself. Ironically both Monet and Edgar Degas continued to work late in their lives, though both were nearly blind.

At left as you enter the central gallery is one of the first paintings Claude Monet, then age twenty-six, did entirely out-of-doors.

Terrace at Sainte-Adresse by Monet (1840–1926). Everything the young painter needed to pursue his experiments with color and light was here: radiant afternoon sunlight bouncing off the ocean and raking shadows across the patio, a little Eden of flowers to provide the touches of pure color, and a brisk warm breeze to stir up the water and give the brightly colored pennants their snap. "He's only an eye," Cézanne would observe of his colleague, "but, my God, what an eye!" In this painting you can see that eye

The Metropolitan Museum of Art, purchased with special contributions and purchase funds given or bequeathed by friends of the Museum, 1967

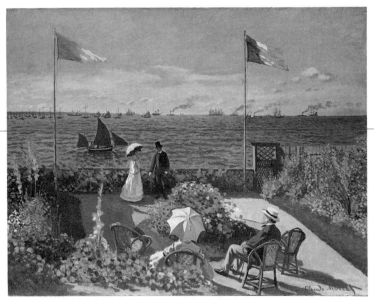

Claude Monet *Terrace at Sainte-Adresse*, 1867

deliberating in its departure from tradition. The patio, grass, and sky are painted with even brushwork, while the garden, water, and flags are rendered in broken strokes.

Monet painted *Terrace at Sainte-Adresse* in the summer of 1867, while he was staying with his family at that resort town on the English Channel (his father is in the foreground of the picture). The next June, he was evicted from an inn at Fecamp, also on the coast. Depressed and in debt, he wrote a letter to his friend Bazille that ended with the words: "P.S.: I was so upset yesterday that I had the stupidity to throw myself into the water. Fortunately, no harm came of it." The suicide attempt marks a curious turning point in Monet's life. If Monet was the eye of Impressionism, he also became its bull. In the following years his response to rejection or hardship was to put his head down and paint.

In 1869, Monet and Renoir painted side by side, at a popular swimming spot on the Seine just west of Paris. Renoir's painting of the scene is in the National Museum of Stockholm, and Monet's is in this gallery.

La Grenouillère, or "The Frog Pond." Monet's skill as a recording angel of the fleeting moment has reached maturity. Water this wet, we feel, has no business on canvas. Monet painted the ripples and the reflection of overhanging trees with broad bands of color. It's a bewitching idyll. It's also an announcement of Monet's fascination with water, light, and reflection, which would become the major obsession of his last years in his "Water Lilies" series. (Some of the final paintings from this series are at the Museum of Modern Art.)

In the summer of 1874, Edouard Manet (1832–1883) joined Monet and Renoir to paint with them at Argenteuil, a village on the Seine northwest of Paris. Manet's picture of a couple boating, located at the opposite end of this gallery, has been called one of the first modern paintings for the way it began to flatten out the traditional "window" of Renaissance art.

Boating by Manet. What are friends for, if not to tease you out of your cherished beliefs? Manet was older than his two companions by nearly a decade, and the intellectual leader of the loosely organized group, but it was their example that inspired him to go to Argenteuil and paint

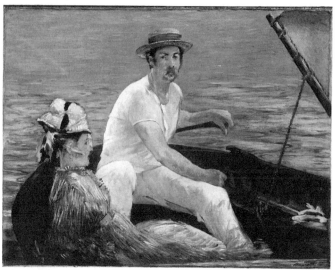

Edouard Manet *Boating*, 1874

outdoors for the first time. Once there, he abandoned the somber palette of the Old Masters for the high-keyed colors of his friends.

Although we think of these three artists as Olympians of nineteenth century art, their method of working together had more in common with children at play. We get a glimpse of this in Monet's description of the amiable rivalry between Manet and Renoir. Once, when Manet was painting a group portrait of Monet and his family as they sat under a tree, Renoir began to paint the same scene right beside him. According to Monet, Manet watched Renoir "out of the corner of his eye and from time to time would approach [his] canvas. Then, with a kind of grimace, he passed discreetly close to me to whisper in my ear, indicating Renoir: 'He has no talent at all, that boy! You, who are his friend, tell him please to give up painting.'" Manet composed *Boating* with the abrupt cropping and aerial perspective he had learned from looking at Japanese prints. He soon abandoned his experiment of working outdoors and returned to Paris, but not before he had done this shimmering hymn to summer.

If you walk counterclockwise around the perimeter of the gallery, you'll come to paintings by Pierre Auguste

Renoir (1841–1919), including **Madame Charpentier and Her Children**, which won the artist his first big success with critics and public alike. The woman is Madame Georges Charpentier, wife of a well-connected publisher, and Renoir used the couple's influence to get this painting into the official Salon of 1878. The smoothly worked style is a retrenchment from Impressionism, and the scene itself is a sweet evocation of a bourgeois world in which Renoir as a bohemian and outsider never felt completely at home. The two children, in their bright blue dresses, look like refugees who have come in from the sunny fields of Impressionism.

Although Paul Cézanne (1839–1906) joined in several Impressionist exhibits, his aim was not to mimic the fleeting moment but to pin it down. His compulsion was to make reality as solid and immovable as an apple in a still life. He prized the apple because it rotted more slowly than other fruit, thus giving him weeks at a time to painstakingly fix it upon canvas. In **The Card Players**, from the early 1890s, the three peasants hunched over their game have been compared, in their permanence of form, to apples turned at different angles in one of his still lifes.

Georges Seurat (1859–1891), like Cézanne, yearned to reduce form to something permanent. His method was to apply dots of color to canvas in a carefully controlled range of color, a technique we know today as Pointilism. His late painting **Invitation to the Sideshow**, 1888, is more ghostly than eternal. Among the other Post-Impressionists on display in this central room is Paul Gauguin (1848–1903), whose **Ia Orana Maria**, painted during a visit to Tahiti in 1891–93, transplanted the biblical Annunciation story to the South Pacific. Henri Rousseau (1844–1910), that hothouse folk art painter, created the exotic jungle in **The Repast of the Lion** after visiting the Paris botanical gardens. Henri de Toulouse-Lautrec (1864–1901) haunted the brothels of Paris and rendered a frank portrait of two prostitutes in **The Sofa**.

Near the middle of the gallery are the Metropolitan's collection of paintings by Van Gogh.

Cypresses by Vincent van Gogh (1853–1890). Van Gogh's letters, most of them written to his brother Theo, have come down to us as an autobiography of the artist

whose words in their directness parallel his paintings. "The cypresses are always occupying my thoughts, and I should like to make something of them like the canvasses of the sunflowers, because it astonishes me that they have not yet been done as I see them," he wrote. For Van Gogh, a cypress was "as beautiful of line and proportion as an Egyptian obelisk. . . . And the green has a quality of such distinction." Van Gogh once enumerated in a letter twenty-seven different kinds of black, and he was haunted by the difficulty of rendering the green and black color of the cypress. "It is a splash of black in a sunny landscape, but it is one of the most interesting black notes, and the most difficult to hit off that I can imagine." He wrote that sentence in a letter to Theo in June of 1889, after admitting himself to an asylum at Saint-Rémy. Early in his year-long stay there he painted this picture.

The three galleries of drawings, pastels, and paintings by Edgar Degas (1834–1917) are like a small museum of one man's art. Although Degas exhibited with the Impressionists and was part of their circle, he was deeply traditionalist. It makes sense, then, that the entrance to the Degas galleries abuts the work of Ingres, whose firm line he so admired.

"Of inspiration, spontaneity, and temperament I know nothing," Degas was fond of saying. He worked in the studio rather than out-of-doors. Characteristically, he first copied horses from the paintings of Théodore Géricault in the Luxembourg Museum in Paris and then afterward began haunting the racetrack to look for motifs. Patrician and aloof, Degas warded off love and close friendship with his cutting wit, and he is known to us today as both a revolutionary of nineteenth century art and one of its great curmudgeons.

Degas suggested that his drawings of nudes washing themselves, on display in the first gallery, are best viewed as if "through a keyhole." A quality of voyeurism, or at least of detachment, informed his art and life. Yet this ability to observe, combined with a temperament that was elegant to the bone, gave his art a feeling of deep joy and calm.

Monet was interested in the passing effects of natural

light. Far more studied, Degas used light artificially, like a
theatrical device, and even invented a fixative that gave
the pigment in his pastels more body, so that he could
better control color. Degas was a classicist in his search for
ideal form and an innovator in his attempt to see the world
in all its immediacy. Influenced both by Japanese prints
and early photography, he was forever looking for fresh
ways of composing his pictures. In **Woman with Chrysan-
themums**, 1865, the asymmetrical view creates an offhand
psychological portrait that looks to our eye like a modern
snapshot. The small bronze sculptures by Degas for many
years have been a major attraction of these galleries. Only
a limited number of them may be on view during your visit,
until they are reinstalled in new display cases. Degas was
going blind when he modeled these sculptures, which were
not shown publicly during his life and which represent his
private exploration of form. Cast posthumously in bronze,
the sculptures reveal his "touch" and his unending search
for perfection.

The Metropolitan Museum
Medieval Art / Lehman Collections
First Floor

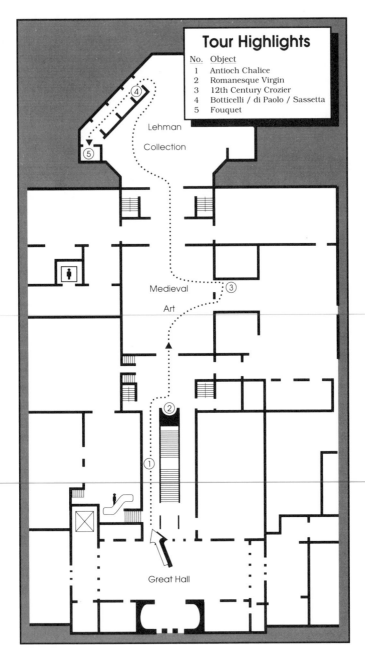

Tour Highlights

No.	Object
1	Antioch Chalice
2	Romanesque Virgin
3	12th Century Crozier
4	Botticelli / di Paolo / Sassetta
5	Fouquet

Lehman

Collection

Medieval

Art

Great Hall

MEDIEVAL ART

THE Metropolitan's collection of medieval art is divided between the main building and The Cloisters, the museum's branch located in Fort Tryon Park on the northern tip of Manhattan. Here in the main building, medieval art is installed straight ahead past the Great Hall as you enter the museum from Fifth Avenue.

The logical step after you tour medieval art is to see the superb paintings from fourteenth and fifteenth century Christendom that are housed in the Robert Lehman Wing, directly behind the medieval department. Because of the relatively isolated location of the wing, it remains somewhat undiscovered by the hordes of visitors who swarm through the Metropolitan. Remarkably, you might chance to find yourself in a room with a masterpiece by Botticelli, alone but for a guard hovering like a watchful angel nearby.

Enter the medieval department by walking to the left of the staircase. This corridor gallery contains art from the early Christian era, including the renowned Antioch Chalice, displayed about halfway down the corridor at left. The chalice comes from Syria, though it was probably not made for a church in Antioch as once thought.

The **Antioch Chalice** (early 6th century A.D.). Christ is depicted among vines ripe with grapes as a beardless man with short hair, an image that is Roman in style and Christian in content. He's pictured twice, as a teacher instructing his disciples and as the resurrected Christ enthroned above an eagle. The cup is a product of the so-called Dark Ages, and survives today because it was deposited in a

Antioch Chalice Syria,
early 6th century A.D.

hoard of liturgical treasures buried near Antioch during a period of marauding barbaric tribes. There's nothing dark or benighted about the wine vessel itself, whose gilded silver ornamentation swirls around the cup in a design that is bursting with life.

In the apse of the medieval department's Romanesque Chapel, to the right off the corridor gallery, is a twelfth century **Virgin and Child** from Auvergne in France. Mary was thought of as a Throne of Wisdom and is literally depicted as such, with Christ as a small adult seated on her lap. Softness has no place in the imposing figure of the Virgin; the message of Christ made man is everything. **Head of King David**, located near the Auvergne Virgin, was also sculpted in the twelfth century, but in it you can sense the winds of change. The face of the Old Testament king shows the rebirth of interest in personality. This fragment of early Gothic sculpture was plucked from its original site on the portal of Notre Dame Cathedral during the French Revolution.

Among the numerous liturgical objects in the Treasury Room, to the right of the Medieval Hall, is a particularly beguiling portion of a **crozier**, or bishop's staff, depicting Saint Michael spearing the devil in the form of a dragon. The crozier is an emblem of divine authority, the bishop being shepherd to God's flock. No shepherd could wield a more fearsome and magical staff than this one, which is

from France and dates from the twelfth or early thirteenth century. The hook of the staff is itself a dragon, which curls its scaly body around the battling saint. Other smaller dragons adorn the shaft. This crozier is crawling with symbols of evil, but it is evil rendered ornamental, and as such its power is subdued and reversed.

THE ROBERT LEHMAN WING

In the Middle Ages a wealthy man could buy a piece of heaven by commissioning an altarpiece and having himself painted into it. Religious donor portraits are no longer an option, but the late investment banker Robert Lehman was granted a monumental secular equivalent when the Metropolitan opened an entire wing in 1975 to house the art collection amassed by him and his parents. Lehman, whose portrait hangs at the wing's entrance, had a special fondness for late medieval and Renaissance painting. The collection also includes nineteenth and early twentieth century art, and a cache of drawings by Old Masters and eighteenth century Venetians that is displayed on a rotating basis.

Walk to the far end of the wing, and enter the series of galleries at the left, which are designed to look like the rooms of the Lehman townhouse on West 54th Street in New York. The first gallery is the Red Velvet Room, which contains altarpiece panels by di Paolo and Sassetta, two highly individualistic artists from Siena, and the painting by Florentine artist Botticelli that was probably once a centerpiece of a private chapel.

Expulsion from Paradise by Giovanni di Paolo (1420–1482). The first man and woman were not politely asked to leave the Garden of Eden, as this strange and marvelous painting makes clear. An angel gives Adam a shove, as God descends from heaven transported on angel wings. God seems to be wheeling the decree of exile before Him, in the form of concentric bands of color containing the zodiac. He points to a medieval map of the earth, upon which Europe and Asia are positioned at top and Africa below. Adam and Eve are destined for this parched and desolate land, which they will water with their tears. The

redemption of mankind is forecast even as Adam and Eve exit. Lilies sprout in their lost paradise, symbolizing the Virgin Mary and the Incarnation of the Savior.

Temptation of Saint Anthony by Sassetta (1392–1450/51). Sainthood is often a precarious occupation. It implies human perfection, and the more holy a man becomes, the greater the forces of darkness are that rise up to confront him. Saint Anthony, the founder of monasticism, was a favorite subject for medieval artists, as much because he was so plagued by temptations as for his triumph over them. The saint spent his days in the desert of Egypt, shown here as a weird and withered Sienese landscape. A taunting devil once appeared in this scene, between Anthony and the rabbit cowering by the rocky knoll, but for some reason he has been painted over. The absence of a literally portrayed figure of evil has the curious and anachronistic effect of making a medieval painting seem modern. The old saint's anguish appears to be a figment of his own mind.

Annunciation by Alessandro Botticelli (1444/45–1510). The archangel Gabriel arrives simultaneously with a burst of light that represents God's word to Mary that she

The Metropolitan Museum of Art, Robert Lehman Collection, 1975

Alessandro Botticelli *Annunciation*, late 15th century

will bear His son. This ordered, tidy picture demonstrates the principles of perspective, which Florentine artists had only recently worked out. Yet Botticelli has more on his mind than the arrangement of classical architecture. The crisp geometry, the sense of serenity in physical order, sets up the drama of the story. The mystical event runs like a swift crosscurrent through the picture. Gabriel's superbly drawn figure and fluttering robe convey the speed of his entrance. Mary humbly kneels. Gabriel is about to kneel, too, if the force of God's message doesn't knock him over first.

In the next room is a bronze **aquamanile** (ca. 1400), or water vessel, depicting Aristotle and the seductress Phyllis. The story of Aristotle made foolish by love was a favorite in the medieval period, and here Phyllis rides horseback on the bearded old philosopher. The next room has paintings by El Greco, Rembrandt, and Goya, and the gallery that follows is the Flemish Room which will bring you back again to the fifteenth century. To enter this gallery, which is tucked away by itself in a corner of the Lehman Wing, walk straight ahead after exiting the gallery that contains El Greco's *Saint Jerome*.

The Flemish Room contains paintings by Hans Memling, Hans Holbein the Younger, and the Master of Moulins, among others. **Saint Eligius** by Petrus Christus shows a goldsmith in his shop, and is one of the first paintings of the Christian era that qualifies as a genre scene, or depiction of everyday life. The goldsmith is traditionally identified as Eligius, patron saint of the trade, although the halo is a later addition.

Not to be missed in the Flemish room is **Descent of the Holy Ghost upon the Faithful** by Jean Fouquet, a fifteenth century prayerbook illumination that gives the first known topographical view of Paris. The city is used as a stage set for the wondrous biblical event. As the faithful gather on the roof of a building overlooking the Seine, the Holy Ghost rents the sky and scatters a pack of demons. In the background is Notre Dame Cathedral and Pont Saint-Michel. The hill beyond the bridge was added by the artist for scenic effect.

PRIMITIVE ART

IN 1907, Pablo Picasso visited the Trocadéro Museum in Paris, crammed with tribal African masks and sculptures. He was so thunderstruck by the experience that he later said, "At that moment I realized what painting was all about." The Trocadéro was more of a warehouse than a museum, stuffy, squalid, haphazardly arranged. At the Metropolitan, native art from around the world is pristinely housed in the Michael C. Rockefeller Wing, which opened in 1982. Being thunderstruck can now be accomplished in comparative comfort.

Picasso, and other avant-garde artists in Paris, admired and were influenced by what they called the "primitive" quality of objects from Africa and the Pacific Islands. The term has stuck, despite its bothersome connotation of backwardness: the Met's collections are administered by the Department of Primitive Art. Generally speaking, ritual and belief shaped the appearance of these objects. One hallmark of primitive art is that it is elemental, essential to the societies that produced it. Another is that, unlike Western art in Picasso's day and our own, it was never intended to be looked at in a gallery or a museum.

The wing is named after the late Governor Nelson Rockefeller's son, Michael, who drowned in 1961 in a rafting accident during an anthropology expedition in New Guinea. Housed in the wing is art from the formerly independent Museum of Primitive Art, which Nelson Rockefeller founded, along with objects from Rockefeller's private collection, and art acquired by the Metropolitan itself. The collection is arranged in a series of large open galleries, beginning with African art.

PRIMITIVE ART TOUR
FIRST FLOOR

Pendant Mask Nigeria, Benin, 16th century

The Metropolitan Museum of Art, The Michael C. Rockefeller Memorial Collection, Gift of Nelson A. Rockefeller, 1972 (1978.412.323)

ART OF AFRICA

The Metropolitan's art of Africa is especially strong in Benin sculpture, located in the center of the second large open gallery.

The kingdom of Benin flourished from the twelfth through seventeenth centuries in what is now Nigeria. Its artisans worked at bronze foundries long before the arrival of Europeans. Bronze and ivory sculpture shatters any notions we might have of a backward art. An ivory **pendant mask** depicting a queen (ca. 16th century) is extraordinary for its elegance and naturalism. The face on the mask is probably the deceased mother of a king of Benin. The king apparently wore the mask on his hip during a ceremony honoring the late queen. The mask also celebrates the appearance of the Portuguese, whose first visit to Benin was in 1485. The ornaments ringing the queen mother's head depict bearded Portuguese traders and also the mud-fish of the coastal waters. The king was considered semidivine, and his spiritual powers were associated with the sea and the fish. It so happened the traders arrived by sea, bringing riches to the king, which is why they get equal billing with the fish.

Near the display of Benin sculpture is a **reliquary mask**, an abstract head and human figure fashioned by an artisan of the Kota tribe in Gabon, on the west coast of central

Africa. This eerie image once guarded a reliquary containing ancestral bones and artifacts. Artists of the School of Paris drew inspiration from similar reliquary masks in their search for powerful new forms; Cubist painter Juan Gris made a cardboard version of one for himself in 1922.

ART OF THE PACIFIC ISLANDS

As you enter the gallery containing art of the Pacific Islands, you come to objects from Polynesia.

Here stands a sleek wooden sculpture, probably the god

The Metropolitan Museum of Art, The Michael C. Rockefeller Memorial Collection, Bequest of Nelson A. Rockefeller, 1979 (1979.206.1466)

Wood Figure (Rogo?)
Polynesian, 19th century

Rogo, which managed to survive the burning of local idols by missionaries in 1836 on the island of Mangareva. In the nineteenth century, Europeans initially romanticized the islanders of the Pacific as noble savages, living in a state of natural grace. Then, with a bump, they were demoted to brutes in need of saving. "Yet untutored offspring of fallen nature, how are you to be pitied," preached Thomas Haweis, founder of the London Missionary Society, in a 1795 sermon at his training school for missionaries. Against such attitudes, island gods could expect little mercy. On Mangareva, which is one of the Gambier Islands, an English missionary and two French priests destroyed most sculptures. A few were shipped back to Europe, to demonstrate the good work of conversion. Typically, wood figures represent Rogo, the god of peace and agriculture, who could transform himself into a rainbow or fog. The figure here appears so untamed and full of life, it's a wonder the missionaries did not transform it into firewood.

Nearby are **slit-gongs** from the New Hebrides, hollowed-out logs that stand some fourteen feet high. Impressive as sculpture, their deeper importance was as ritual instruments: when struck, they produced the voices of ancestors. In the center of the gallery are artifacts of the Asmat of New Guinea, who practiced headhunting until recently in this century. The Asmat blamed their enemies for death among their own people, whether from old age or disease, and the headhunt was intended to restore the balance of nature. Museum-goers have been known to become rather pensive before the Asmat's mbis poles, upon which heads of victims were placed.

ART OF THE AMERICAS

In the galleries containing art of the Americas, one of the most popular attractions is the Treasury with its gold artifacts.

"The sweat of the sun, the tears of the moon," is how the natives described gold and silver. The Spanish conquistadors, less poetically, thought of gold as convertible wealth. As they defeated the tribes of the New World, one after the other, they melted down most captured gold ornaments and shipped the raw metal to Spain. The sixteenth

Figure Pendant
Colombia, Tairona,
14th–16th century

The Metropolitan Museum
of Art, Gift of H.L. Bache
Foundation, 1969 (69.7.10)

century was literally a golden age as Spain financed its global empire on this infusion of capital. One particularly fierce tribe, the Tairona of Colombia, held off the Spanish for most of the century before finally falling. A **figure pendant**, an ornament once worn by a Tairona warrior, depicts a belligerent little man who is himself festooned with ornaments. The gold figure wears a lip plug, nose ornament, two baubles in each ear, and shakes a rattle in one hand (another rattle is missing). His enormous head-dress is made up of phantasmagoric bird and animal heads. The most impressive part of the pendant's design is the scowl on the face of the tiny man, which tells one and all to back off.

In the next gallery are artifacts of the Aztecs, Toltecs, and Mayans. A **Seated Mayan Figure** (ca. 6th century A.D.) is a rare wood carving to have survived the wet climate of Guatamala or southern Mexico. The figure, engaged in some unknown ceremony, carries himself with great dignity and gravity. His luxurious curled moustache suggests that the Mayans knew something about vanity. Displayed in a glass case is a plump **Baby Figure** (ca. 12th–9th century B.C.), a ceramic made by the Olmecs, an early civilization of Mexico. The baby may be a god whose tears brought tropical rains to the Gulf of Mexico.

ASIAN ART

IN Buddhism, the religion that originated in India and spread to the Far East, it's a virtue to mind what you're doing and to do it well. That's not a bad rule of thumb for museum-going either. The Asian Art department is divided into several sections. The leaps from region to region are sizeable, and it pays to take your time rather than rushing.

You could begin with Indian and Southeast Asian art, located on the Great Hall balcony. A red sandstone **Standing Buddha** (5th century A.D.) dates from the Gupta period, the so-called golden age of Indian art. The absolute calm of this Buddha's face reassures the faithful that it is possible to live in a troubled world and also transcend it. Also from India is an eleventh century bronze sculpture of the monkey warrior named Hanuman, a character from the Hindu pantheon of heroes known for his bravery and loyalty. This figure of a **Standing Hanuman** looks like a most suave and self-confident fellow, as we might expect from a fearless ally of the great Hindu god Rama. The elephant-headed **Standing Ganesha,** a Cambodian sculpture from the late seventh or early eighth century, may also be on display during your visit to the balcony gallery. Ganesha is the Hindu god of luck, his elephant strength coming into play to lift obstacles out of the way. This particular statue is small but doughty, a persuasively good god to have as a friend.

If you go down the corridor displaying ancient Chinese art and turn right into the gallery off of it, you will be greeted by two over-lifesize sculptures of **Lohan**, a disciple of Buddha. These glazed pottery figures date from eleventh

Lohan, 11–12th century A.D.

or twelfth century China. One is meditating, but the other appears ready to speak or to deliver a sermon. The latter wears a fixed glare that is startling in its realism. Buddhism recognizes the play of moods, though we can't be sure what has upset Lohan. He may be about to admonish a thick-headed student of Buddhism; or perhaps as museum-goers we can interpret his look as a warning to open our eyes and look clearly at the objects around us.

Also in this gallery is a **Seated Buddha**, T'ang Dynasty (7th century A.D.). How should a Westerner look at Buddhist sculpture? A seated Buddha, like the Crucifixion in Christian art, is the central image of Buddhist art and religion. One way to understand the image is to see it as a retelling of what the Buddha did. Siddhartha Gautama, who became known as the Buddha, was an Indian prince

ASIAN ART TOUR
SECOND FLOOR

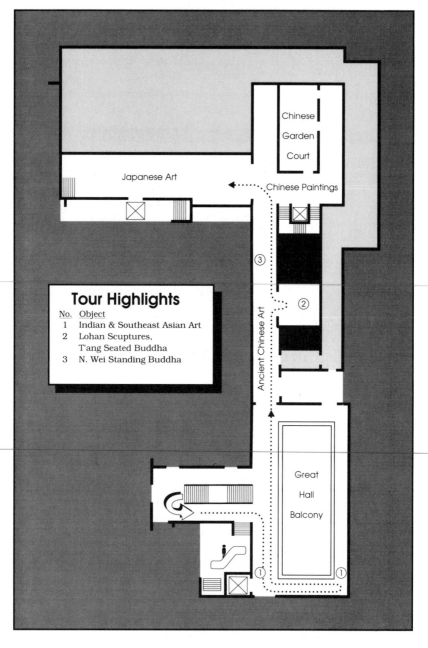

Chinese

Garden

Court

Japanese Art

Chinese Paintings

③

②

Ancient Chinese Art

Tour Highlights

No.	Object
1	Indian & Southeast Asian Art
2	Lohan Scuptures, T'ang Seated Buddha
3	N. Wei Standing Buddha

Great

Hall

Balcony

①

①

who lived in the sixth century B.C.. After years of devotional and ascetic practices, and at his wit's end to discover the causes of human suffering, he sat down under a bodhi tree, meditated long and deeply and was enlightened. It is said that people who saw him afterward asked whether he was a god or an angel. "I am awake," he replied. Buddha is the literal meaning of his answer, from the Sanskrit word "budh," which in English is "to wake up."

It's a fair question, then, to ask whether a sculpture looks like it is awake, especially since a common Western perception of Buddhism is that it is an escapist religion, a refuge for daydreamers. The seated Buddha in this gallery, eyes partly closed, is relaxed, alert, straight-spined, and by all appearances, alive to the moment. A beginner at Buddhism today might see this ancient sculpture as a model for how to meditate. Another way to see it is as a very old object that has managed to survive for thirteen centuries. It was made by the dry-lacquer technique: layers of cloth

The Metropolitan Museum of Art, Rogers Fund, 1919

Seated Buddha T'ang Dynasty, 7th century A.D.

were soaked in lacquer and then wrapped around a wooden armature and painted. Buddhist doctrine emphasizes the transience of existence. In a world subject to change, this figure of Buddha has proved remarkably durable.

Although acceptance of suffering and disappointment is central to Buddhism, so is the joy which comes from such an attitude. In the Chinese Art corridor is a gilt bronze **Standing Buddha**, Northern Wei dynasty (ca. 5th century A.D.). This Buddha with his half-smile delivers a buoyant message of optimism. The statue's left hand is extended in the traditional gesture of charity, and the right hand is open in the gesture of fearlessness.

Chinese paintings are straight ahead. Situated in the center of the paintings galleries is the **Astor Court**, a re-creation of a scholar's garden retreat from the period of the Ming dynasty (14th–17th centuries).

The tradition in China is to display paintings according to season or holiday, then carefully roll them up for storage. This is why centuries-old paintings are often in excellent condition, even though ink is subject to fading, and paper or silk to deterioration. Museum policy follows suit by rotating paintings rather than putting them on permanent display.

Among the paintings you may see on your visit, one of the earliest is **Night Shining White**, by the eighth century court artist Han Kan. Night Shining White was the name of a horse belonging to the T'ang emperor Ming-huang, an animal of demonic spirit chafing against its tether. The painting, one of the most renowned depictions of a horse in Chinese art, is also famous for the seals of ownership that cover its surface and that document its long history. As elsewhere in Chinese painting, the creative impulse of the artist is important, but so is the act of appreciation by the beholder.

Other notable paintings in the collection include **Summer Mountains**, an eleventh century Northern Sung monumental landscape, demonstrating the wonders of nature and insignificance of man. In **Emperor Ming-huang's Flight to Shu**, an eerie twelfth century Southern Sung landscape, nature reflects the dismal mood of the emperor, dressed in red, who is fleeing mutinous troops after they

forced him to watch the execution of his concubine. **Watching Geese**, a tranquil thirteenth century Southern Sung landscape, is about art as much as nature. Wang Hsi-chih, a fourth century patriarch of calligraphy, is shown in this scene watching the movements of geese to learn how to use his paintbrush as gracefully. Metaphysics never seemed so basic and practical.

The Metropolitan's collection of Japanese art is in a large nearby gallery. Portable screens have served as room dividers in Japanese architecture since the eighth century. The screens are fragile barriers, but thinking of them in terms of function alone would be like admiring the ceiling of the Sistine Chapel for its capacity to keep out rain. A screen divides space and imposes a sense of order on life that is partly physical and partly a state of mind.

The screen paintings, because of their sensitivity to light, are exhibited on a rotating basis. Among the master-pieces in the collection are: **The Battle of Hogen** and **The Battle of Heiji**, late sixteenth century, artist unknown. This pair of screens was painted at the height of samurai power for warrior patrons who could best appreciate a blood and thunder epic. The narratives depicted on the screens are based on Japan's first historical novels, which chronicled the brief but fierce clan rebellions of the twelfth century that heralded the rise of the samurai class. In these aerial views of two battles, events that took place over a day or several weeks are compressed into unified narratives, with episodes demarcated by gold-leaf clouds drifting over Kyoto.

The Old Plum, a seventeenth century screen that once stood in the abbot's quarters of a Zen monastery in Kyoto is a symbol of perseverance and renewal. A twisted old tree sprouts pink blossoms, the sight of which must have cheered more than one hard-working seeker of enlightenment. Ogata Korin, the renowned eighteenth century artist, is represented by two memorable screen paintings, **Irises** and **Rough Waves**. Korin was an artist of an age characterized as the "Ukiyo," or "floating world" of material and transitory pleasures that a newly emerging moneyed class hungered for. His cresting waves have come down to us as an emblem of the restless energy of the times.

NEAR EASTERN AND ISLAMIC ART

In Egypt, the pharaohs and their artists maintained the illusion that nothing ever changed from one millenium to the next. A cooperative river Nile backed their claims by regularly fertilizing Egypt's long narrow strip of arable land. The ancient Near East lacks such convenient historical or geographic brackets. In effect, the open-ended geography of the ancient Near East, its fragile boundaries, wrote its history, which is one of trade, migration, war, and the rise and fall of kingdoms.

The Ancient Near Eastern Art collection encompasses art of the Assyrians, Sumerians, Elamites, Hittites, and Babylonians, among other peoples, in a time frame of some five thousand years. The modern countries of this area include Syria, Turkey, Iraq, and Iran. Although the Near Eastern galleries offer no unified storyline to the museum-goer, they do contain some of the most striking objects in the Metropolitan.

The main entrance to the Near Eastern collection is guarded by an Assyrian **Human-headed Winged Lion** and **Bull**, from a palace at Nimrud (9th century B.C.). These guardian spirits are equipped with an extra leg, and when viewed from the side they appear to be stepping briskly forward to challenge all comers.

Farther along, in the gallery of art from Mesopotamia, is a small sculpture of a bearded praying man, with large unblinking eyes and hands clasped tight. This **Standing Male Figure** (ca. 2750–2600 B.C.) once belonged to a temple at Tell Asmar, in what is now Iraq. He was put there with other figures like him as a stand-in for human wor-

shippers. The gods of the period could be rather remote, so this intermediary with his touchingly earnest face had to pray very hard.

In the galleries of Iranian art are objects as mysterious as they are beautiful. **Bull Holding a Vase** (ca. 2900 B.C.) is a silver figurine of a kneeling bull in human dress. Animals which behave like people appear early and often in the art of the Near East. Historian H. W. Janson has affectionately

Male Standing Figure, ca. 2750–2600 B.C.

dubbed them the lost ancestors of our Aesop fables. The unknown myth or ritual performed by this man-bull must have been urgent to whomever fashioned it, for the creature carries itself with absolute conviction of purpose.

Also in the Iranian galleries is the stunning silver **Head of a Sasanian King** (late 4th century A.D.). The Sasanians ruled over the last great Near Eastern empire before the coming of Islam. This portrait is sometimes identified as Shapur II, a monarch and warrior who was described this way by a historian of the period: "The power of heaven had driven the king to an enormous degree of self-confidence,

Head of a Sasanian King, late 4th century A.D.

and to the belief that [his enemies] would be paralyzed with fear at the mere sight of him." The king of this portrait, with his hypnotic eyes and towering globe-like crown, is certainly not one of history's wallflowers. A gilded silver plate with a **King Hunting Antelopes** (ca. 5th century A.D.) depicts another Sasanian king, Peroz or Kavad I, bounding on a charger in the exuberance of the chase. It's a fabulous image of courtly pleasure.

Although the Arabs of Islam swept away the Sasanian empire in the seventh century, the pleasures of courtly life remained and flourished. The art of Sasanian kings is a logical transition leading the visitor to the Islamic collection.

The entrance to Islamic Art is straight ahead, and the miniature paintings that are the collection's chief glory are displayed in glass cases beginning in the first gallery on the left.

ISLAMIC ART

Miniature painting is an art of magnificent selfishness. The irony is that the religion of Islam rejected the rendering of figures, because it was blasphemous to represent God, much less any other being. Miniature manuscripts and albums were a palace art, an art of the royal "I," which shahs and princes savored in private. The practical reason for their smallness was that they were intended to be held in the hand and lovingly examined up close.

The permissible art of Islam is the arabesque, the sinuous line and two-dimensional pattern that you see on the carpets, metalwork, glasswork, and other objects in the museum's collection. Secular painters, imbued with this sense of pattern and decoration, added the figure, and small, brilliant fairytale worlds sprang up. In the workshops of Tabriz, the center of sixteenth century Persian painting, artists took months to produce their most ambitious designs.

For us today the sheer pleasure of looking at these pictures seems almost sinful. It seemed so for Shah Tahmasp, the great patron of the epoch, who sickened of visual hedonism and turned in later life from connoisseur to puritan. In 1556 he issued an edict of "Sincere Repentance" that banned the secular arts from his realm. Fortunately for

the unroyal "we" of the museum-going public, the *Shah-nameh* (Book of Kings), the highest achievement of his workshops, survives. In addition to seventy-eight pages from that manuscript, the Metropolitan possesses works from the major schools of painting in India, Iran, and Turkey.

Because the paintings are sensitive to light, they are displayed on a rotating basis. Among the paintings which you may see on your visit is **The Feast of Sadeh** (ca. 1520–22), a shimmering masterpiece from the *Shah-nameh*, the Iranian national epic, in which an early king of Persia discovers fire. The **Concourse of Birds** (ca. 1600) from Herat in Iran, tells the allegorical tale of birds on a pilgrimage to find God.

The Mughal rulers of India had their origins in Persia, or what is now Iran, and their court art is a blend of both cultures. **Krishna Holds up the Mountain as an Umbrella**, a Mughal masterpiece from 1590, depicts the wondrous story of the Hindu god Krishna protecting villagers from a storm. **Shah Jahan on Horseback** portrays, with due splendor, the potentate who reigned from 1628–58 and is most famous as the builder of the Taj Mahal.

AMERICAN ART

SOME thoughtful curator should hang a banner at the entrance to the American Wing with the inscription, "Thank you, Europe." It might be stretching things to say that every painting and sculpture here owes its existence to the influence of European culture, but not by much. American art in these galleries emerges against the backdrop of the parent culture.

The Garden Court of the American Wing contains Tiffany stained glass, neoclassical sculpture, and the Sullivan Stairs, designed by Louis H. Sullivan for the Chicago Stock Exchange Building. As you can see the moment you enter the court, it is also a prime oasis for visitors wishing to ward off museum fatigue. **Diana**, the elegant Beaux-Arts gilded bronze by Augustus Saint-Gaudens (1848–1907) is here. So are other sculptures which display the sentimentality that characterized much of late nineteenth century American art. **Bacchante** by Frederick MacMonnies (1863–1937), a bronze of a lady with grapes who has a case of the sillies, should restore your good humor if you happen to have misplaced it elsewhere in the museum.

Most of the collection is located in the wing's multilevel building behind the court. The entrance is through the Bank Façade, an 1820s classical structure transported from Wall Street to the Metropolitan early in this century. On the first and second floors are American decorative arts and period rooms from early America through Frank Lloyd Wright.

The paintings collection is on the second floor and mezzanine. Among the highlights are early American por-

traits, nineteenth century landscapes, and paintings by
Sargent and Eakins. Go through the Bank Façade en-
trance, take the elevator to the second floor, and enter
Gallery 217.

Portraits gave Americans a chance to get all dressed up
and declare, "This is me, here's my property, and I've done
rather well for myself in the new land." Many early Ameri-
cans turned to untrained folk artists, but the yearning for
European sophistication was strong. The European con-
nection with American painting began in earnest when
the Scotsman Francis Smibert (1688–1751) arrived in
1729. Smibert, an obscure artist in Britain, gave his new
clients what they wanted by copying poses from mezzotint
prints of Old World art and substituting the faces of his
sitters. He probably took the pose for **Mrs. Francis Brinley
and Her Infant Son** from a print of a madonna and child.
The orange tree next to Mrs. Brinley is her status symbol,
for in colonial Massachusetts where she lived, only the
well-off owned greenhouses where such luxury items could
grow.

John Singleton Copley (1738–1815) was an American
original if ever there was one, but when he got good
enough he left for Europe and never came back. In his
portrait of **Mrs. John Winthrop**, from 1773, he treats
material objects, and the lively personality of the sitter
herself, with tangible relish. Two portraits in this gallery
offer a before-and-after contrast of the painter in America
and England. His 1771 portrait of **Daniel Crommelin
Verplanck**, scion of a wealthy New York landowner,
shows us a dandified little boy who is full of vitality and as
sharp-eyed as his pet squirrel. After arriving in England in
1775, Copley adopted the loosely worked style of the Brit-
ish court in his portrait of **Midshipman Augustus Brine**,
thirteen-year-old son of British Admiral James Brine. In
the process Copley lost his provincialism, and arguably
himself.

In Gallery 218, **George Washington** by Gilbert Stuart
(1755–1828) is a familiar national icon of the first presi-
dent, painted in the best British style of the day. Stuart
painted numerous copies, and this early version, circa
1795, may have been done partly from life.

George Caleb Bingham *Fur Traders Descending the Missouri,*
ca. 1845

In Gallery 219, and the two galleries after it, the subject
is the New World and its wonders.

Fur Traders Descending the Missouri by George Caleb
Bingham (1811–1879). Bingham began as a sign painter
and studied painting briefly in Philadelphia. Judging from
his subtle handling of light and depth in this painting, he
had some knowledge of European painting, probably at
second hand from looking at prints of Continental master-
pieces. The scene, painted about 1845, is a splendid bal-
ance of anecdote and lyricism. It suggests both the mischief
of Mark Twain and the meditative quality of Henry David
Thoreau. The pet belonging to the old trader and his son
has been identified as a fox.

In Gallery 220 is **View from Mount Holyoke, North-
ampton, Massachusetts, After a Thunderstorm (The Ox-
bow)** by Thomas Cole (1801–1848). Cole grew up in Eng-
land and emigrated to America where he apprenticed as a
woodblock engraver. By painting nature, he believed, you
could see God's hand. He depicted trees and plants with
meticulous care, even while singing the praises of nature's
power and sweep. You can see the artist himself perched in

the cleft of the rock formation in the foreground of this painting, pleased with himself at having weathered the thunderstorm God had brought his way.

If Cole painted big, his student Frederick Church (1826–1900) painted cosmic. Church became a leading inter of the Hudson River School, but his yearning for vastness could not be contained by the comfortable vistas of the Catskills and Berkshires. *Heart of the Andes* was inspired by a trip to Ecuador. He finished the painting and showed it in New York in 1859. A year later, the painting was exhibited in St. Louis, where Mark Twain scrutinized its details through opera glasses and admired how "you may count the very leaves on the trees." It now hangs in Gallery 221 opposite **The Rocky Mountains, Lander's Peak** by Albert Bierstadt, a German-born painter who studied in Düsseldorf and in 1858 accompanied a surveying expedition to the West. The painting depicts Fremont's Peak (not Lander's Peak as in the title) towering over a Shoshone Indian camp. Bierstadt's romanticized mountains owe a part of their grandeur to the alpine views the artist had seen on a trip to Europe.

In an age before Hollywood blockbusters, such paintings fired the imaginations of stay-at-home easterners. Hokey theatricality surrounded the New York exhibitions of each painting. The paintings hung opposite each other at the 1864 Metropolitan Fair, and, as a sideshow elsewhere at the fair, Bierstadt got some Indians to pitch wigwams and demonstrate native dances. When Church first exhibited his *Heart of the Andes* a few years before, the painting was displayed with tropical foliage in a room lit by gas jets. Visitors were invited to gaze at the painting through viewing tubes that gave a three-dimensional effect. You can recreate that effect for yourself, with a fair degree of historical accuracy, by curling your thumb and fingers into a tube shape and peering through.

Also in this gallery is **The Coming Storm** by Martin Johnson Heade (1819–1904), an 1859 painting that magically renders light and atmosphere.

In Gallery 222 is the art of Winslow Homer. To the left as you exit is the gallery of nineteenth century history and genre painting. This gallery contains **Washington Cross-**

ing the Delaware by Emanuel Leutze, an 1851 painting noted for its outsized patriotism and its historical inaccuracies. (Horses are mistakenly shown in the boat with the men, and the river is festooned with ice chunks rather than a thin glaze of ice.)

The paintings of Sargent and Eakins are on the mezzanine. To get there, turn right from Gallery 222 and reverse your direction. Walk the length of the long narrow Gallery 224, which contains the little fool-the-eye masterpieces of William Harnett (1848–92) along the way. Near the staircase above the mezzanine is the small, sublime **Toilers of the Sea** by Albert Pinkham Ryder (1847–1917). In his quest for the visionary, Ryder reworked his paintings obsessively, building up the surface in numberless glazes. His experiments in the medium caused many of his canvasses to crack, but also produced the gem-like luminosity of this seascape.

Descend the stairs to the mezzanine, where you will find paintings by Thomas Eakins at one end, John Singer Sargent at the other, and the American Impressionists in between. In the last century Sargent was far more popular than Eakins, and inevitably today we compare the two. For

The Metropolitan Museum of Art, purchase, 1934, Alfred N. Punnett Fund and Gift of George D. Pratt (34.92)

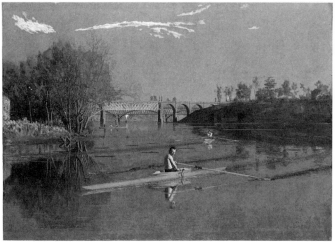

Thomas Eakins *Max Schmitt in a Single Scull,* 1871

if Sargent was America's flashiest painter of the period, Eakins was arguably its best.

Their careers reflect the gravitational pull of European art, and in the case of Eakins, the cutting loose from its ties. Both apprenticed in ateliers in Europe, as was common for American artists, and both admired the paintings of Velázquez. In a sense Sargent *was* European. Though born of American parents, he spent much of his life on the Continent and made his living in what he once called the "pimp's profession" of society portraitist. He spent his last years working on an allegorical religious mural in the Boston Public Library, as if to atone for a life spent painting fashionably well. Eakins studied art in Paris as a young man, returned to Philadelphia, and devoted himself to painting, in a firmly realistic style, his small corner of the world.

Max Schmitt in a Single Scull by Thomas Eakins (1844–1916). Eakins' friend Max Schmitt pauses to scrutinize us, and the artist himself glides away behind him. Eakins, who was fascinated by science and technology, depicts the railway trestle with an almost tender exactness. Eakins has described the bridge, the clouds, the water, and the rowers themselves with clarity and firmness, while painting the foliage of the trees more freely. Some artists exaggerate what they see to get at a truth behind it. Eakins closely observed the life that he knew and found the facts wonderful in themselves.

Madame X by John Singer Sargent (1856–1925). We admire Sargent today for the sparkling ease of his brushwork, but the skin tone of this society vamp, which Sargent called "uniform lavender or blotting-paper color," caused him fits. Virginie Gautreau, the "X" in question, was the American-born wife of a French banker. The portrait hung in the Paris Salon of 1884, along with another Sargent portrait of a prominent doctor with whom she was supposedly having an affair. Parisians were scandalized by her reputation and low-cut gown, and in the wake of the uproar Sargent scurried to London. When he later sold this profile in vanity to the Metropolitan he wrote, "I suppose it is the best thing I have done."

20TH CENTURY ART

FOR much of this century, the Metropolitan Museum viewed avant-garde art as an unfortunate aberration that might go away if ignored. The Metropolitan did collect living artists, but fitfully and suspiciously. Picasso, for instance, was beyond the pale. In the 1930s, the curator of paintings Harry Wehle refused a Picasso with the remark: "If it's a pile of bones, the answer is no." Both the Museum of Modern Art and the Whitney Museum of American Art were founded in the void left by the Metropolitan's imperial disdain toward living artists. Eventually attitudes at the Metropolitan changed. In 1946, the American writer Gertrude Stein bequeathed to the museum a Picasso portrait of her that is now a treasure of the collection. In the 1950s, Robert Hale, curator of American art, boldly began acquiring New York abstract paintings, including Jackson Pollock's *Autumn Rhythm*. In 1967, a separate department of contemporary art was finally established.

The Lila Acheson Wallace Wing, which opened in 1987 and was named for the late cofounder of *Reader's Digest*, is a superb showplace for twentieth century art. Spacious and open, it boasts two areas for sculpture, a skylit mezzanine above the first floor and a rooftop garden (open from May 1 to November 1). It's a big place, and as yet the Metropolitan does not have enough acknowledged masterpieces to fill it. Museum administrators themselves admit the collection is spotty and uneven. They plan to change the displays often to generate a sense of surprise, while hoping donors in years to come will fill the collection's gaps.

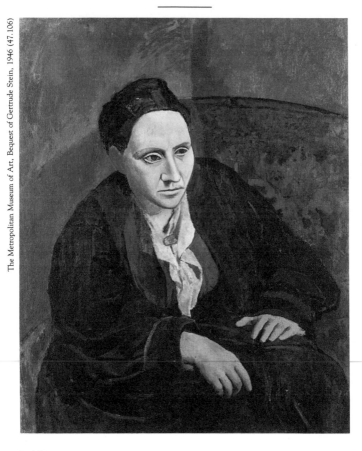

Pablo Picasso *Gertrude Stein*, 1906

The wing can be entered at two locations, on the first floor from the Art of Africa, Pacific Islands and the Americas; or on the second floor from the André Meyer Galleries of nineteenth century European art.

The first floor galleries contain art from 1905 through 1940. (A large gallery on this floor is also devoted to temporary exhibits.) The collection has large numbers of American painters, including Grant Wood, Thomas Benton, Arthur Dove, Marsden Hartley, and Georgia O'Keeffe. Matisse and Picasso, giants of the School of Paris, are represented by a pair of paintings that would be the envy of any museum:

Gertrude Stein by Pablo Picasso (1881–1973). Picasso

was twenty-four years old when he began painting the writer Gertrude Stein, who was then thirty-one. The portrait rivets us today, but its sense of rock-like rightness was the product of terrific labor and indecision. According to Alice B. Toklas, Gertrude Stein's secretary and companion, the artist had Stein pose for him ninety times. The sittings took place over several months in Picasso's studio. One day Picasso painted out the face entirely and told Stein in disgust, "I can't see you any more when I look." Months afterwards, after a vacation in the Pyrenees, Picasso painted in the primitive, mask-like face we see today. He apparently was inspired by the ancient Iberian sculpture he had recently seen at the Louvre. This 1906 portrait of Stein as a stone-faced oracle pleased Stein herself, and puzzled other observers. When someone commented to Picasso that it didn't look like Stein, Picasso is said to have replied: "It will."

Nasturtiums and "Dance" by Henri Matisse (1869–1954). This ravishing painting from 1911 is a picture within a picture. *Dance*, a 1909 painting that is now in the collection of the Museum of Modern Art, is shown leaning against a wall. Or at least a section of the painting is shown, as is a glimpse of Matisse's studio. We see a chair and a vase of flowering nasturtiums, whose curling stems repeat the curve of the dancers' arms.

The theme of *Nasturtiums and "Dance"* is memory and the transporting power of art. The naked dancers in the original painting of *Dance* belong to a nameless, timeless place of green earth and blue sky, removed from the troubles of the world. In the 1911 painting, the artist is saying it is wonderfully easy to go there. Matisse has merged in his imagination the everyday world of the studio with that place. The brushwork is sketchy and free, just as memory is when recalled in a happy mood.

On the mezzanine, on each side of the sculpture gallery, are two small galleries. One contains prints, drawings, and photographs. The other is a gallery of art by Paul Klee (1879–1940). The Metropolitan owns ninety Klees, donated by Swiss collector Heinz Berggruen, which will be shown in the gallery on a rotating basis.

On the second floor are paintings from 1940 to the present (and a large special exhibit gallery). Here you will find art by the Abstract Expressionists and by Jackson Pollock, the dominating figure in a movement that required enormous canvasses to express its outsized emotions.

Someone once suggested to Jackson Pollock (1912–1956) that he might reap fresh insights if he tried working directly from nature. "I am nature," Pollock answered. Such bravado is central to the life and myth of Pollock, American art's upstart. As a young art student in New York, Pollock had learned to draw by copying Michelangelo and El Greco. He admired Picasso and the Surrealists. But in the 1940s, Pollock adopted a technique that was direct and instinctive. He dripped and flung paint at unstretched canvas on the floor, walking around the canvas, even stepping onto it as he worked. His favorite tools were caked paintbrushes, and he learned to apply his splatters and splotches with a fine sense of control. Pollock, a devotee of Jungian psychology, believed that his paintings came from the unconscious. In painting, thought and action became one. The Cubists had fractured the illusion of a picture's three-dimensionality. Pollock's contribution to the history of art was a seamless "allover" pattern that seemed to deny that illusion altogether. An alcoholic pursued by personal demons, Pollock spent years in psychiatric analysis. By the early 1950s, he was being hailed by critics as an American colossus who had redefined Western painting. Pollock, tormented by self-doubt, could barely work in the last years of his life. He wondered whether his work said anything. He once called his wife, the painter Lee Krasner, into his studio, showed her a completed painting, and desperately asked: "Is this a painting?" On August 11, 1956, he died after the car he was driving crashed into trees on a road near his home outside of Easthampton, Long Island.

The title of Pollock's **Autumn Rhythm** (1950) helps us in looking at the painting. There is the rhythm of paint, the repetitions of pattern and color our eye picks up as it moves across the canvas; and, if we think of how the artist made the painting, the rhythm of his arm and hand. Pollock's paintings have been described as a balancing act between violence and decoration. The violence was in the

act of making them, and we can still sense that energy even if it feels distant to us today. We may choose to see *Autumn Rhythm* as decoration, just as the repetitions in Islamic pattern or Celtic art are decorative. Approached quietly, meditatively, *Autumn Rhythm* yields a pleasure that is indefinable and personal. There is no literal subject, but in a metaphorical sense the subject of the painting is the rhythm of nature, the pulse of life.

FORT TRYON PARK
NEW YORK, NY 10040
TELEPHONE: 212-923-3700

HOURS: *Tuesdays–Sundays, 9:30–5:15 (March through October); 9:30–4:45 (November through February). Closed Mondays, and December 25, January 1, and Thanksgiving Day.*

ADMISSION: *$5 suggested for adults, $2.50 suggested for students and senior citizens, free for members of the Metropolitan Museum and children under 12 accompanied by an adult. Some admission fee is required, but you may pay more or less than amount suggested.*

GETTING THERE: *Madison Avenue bus number 4 ("The Cloisters") to museum door. By subway, train A to 190th Street; then take number 4 bus or walk through Fort Tryon Park to museum. By car, Henry Hudson Parkway north to first exit after George Washington Bridge. Free parking.*

GIFT SHOP: *Books, catalogs, bulletins, postcards, facsimiles of art objects, recordings of medieval music.*

SPECIAL EVENTS: *Recorded medieval music daily. For information on live concerts, consult the Metropolitan Museum calendar or call 923-3700.*

TOURS: *Tuesdays–Thursdays at 3 p.m. spring, summer and fall; Wednesdays only in winter. Group tours by arrangement only, call 923-3700 ext. 26.*

MEMBERSHIP: *Included in Metropolitan Museum membership.*

THE CLOISTERS

C HAUCER wrote that people long to go on pilgrimages to far-off shrines. The Cloisters, located on a hilltop on the northern tip of Manhattan, is not so far geographically from the heart of an enormous modern city. Yet for many visitors to this museum of medieval art, something of the pilgrimaging spirit prevails. The setting seems almost impossibly tranquil, a world apart. John D. Rockefeller, Jr., whose fortune built this branch of the Metropolitan Museum, even bought the land on the opposite bank of the Hudson River. The view to the west of the Palisades Interstate Park remains unspoiled, like an ideal landscape in a medieval prince's illuminated prayerbook.

Medieval artists could be sticklers for accuracy based on the traditions they knew, yet they also embraced the fanciful. Likewise, the design of The Cloisters is a composite: authentic medieval architectural fragments incorporated in a building from this century that evokes period style. The Cloisters actually encompasses parts of four cloisters, including the cloister from St.-Michel-de-Cuxa, which in the twelfth century was the largest monastery in the south of France.

A cloister, with its open court and protected arcades, was at the center of monastic life. Monks walked in silent meditation, read their prayerbooks, or talked among themselves. In some monasteries they copied manuscripts there and even washed their clothes if the courtyard had a fountain. The monastery buildings enclosed the cloister (as the museum buildings now enclose the Cuxa Cloister) and

THE CLOISTERS TOUR

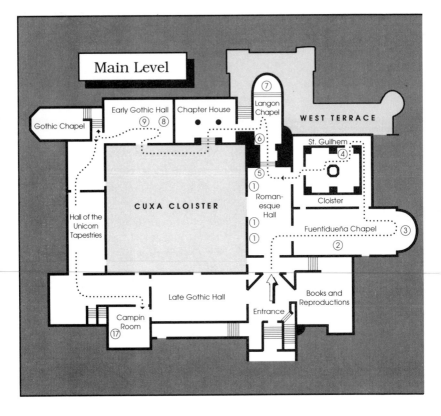

Main Level

Gothic Chapel

Early Gothic Hall ⑨ ⑧

Chapter House

Langon Chapel ⑦

WEST TERRACE

St. Guilhem ④

⑥

⑤

CUXA CLOISTER

Roman-esque Hall ①

Cloister

Hall of the Unicorn Tapestries

① ①

Fuentidueña Chapel ③

②

Late Gothic Hall

Entrance

Books and Reproductions

Campin Room ⑰

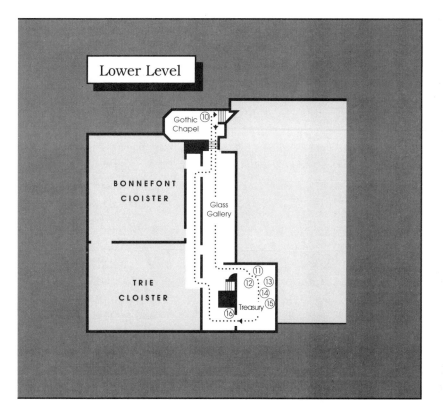

Tour Highlights

No.	Object	No.	Object
1	Lions	10	Effigy of a Boy
2	Romanesque Crucifix	11	Altar Cross
3	Fresco of Virgin		Arm Reliquary
4	Hell's Mouth Capital	12	Reliquary Shrine of Virgin
5	Gothic Door		English Ivory Virgin
6	Autun Angel	13	St. John Ivory Plaque
7	Autun Virgin	14	Ivory Crozier
8	Virgin from Strasbourg	15	The Lamentation
9	Virgin from Ile-de-France	16	Illuminated Manuscripts
		17	Annunciation Alterpiece

typically consisted of a church, dormitory, dining hall, library, and a chapter house where monks met as a community.

Like so many inspired ideas, The Cloisters is the product of several minds and the culmination of a process marked by at least one false start. At the turn of this century, American sculptor George Grey Barnard, who was living in France and strapped financially, began a lucrative business dealing in Gothic carvings and architectural fragments. Barnard eventually conceived the grandiose vision of salvaging cloisters from ruined medieval monasteries scattered about the French countryside. He bought a number of the Cuxa Cloister's marble capitals from villagers who had set them up on their property as garden decorations. After an initial deal to sell his acquisitions to the Metropolitan Museum fell through, Barnard in 1913 shipped his architectural fragments to New York and established his own "cloisters museum" in a building on Fort Washington Avenue near the present site of The Cloisters.

In 1925, Rockefeller bought Barnard's collection, donating it to the Metropolitan and later giving the land of Fort Tryon Park to the city. The architect of The Cloisters was Charles Collens, who designed Manhattan's Riverside Church. Although construction was initially delayed by the Depression, The Cloisters opened in 1938. Much of the art inside was bought with Rockefeller money. James Rorimer, the curator responsible for the master plan of The Cloisters, even managed to coax the famous *Unicorn Tapestries* from Rockefeller, who had them hanging in his Manhattan townhouse as his most prized possession.

In a tour of an hour or so, the visitor can travel across four centuries of the Age of Faith, by following a roughly chronological sequence of rooms and displays that begins in the Romanesque Hall and ends in the Late Gothic Hall. The entrance to the Romanesque Hall is through a stone archway from mid-twelfth century France.

To the left in this Hall are the fierce guardian **lions** of The Cloisters, all from the thirteenth century. A pair of stone lions, from a church in a small village in northern Italy, flanks the doorway to the Cuxa Cloister. Another lion is pictured in a wall fresco from a chapter house en-

tranceway of a monastery in northern Spain. According to the lore of medieval bestiary writers, lions slept with their eyes open, in eternal vigilance against evil. The lion was also associated with Christ's resurrection, since the beast supposedly could breathe life back into a litter of dead cubs.

From the Romanesque Hall enter the **Fuentiduena Chapel**.

Like much of the architecture in The Cloisters, this chapel is partly original and partly a modern construction in period style. The apse, or recessed area, came from a twelfth century church in Fuentiduena, near Madrid. The fresco above the altar came from the Church of San Juan de Tredos, another twelfth century church in northern Spain.

The fresco depicts a **Virgin and Child Enthroned**. They stare down with the monumental calm that characterizes so much of Romanesque art. One should imagine the apse lit by candles to understand the theatricality of this period, when faith was inspired by awe. A Romanesque **crucifix,** from twelfth century Spain, is very different from the crucifixes of a human, suffering Christ that evolved later in the Middle Ages. Instead of a crown of thorns, this Christ wears a heavenly crown and has already transcended the torments of this world.

The **St. Guilhem Cloister**, which can be entered from the Fuentiduena Chapel, dates from the early thirteenth century, when a Benedictine monastery near Montpellier in the south of France was rebuilt. The monastery was named for Guilhem, a legendary soldier of Charlemagne who turned monk, and it was a popular stop for travelers who could stay there as guests during pilgrimages to Santiago de Compostela in Spain.

The cloister's capitals and columns are decorated with acanthus leaves, in a surpising variety of designs, many of them probably inspired by Roman ruins in the area. The **Hell's Mouth Capital** is an oddity here. It dates from the fourteenth century and may have come from elsewhere than St. Guilhem's. No matter what its origins, modern pilgrims at The Cloisters are drawn to this medieval vision

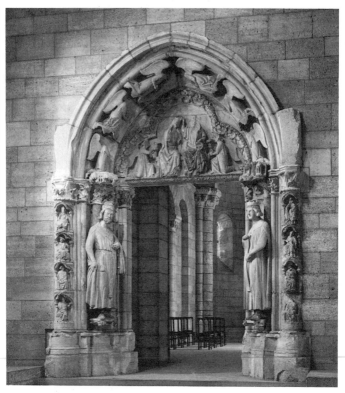

Gothic Doorway from the Abbey of Mouriers-Saint-Jean, 13th century

of damnation. The Devil's face leers on one side of the capital, and cloven-hoofed demons lead sinners in chains to a monster's mouth that spits out flames. One greedy sinner carries a moneybag with him into the very jaws of hell.

From the St. Guilhem Cloister, re-enter the Romanesque Hall. At this end of the hall is a late thirteenth century **Gothic Doorway** from the monastery church of Moutiers-Saint-Jean in Burgundy, France. (Gothic architecture comes out of chronological sequence in this part of The Cloisters. The mismatch is not so jarring when you consider that the church architects of Europe routinely constructed additions in one style onto an existing building of an earlier period.)

The two kings flanking the Gothic Doorway are prob-

ably Clovis, the first Christian king of France, and his son Clothar. In Romanesque sculpture, portal figures conformed to the configuration of columns. Here the kings stand free from the columns of the portal, as if to assert their humanity. On the tympanum above the kings, Christ crowns Mary. Ripe naturalism is the hallmark of Gothic art. Even the oak and maple leaves adorning the tympanum are freshly observed. Note the green of Christ's robes which, though now somewhat faded, gives a good idea of the original polychrome. The greens, reds, blues, purples, and golds of medieval sculpture gave church interiors a colorful, even gaudy appearance.

The Gothic Doorway leads to the **Langon Chapel**, a modern reconstruction in the Romanesque style, using some of the stone from the choir of a twelfth century church in southwestern France.

At left and above as you enter Langon Chapel is a Romanesque **angel** from the north portal of the Church of

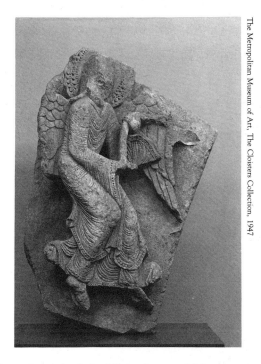

The Metropolitan Museum of Art, The Cloisters Collection, 1947

Angel from the cathedral of Saint Lazare, 12th century

St. Lazare in Autun, northeastern France. This airborne angel probably once held a censer, and you might imagine this figure raising impressive clouds of incense with it. The angel embodies a faith that is raw, instinctive, inspired, a faith of emotion more than ideas. In the Old Testament, the Lord sent "a great and strong wind" to the prophet Elijah on Mount Horeb. Such a wind seems to be blowing this angel along and swirling its garments. A master sculptor named Gislebertus signed his name on the west portal of the Church at St. Lazare and presumably was responsible for the flight of this angel.

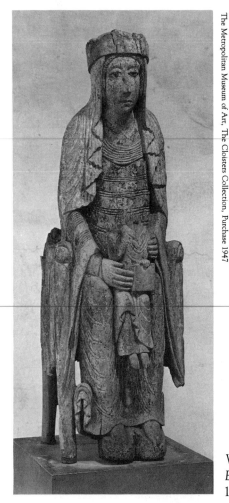

The Metropolitan Museum of Art, The Cloisters Collection, Purchase 1947

Virgin and Child Enthroned from Autun, 12th century

The Langon Chapel also contains two twelfth century French cult statues of the **Virgin and Child**, one from Autun and the other from Auvergne. These wood sculptures show the Virgin as a Throne of Wisdom, in the period's customary throne-like pose with the Christ Child on her lap. Such statues were worshipped like idols in their day. The faithful prayed to them for rain during droughts, and medieval writing is full of strange and marvelous accounts of them talking, crying, and even levitating out of windows. In one legend, a wooden Christ Child mischievously put His mother's crown on His own head during Mass. Another tale describes a sculpture of the Virgin springing to life and swatting a sinner on the ears. The statues sometimes contained relics, which could only have increased their magical powers. Such statues of Mary and other saints were sometimes carried in processions and used to raise money. Romanesque Virgins are known for their fixed, severe gazes, although the *Virgin* from Autun (on display in the apse of the Langon Chapel) has the melancholy look of a mother who knows she must give up her son. One of the Autun Virgin's original blue glass "eyes" is still intact. The swirling fold of the Virgin's garment near her right ankle make it look as though she has been brushed by the same strong wind the angel from the Church of St. Lazare at Autun is riding.

A passage from Langon chapel leads to the **Chapter House** from Pontaut.

This twelfth century chapter house opens on one side to the Cuxa Cloister, just as it originally opened to the cloister at the monastery of Notre-Dame-de-Pontaut in the south of France. The two great monastic orders of the Middle Ages occupied Notre-Dame-de-Pontaut at different times. The Benedictines built the monastery in 1115, and the Cistercians took it over in 1151.

Monks gathered in the chapter house daily, sitting on the stone benches, to discuss business and hear readings from the Rule of monastic conduct. Despite the southern climate, it could be a cold and drafty place. Hinge emplacements indicate that shutters could be closed in the winter.

The chapter house stones are almost entirely original,

except for modern floors and the ceiling vaults between the twelfth century ribbing. The architecture is a hybrid of styles: light, elegant Gothic ribbing supported by massive Romanesque style arches and columns. The supports are larger than necessary to hold up the ceiling, apparently because the medieval designers were unwilling to trust the airy new Gothic style on faith alone.

The Pontaut chapter house opens upon **Cuxa Cloister**.

The cloister was once part of Saint-Michel-de-Cuxa, a twelfth century Benedictine monastery in the eastern Pyrenees. As it now stands, it is about half the original size and was once rectagular in shape and not square.

Today visitors who stroll around the cloister admire its garden and scrutinize the playful carved creatures on the marble capitals: apes, lions, animals with two bodies and one head, a mermaid, a man who plays a horn and leaps for joy. This was just the sort of visual frivolity frowned upon by Saint Bernard of Clairvaux, the founder of the Cistercians who ultimately replaced the Benedictines as the dominant medieval monastic order.

According to Bernard, carved beasts and grotesques were a "ridiculous monstrosity," and a symptom of spiritual malaise. Bernard preached that some monks had fallen prey to sloth, gluttony, and loose living, and he espoused a return to a strict observance of the monastic Rule estab-

Marble capital from the cloister of the monastery of St.-Michel-de-Cuxa, 12th century

lished by Saint Benedict. His reforms extended to architecture. In 1157 the Cistercians issued regulations for their own buildings that eliminated painting and sculpture, except for crucifixes, and forbade such carved beasts as you see in the Cuxa Cloister as "curiosities likely to distract the attention of monks and disturb meditation."

From Cuxa Cloister enter the **Early Gothic Hall**, which opens up at one end to a view of the **Gothic Chapel**. Both are modern constructions in period style, and serve as architectural showcases for original thirteenth and fourteenth century stained glass. In Gothic architecture, stone walls gave way to vast windows that let light flood through. The resplendent colors of stained glass were analogous, in the medieval mind, to the light of heaven.

The Early Gothic Hall also contains a pair of sculptures from the thirteenth and fourteenth centuries that chronicle the evolving cult of the Virgin. The **Virgin** from Strasbourg Cathedral is a heavenly queen, remote and powerful. The statue once held a Christ Child who sat on a bed of roses. A **Virgin and Child** from Ile-de-France wears the crown of heaven, but she has become a courtly lady. Her body gently sways, her expression is fey and charming. We've come a long way with this image from the austere Romanesque Virgins on display in the Langon Chapel.

From the Gothic Hall you can see into the two-story **Gothic Chapel**. Descend the stairs to the lower level and the chapel itself, which has on display fourteenth century tomb effigies including several of the Urgel family of Catalonia in Spain. Count Ermengol X commissioned a series of family effigies for a chapel he rebuilt. The **Effigy of a Boy,** at the bottom of the stairs, is probably his ancestor Ermengol IX who died as an adolescent. Death at an early age is charmingly portrayed: the boy rests his head comfortably on a pillow with finely carved tassels.

From the Gothic Chapel it's a short walk to the **Treasury**. Every medieval church had its treasury, where precious liturgical objects (and money too) were stored for safekeeping. The Treasury at The Cloisters contains some of the museum's most splendid small works.

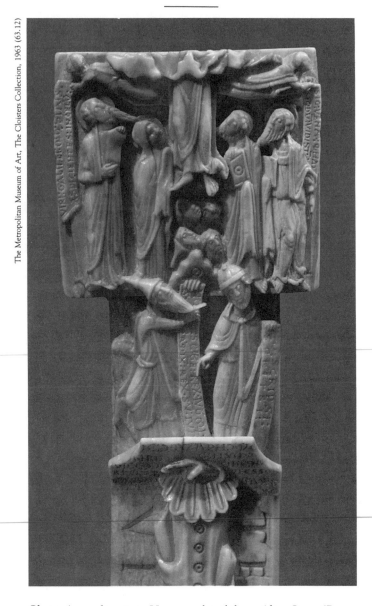

Christ Ascending into Heaven, detail from *Altar Cross* (Bury Saint Edmunds?) mid-12th century

One of the great objects in this gallery, a carved ivory **altar cross**, is extraordinary for its dramatic vigor. The Cross dates from the mid-twelfth century, and may come from the Abbey of Bury Saint Edmunds, England. Dozens

of tiny carved figures animatedly act out the story of man's redemption, and a profusion of Latin and Greek inscriptions attest to the medieval reverence for the revelatory power of words. The Cross is a Tree of Life, and it has sprouted a pictorial narrative. Among the carvings on the front of the Cross, Adam and Eve cling gamely to the bottom of the tree. Near the top, Pilate and a high priest squabble over the meaning of a Latin scroll prophesying the Savior. Meanwhile, just above them, Christ is already whisking heavenward, His feet dangling in midair, as the Apostles gape in wonder. Wonderful as the Cross is artistically, it also reveals a virulent antisemitism. The high priest wears the conical hat that was a derogatory emblem

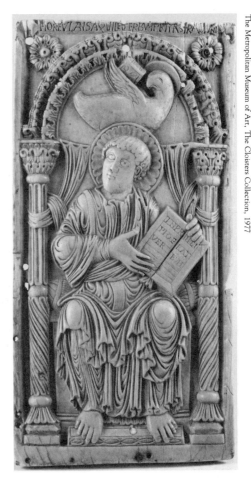

Saint John the Evangelist, early 9th century

for Jews. On the back of the Cross is a depiction of Synagogue, a female personification of Judaism, who slaughters the Lamb of God.

Also on view is an early ninth century ivory **plaque** that depicts the New Testament writer Saint John the Evangelist. The plaque probably once formed part of a devotional triptych. It was produced for the court of Charlemagne, who was illiterate himself but who established a scriptor-

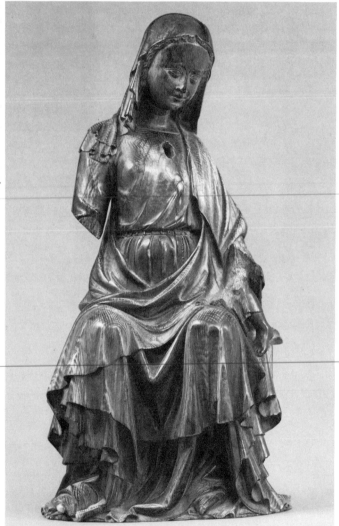

Virgin England, ca. 1300

ium for manuscript copiers to spread the faith. On this plaque, Saint John holds a manuscript of his Gospel inscribed with its opening phrase: In Principio Erat Verbum (In the Beginning Was the Word). The saint is a word-drunk author. You can see inspiration in his face, and the raw spirituality of the early Church in the whirlwind movement of his robe. Another superb ivory carving is a twelfth century **crozier shaft** from England, part of a bishop's ceremonial staff. The surface of the crozier is packed with vigorously carved figures. God the Father and the Virgin Mary are in heaven above, below them are angels dressed as church deacons, and in the worldly realm at the bottom of the shaft a new bishop is being invested. Look closely and you'll see an angel swooping down to place a miter upon the bishop's head.

Every large medieval church, and many small ones, had relics, potent little pieces of the faith. The relics inside their reliquaries were placed on altars, solemnly exhibited in processionals, and venerated by local worshippers and pilgrims. An ornate thirteenth century **arm reliquary** from Flanders, made of silver and bronze, must once have contained the arm bone of a saint who had been a bishop. The hand of the reliquary is raised in a startling blessing.

The **Virgin** from England is a small, rare, beautifully carved ivory that must once have been a prized devotional object in a private chapel. This Gothic Virgin, fashioned about 1300, once dandled a Christ Child on her knee. In Langon Chapel, the Romanesque Virgins inspire awe; here, the Virgin is a sweet young mother who loves her boy.

Also on view in the Treasury is a fourteenth century silver gilt **Reliquary Shrine** with the Virgin Mary and Child flanked by two angels holding relic boxes. The relic boxes now hold trinkets of an unknown date, but probably once held relics related to the cult of the Virgin. The shrine, thought to have been made for Queen Elizabeth of Hungary, is fashioned in the shape of a fanciful Gothic church. The scenes on the wings, in blue enamel that mimics stained glass, illustrate events from Mary's life. Musical angels are depicted playing a fiddle, lute, recorder, shawm (medieval oboe), and a psaltery (a dulcimer-like instrument plucked with the fingers). The shrine is a daz-

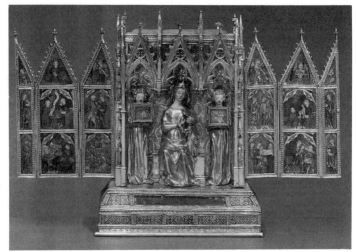

Reliquary Shrine with the Virgin Mary and Child, 14th century

zling altarpiece meant for private devotion, and one feels that only a saint could look at it without a fine twinge of worldly delight.

As museum-goers, we sometimes forget that the faithful prayed before objects that today we look at purely as art. A pair of devotional images in this gallery demonstrates the intensity of medieval faith. **The Crucifixion** and **The Lamentation** is a fourteenth century diptych by an Italian painter known as the Master of the Codex of Saint George. The lamentation, in which the Virgin Mary and followers of Christ weep over His body, is not described in the New Testament. Medieval artists were inspired to depict it by Pseudo-Bonaventure, a Franciscan monk once thought to be Saint Bonaventure, who wrote a text widely read in its time on how to pray titled *Meditations on the Life of Christ*. According to Pseudo-Bonaventure, a good meditator must dwell on the death of Christ "from the bottom of the heart and with the marrow of his being." The artist of *The Lamentation* painted the scene with an emotionalism that matches such fervent prayerfulness. In Pseudo-Bonaventure's text, Mary is said to have suffered so deeply at the Crucifixion that in her mind's eye, "She hung with her Son on the cross and wished to die with Him rather than live any longer." In the painting, she has finally buckled under the strain and fainted.

Just outside the Treasury are the illuminated manu-
scripts of The Cloisters. Among them are two splendid
prayerbooks, a book of hours from the 1320s thought to
have belonged to Jeanne d'Evreux, queen of France, and
another owned by the Duc de Berry, the famed art patron
of the early fifteenth century.

From here, it is a few steps to the outdoor gardens of the
Trie Cloister and **Bonnefont Cloister**. The two cloisters
incorporate elements from a number of monastic ruins in
southwestern France.

The gardens are open-air museums of medieval horticul-
ture, planted and nursed by staff gardeners at The Clois-
ters. The Bonnefont garden grows some 250 species of
plants and flowers from the Middle Ages, including such
medicinal herbs as comfrey and lungwort, which were folk
remedies for the common cold and rheumatism. It also
produces the same dye plants that the makers of the *Uni-
corn Tapestries* used to derive their colors, woad for blue,
madder for red, and weld for yellow.

The Trie garden has an even stronger connection to the
Unicorn Tapestries. Pictured in the tapestries are 101 plants
and trees. The garden grows about half that number, in an
approximation of how they appear in the second tapestry
(the *Unicorn at the Fountain*). In the *Unicorn Tapestries*,
plants and flowers bloom all at once, according to the
medieval fantasy of how they would in paradise. The gar-
den of the Trie Cloisters, limited to a less than ideal world
and climate, blooms according to the dictates of spring,
summer, and fall.

Go back to the main level, by either staircase, and to the
Hall of the **Unicorn Tapestries**.

Medieval symbolism abounds in the tapestries, touching
plants and animals, filling every corner of an enchanted
world. They were likely woven in Brussels, circa 1500, as a
wedding gift, but for whom is a mystery. It may have been
for Anne of Brittany, queen of France, and her husband
Louis XII: the "AE" stitched into the tapestries could rep-
resent "Anne," but this is only conjecture. The first docu-
mented owner was François VI de La Rouchefoucauld, the
famed writer of epigrams and maxims, who had the tapes-

tries hanging in his Paris bedroom in 1680. During the French Revolution, peasants spirited them from the Rouchefoucauld chateau in Verteuil, near Paris. The family recovered the damaged tapestries in the 1850s from a shed; they had been used as covers to keep frost off vegetables.

According to art historian Margaret B. Freeman, the narrative of the tapestries is a two-fold tale, a secular romance and a religious allegory. The tapestries can be read as a blessing of marriage and fertility, and God's triumph in all things. The elusive unicorn was prized for its horn, which cured many ills and was also a symbol of Christ the Savior. In the tapestries the unicorn is tamed by a virgin, as a husband is betrothed to his bride and as Christ was born to Mary.

The tapestries are hung somewhat out of sequence. The first and seventh, with their idealized meadows, flank the gallery windows. (Stylistically this pair differs from the others and may have been designed by a different artist.) The second through sixth tapestries, which tell the actual story of the hunt, are arranged in clockwise order.

In the **first tapestry**, an attendant in the woods signals for the hunt to begin. Three nobles wear fancy dress rather than hunting garb, which seems only fitting since their quarry is the fabulous unicorn. The cherry tree behind them is a double symbol, of sweet earthly love and divine salvation. The religious meaning derives from a legend of a cherry tree that bloomed in winter when the Virgin Mary passed by on the way to Bethlehem.

The hunters see the unicorn at a fountain in the **second tapestry** and stop to dreamily admire it. The Christ-like unicorn dips its magical horn in a stream to cleanse the water from the evil of serpent's poison. Several of the animals who gather to drink are also symbols for Christ. In medieval bestiary writing, the lion (at left) represents His courage and watchfulness, the panther (center) is like Him in beauty and gentleness, and the stag (at right) kills serpents just as Christ defeats the Devil. The lion is accompanied by his mate as a sign of fidelity in marriage. To the right of the fountain is a rabbit, petrified by the commotion. The rabbit, a symbol of fertility, may have been meant to bring offspring to the early owners of the tapestries.

The Unicorn in Captivity, ca.1500

Only a virgin can capture a unicorn, but in the **third** and **fourth tapestries** the hunters chase and fight the beast as if oblivious to the power of the legend. In the fourth tapestry, the hunter sounding a horn personifies the angel Gabriel, who announced the coming of Christ to the Virgin Mary. On his sword sheath are the Latin words, *Ave Regina C*, or Hail Queen of Coelorum (heaven).

In the **fifth tapestry**, which exists only in fragments, a virgin tames the unicorn. All you can see is her sleeve, just beneath the unicorn's white beard, and her hand as she reaches around the beast's neck to caress its mane. The blonde temptress nearby is the virgin's attendant, who appears ready to beckon waiting hunters to strike. In the **sixth tapestry** the unicorn allows itself to be killed and carted on horseback to the gates of a castle where a lord and lady wait for their trophy. The thorns draped over the dead unicorn are probably a symbol of Christ's crown of thorns.

The **seventh tapestry** shows the unicorn alive again, as Christ was resurrected. The unicorn here also symbolizes a groom who binds himself to marriage, just as the mythical beast is chained to the tree. The red droplets on the unicorn's body are juice which has fallen from the ripe pomegranates above, fruit symbolizing fertility; the red might also be interpreted as the blood of Christ. The meadow, blooming inexhaustibly, is paradise regained. Numerous flowers symbolize generation and heavenly grace. Among them is the Madonna lily, in the lower right corner just below the fence, a sign of true love and also of the Virgin's saving purity.

Perhaps the most prized single object at The Cloisters is the *Annunciation Altarpiece*, also called the Merode Altarpiece after the family that owned it in the last century. The altarpiece was painted in about 1425 by Flemish painter

The Metropolitan Museum of Art, The Cloisters Collection, 1956 (56.70)

Robert Campin *Annunciation Altarpiece*, early 15th century

Robert Campin, Rogier van der Weyden's teacher, and is located in the Campin Room.

Annunciation Altarpiece by Campin (ca. 1378–1444). It took egotism, a certain glorious moxie, for the newly moneyed Flemish burghers who commissioned altarpieces to have themselves pictured in the paintings. In the center panel, the angel Gabriel is about to inform the Virgin Mary that she will bear Christ the Savior. In the panel at left, a man named Ingelbrecht (his first name is unknown but his family crest is visible at left in a window) kneels with hat in hand. Slung from his waist is a fat purse, whose contents have bought him and his wife the privilege of piously spying through an open door upon this pivotal scene from the New Testament. If we can judge from Ingelbrecht's earnest face, he not only enjoyed the perquisites of wealth but had real faith as well.

The setting for the *Annunciation* is the everyday world of fifteenth century Flanders, painted glowingly by Campin in the relatively new medium of oil. Religious symbols flourish. In the center panel, Gabriel may have extinguished the candle in the gust of his miraculous appearance; the smoking wick awaits the coming of Christ, the new light of the world. Above Gabriel, a tiny child with crucifix arrives upon a stream of light, the light symbolizing Mary's virginity since it has penetrated glass without breaking it. Madonna lilies (which also appear in the Unicorn Tapestries) are another symbol of virginal purity, as is the wash vessel. In the panel at left, the loitering man may represent Isaiah of the Old Testament, who prophesied the Savior.

In the panel at right is Mary's industrious husband Saint Joseph. Two mousetraps are snares to catch the Devil, for as Saint Augustine said, "The cross of the Lord was a mousetrap for the Devil, the bait by which he would be caught by the Lord's death." The odd design of the mousetraps is authentic, as demonstrated in recent years when one was built and caught a mouse. To our eye the hidden meanings are fascinating. In the context of the period, they express the immense comfort of an orderly world in which the ordinary mingles with divine plan.

11 WEST 53RD STREET (BETWEEN 5TH AND 6TH AVENUES)
NEW YORK, NY 10019
TELEPHONE: 212-708-9400

HOURS: *Daily, 11–6; Thursdays, 11–9; closed Wednesdays and December 25.*

ADMISSION: *$5 for adults, $3.50 for students, $2 for senior citizens. Free for members and children under 16 accompanied by an adult. Thursdays, 5–9, pay what you wish.*

GETTING THERE: *By subway, train E or F to 53rd Street at Fifth Avenue. By bus, southbound on Fifth Avenue or northbound on Madison Avenue. Also, from the West Side take bus M5 south to Fifth Avenue; from midtown take bus M5, 6, 7, or 104 on Sixth Avenue.*

RESTAURANTS: *Garden cafe has meals, beer, and wine, cafeteria-style. Members' dining room on second floor. Members may call for reservations, 708-9710. Members' dining room is open to the public on days when space allows, see notices near restaurants. Tea, coffee, and snacks in sculpture garden cafe in the summer.*

GIFT SHOPS: *Store near lobby and also at 37 West 53rd Street. Books, catalogs, posters, postcards, slides, toys, Christmas cards, designer objects including glass and flatware.*

SPECIAL EVENTS: *Call 708-9480 for recording of current exhibits; 708-9490 for film times; 708-9500 for other information. Two film theaters are located on lower level. Film tickets are free with admission, and can be picked up at the Information Desk after 11 for afternoon and early evening screenings. See museum calendar at Information Desk for video events and lectures.*

TOURS: *Gallery tours daily, inquire at Information Desk.*

MEMBERSHIP: *$45 and up; $25 for students. Among the benefits are entry to Members' dining room, free publications, discounts in museum store and on lectures and special events.*

LIBRARY: *By appointment only, call 708-9433.*

THE MUSEUM OF MODERN ART

N O museum in the world tells the story of modern art better than the New York institution that bears its name. The Museum of Modern Art's acronym, MOMA, happens to be a wryly accurate description of the museum's parental role toward its art. Modern art existed before the museum's founding in 1929, but it was MOMA that nurtured it, defined what it was and how it happened, for a large public audience.

From the beginning, MOMA's heart belonged to the Europeans. The permanent collection is particularly rich in the art of Picasso and Matisse and other artists from the School of Paris who worked in the French capital or were drawn into its orbit. The founders of MOMA were Mrs. John D. Rockefeller, Jr., Miss Lillie Bliss, and Mrs. Cornelius Sullivan. All were patrons of the new art as epitomized in the 1913 Armory Show in New York. In 1921, Lillie Bliss helped organize an exhibit of modern art at the Metropolitan Museum, but the press panned that show and the Met timidly backed away from any similar adventure. And so "the ladies," as they are remembered in museum circles, decided to form a separate museum of modern art.

The first director was Alfred Barr, Jr., hired at age twenty-seven from his job as assistant professor at Wellesley College, where he taught the first college course on modern art. Barr, the son of a Presbyterian minister, promoted the cause of modernism with missionary zeal. The first exhibit, held in 1929 at temporary quarters at Fifth Ave-

nue and 57th Street, was of Cézanne, Seurat, Van Gogh, and Gauguin. The museum three years later moved to a townhouse at 11 West 53rd Street leased from John D. Rockefeller, Jr. After acquiring and razing several buildings around this site, in 1939 the museum opened its present glass façade building designed in the International Style by architects Philip Goodman and Edward Stone.

Barr believed in a unified view of modernism extending across the fine and applied arts, an approach inherited from the Bauhaus in Germany. The collection of painting and sculpture is unequaled, but beyond this great repository of art are the various media presented by the museum's other departments. MOMA has vast holdings in Drawings, which it shows in galleries on the third floor. Among the drawings are Georges Seurat's 1887 *At the Concert Européen*, an utterly magical scene conjured up through the technique of conte crayon, and Paul Klee's famous 1922 *Twittering Machine*, an ingeniously comic depiction of a crank-up bird concerto. Prints and Illustrated Books, on the third floor, exhibits on a rotating basis work by such artists as Max Beckmann, Henri Matisse, Pablo Picasso, and Jasper Johns. The Film Archives consist of ten thousand prints, ranging from films by Sergei Eisenstein and D.W. Griffith to John Ford westerns and vintage Mickey Mouse cartoons. There is also an ongoing video program on the ground floor and lower level, the latest medium to receive MOMA's attention. The department of Photography, with more than fifteen thousand prints, encompasses images from the mid-eighteenth century to the present day. Among the photographers represented in second floor galleries are Ansel Adams, Eugene Atget, Walker Evans, Edward Steichen, Alfred Stieglitz, and Edward Weston. On the fourth floor in Architecture and Design, you will find the 1918 *Red and Blue* chair by Gerrit Rietveld, furniture for Utopia that is the three-dimensional equivalent of a grid painting by Mondrian. Also here is a hockey mask manufactured in 1983 by the Ernst Higgins Co., a duplicate of one worn by former Boston Bruin goalie Giles Gilbert. Isolated on a museum wall, it looks primitive and eerie, like a surrealist "found object."

The Painting and Sculpture galleries are arranged chronologically and by movement. Monet's *Water Lilies*

(on the second floor) and Matisse's paper cut-outs titled *Swimming Pool* (third floor) are environmental in nature and displayed in their own separate rooms. Both artists were old men when they did this art, and both in these great late works seem very nearly to have escaped the confines of space and time. The following highlights will take you through the second floor galleries to the Matisse cut-outs on the floor above.

PAINTING AND SCULPTURE TOUR
SECOND FLOOR

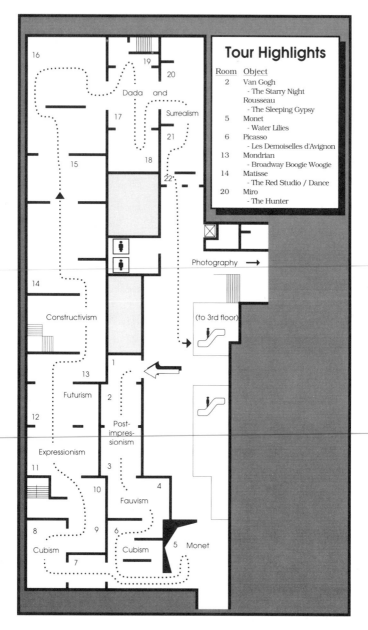

Tour Highlights

Room	Object
2	Van Gogh - The Starry Night Rousseau - The Sleeping Gypsy
5	Monet - Water Lilies
6	Picasso - Les Demoiselles d'Avignon
13	Mondrian - Broadway Boogie Woogie
14	Matisse - The Red Studio / Dance
20	Miro - The Hunter

Dada and Surrealism

Constructivism

Futurism

Expressionism

Post-impressionism

Fauvism

Cubism

Cubism

Monet

Photography →

(to 3rd floor)

PAINTING AND SCULPTURE

"EVERYONE wants to understand art," said Picasso. "Why not try to understand the song of a bird? Why does one love the night, flowers, everything around one, without trying to understand it?" He was right, of course, but that doesn't stop us from attempting to explain what we see, because in doing so we are really trying to explain ourselves. What we find with modern art is that all the old rules have been suspended. In the Middle Ages, artists knew their purpose, which was to glorify God. The focus gradually shifted to humankind, but in the centuries after it did, artists still felt they knew *how* to paint. Through the nineteenth century artists could rely upon a structure, the "window" of perspective described by Renaissance theorist Leon Battista Alberti. (Imaginary lines, converging at a central vanishing point on the horizon, determine how an artist foreshortens objects to give the illusion of perspective.) They shared some basic assumptions about composing a picture, applying light and shade, and completing the illusion of reality with color. Quite suddenly, historically speaking, the artists of the avant-garde won their rebellion against tradition and were left to their own devices, to use what they wanted of academic technique or to reject it wholesale. The permanent collection at the Museum of Modern Art, in particular the art on the second floor, records the moment (or rather the several decades) when this happened. For many post-Impressionist and modern artists, art became a new religion. Some artists looked to art for individual salvation, others believed that art could help build a more perfect society. MOMA in a broad sense is a fabulous

orphanage, the artists represented in the collection having conspired in their own abandonment. Some react to their freedom with joy, others with anxiety, still others with both emotions at once.

In Gallery 1 is a late landscape by Cézanne, often called the father of modernism, who said that he wanted to make of Impressionism's misty colors "something solid like the paintings in museums."

Pines and Rocks by Paul Cézanne (1839–1906). Cézanne yearned for a vision that was fixed and permanent, but the only way he knew to fix his subject upon canvas was to record his every hesitation in doing so. He rejected the academic approach of using line and modeling to achieve the illusion of volume and instead constructed his images with juxtaposed patches of color. He once described his method as "forgetting all that has existed before." Bit by bit, part by part, he made each picture. His brushstrokes, the planes of broken color, all his equivocations, are there for us to observe. Art historians tell us this was revolutionary, that the Cubists might never have completely shattered Renaissance perspective without his example. Yet what impresses us about Cézanne is not that he found a new structure to replace the old one, but that we see him *trying* so heroically to see nature freshly. He felt obliged to create the world all over again each time he picked up a brush, meticulously and painstakingly, with new rules tailored to each image. He is the modern era's patron saint of uncertainty, for as Picasso once said "what forces our interest in Cézanne is his doubt."

The date of *Pines and Rocks* is unknown, but it was probably painted in the late 1890s, in the forest of Fontainebleau. It is a mosaic of cool blues and small touches of reds, oranges, and ochres. Perhaps this is the "solid" Impressionism Cézanne was searching for. The atmosphere is so persuasively rendered, you feel equally certain you might breathe the air, or touch it.

In Gallery 2 are two of the museum's popular landmarks, Van Gogh's *The Starry Night* and Rousseau's *The Sleeping Gypsy*.

Vincent van Gogh (1853–1890) was a lost soul from the

beginning. Exactly one year before his own birthday, a brother, also named Vincent, died the day he was born. The Dutchman who became modern history's most anguished and ecstatic artist was Vincent the second, viewed by his father as the inferior version. Young Vincent was often reminded of his inadequacy by the morbid necessity of passing a tombstone inscribed with his own name and the day of his birth.

His life was a quest to be saved. As a theological student in 1878, he was sent to preach to miners in Belgium, but his intensity and erratic behavior got him fired the next year. In the following decade (his last), he looked to painting for salvation. His formal schooling in art was scant, but he was both highly disciplined and feverishly productive. He sold but one painting during his life and was supported by his brother Theo, who was an art dealer and his best friend.

Van Gogh lived in Paris for two years, adopting the style of the Impressionists, and left for the south of France in 1888. He hoped that the light of Provence would be his saving grace, and it did intensify what he spoke of as his "terrible lucidity." Most people know that after an argument with the painter Paul Gauguin, who was visiting him in Arles, he cut off his earlobe and gave it to a local prostitute. His fits of madness, too, are famous, as is his suicide by gunshot in a cornfield. Van Gogh's life story takes us only so far. We know him most directly through his art because of how clearly he put his feelings on canvas.

The Starry Night by Van Gogh. Except in times of great sadness or happiness, most of us keep a kind of barrier between ourselves and how we perceive our surroundings. Van Gogh lacked this protective skin. In his *Starry Night*, there is virtually nothing between us and the whirl of rushing stars but the paint itself, which Van Gogh has brushed onto canvas with a visceral physicality.

Van Gogh had thought of painting a "star-spangled" sky for more than a year before he did the painting that now hangs in this gallery. "I wonder when I'll get my starry sky done, a picture that haunts me always," wrote Vincent to his brother Theo in May 1888. In September of that year, Van Gogh did an early version of a starry night, a comparatively calm and Impressionist-like view of the sky above

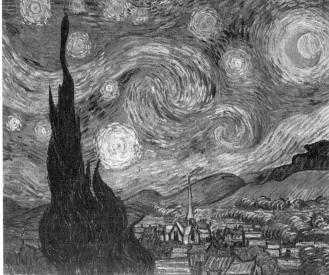

Oil on canvas 29" × 36 ¼"
Collection, The Museum of Modern Art, New York, the Lillie P. Bliss Bequest

Vincent van Gogh *The Starry Night*, 1889

the Rhône River. During this period, Gauguin encouraged him to express his feelings more freely ("Gauguin gives me courage to use my imagination," he wrote to Theo). In June of 1889, the month after he had admitted himself to an asylum in Saint-Rémy, he painted *Starry Night*. According to a recent astronomical study, Van Gogh must have watched the night sky from his hospital window for a number of weeks and then made a composite picture of the Milky Way, the moon, and Venus (the bright orb positioned to the right of the cypress tree). He painted the picture quickly, as was his custom, with convulsive brush strokes that leave the canvas bare in places. All of creation is charged with energy. The moon bursts with light, and a cypress tree shoots up to the heavens like a black flame. Beneath this boiling sky is a church and village. The church spire is northern European in style and out of place here, apparently Van Gogh's nostalgic remembrance of his past.

Henri Rousseau (1844–1910) is often, and quite justly, called the ultimate Sunday painter. A toll officer with the Customs and Excise Office in Paris, he taught himself to paint when he was about forty, and took his pension about ten years later in 1893, to paint full-time. He admired such academic painters as J.L. Gérôme, who also painted wild

beasts in exotic settings, but to Rousseau's perpetual disappointment he was refused admission to the official Salon exhibits. Instead, Rousseau showed in the unjuried Salon des Indépendants and Salon d'Automnes with the likes of Seurat, Cézanne, Gauguin, Van Gogh, and other outsiders. Toward the end of his life, Rousseau was befriended by the Paris avant-garde, including Picasso, who threw him a party in Picasso's Montmartre studio. Rousseau regarded the modernists' adoption of him with bemused satisfaction. He once told Picasso, cryptically: "We two are the greatest artists of our epoch, you in the Egyptian style, I in the modern."

The Sleeping Gypsy by Rousseau. "A wandering Negress, playing the mandolin, with her jar beside her (vase containing drinking water) sleeps deeply, worn out by fatigue. A lion wanders by, detects her and doesn't devour her. There's an effect of moonlight, very poetic." Rousseau wrote this description in a letter to the mayor of his hometown of Laval, in an unsuccessful attempt to sell the picture he had painted in 1897. Years later the Surrealist poet and filmmaker Jean Cocteau noticed that Rousseau had omitted footprints on the sand near the gypsy. Cocteau said that he thought the lion, and the river in the background, might be the sleeping woman's dream.

Oil on canvas 51″ × 6′7″
Collection, The Museum of Modern Art, New York, Gift of Mrs. Simon Guggenheim

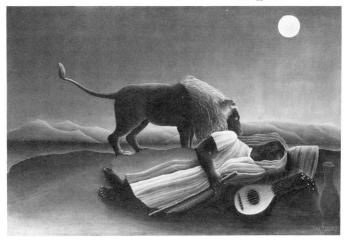

Henri Rousseau *The Sleeping Gypsy*, 1897

The Sleeping Gypsy seems to have materialized on moon-beams: everything is precisely as it should be, from the beady eye of the fairytale lion to the many-colored folds of the gypsy's oriental robe. Rousseau wasn't sophisticated enough to be an academic painter, and so, in this painting, he overcompensated by being perfect.

In Gallery 3 is **The Breakfast Room** by Bonnard.

Pablo Picasso compared art to the "song of a bird," but he was deaf to the song of his contemporary Pierre Bonnard (1867–1947), whom he considered old-fashioned and too close to the traditions of Impressionism. In particular, Picasso disliked "the way [Bonnard] fills up the whole picture surface, to form a continuous field, with a kind of imperceptible quivering, touch by touch, centimeter by centimeter, but with a total absence of contrast. . . . It's an extremely orchestrated surface developed like an organic whole, but you never once get the big clash of the cymbals which that contrast provides." Picasso, a cymbal-clasher himself, inadvertently put his finger on the reason many people find a painting like *The Breakfast Room* so ravishingly beautiful. If Picasso was a striding giant, by contrast Bonnard was a sort of visual diarist, patient and passive, rendering what he saw with a flickering brushstroke. In *The Breakfast Room*, colors are often arbitrary and saturated with light. The artist seems to linger over each individual object on the breakfast table (teapot, bowl, bread, fruit) as if the painting was about it alone. The doll-like woman at left holding the teacup appears to be in a trance. The view through the window, of dense green foliage, lacks spatial perspective and contrast. This makes the outdoor view look like a picture within the picture, an ambiguity that leads us to question the relationship of art and nature.

In Gallery 4 are paintings by the Fauves, the "wild beasts," as they were dubbed by a critic when these young artists, who included Matisse and André Derain, exhibited together in the 1905 exhibit of the Salon d'Automne in Paris. Influenced by the Impressionists, Van Gogh, and such Symbolist artists as Odilon Redon, the Fauves used brilliant unmixed color straight from the tube. **La Japonaise** (1905) is a portrait by Henri Matisse, the group's

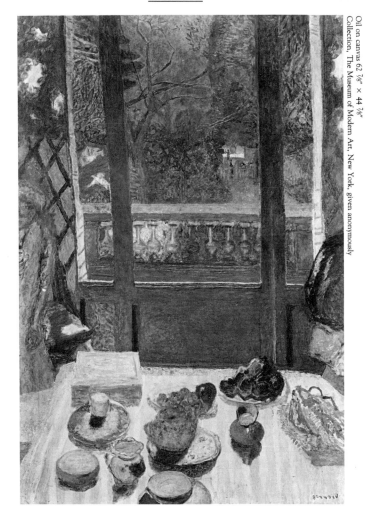

Oil on canvas 62 7/8″ × 44 7/8″
Collection, The Museum of Modern Art, New York, given anonymously

Pierre Bonnard *The Breakfast Room*, ca. 1930–31

leader, of his wife in a Japanese robe. She sits by water in which dabs of color flow freely across the canvas.

In the next gallery, the Cubist revolution unfolds. If the Fauves liberated color from the restraints of academic tradition, the Cubists freed form from rules that had applied since the Renaissance. Cubism was the invention of two artists, the Spaniard Picasso and the Frenchman Georges Braque.

Les Demoiselles d'Avignon by Pablo Picasso (1881–

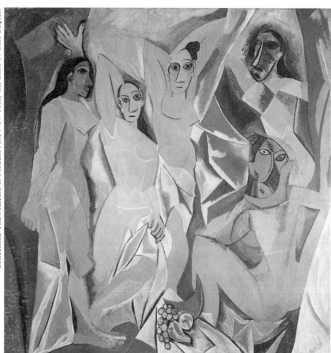

Pablo Picasso *Les Demoiselles d'Avignon*, 1907

1973). Picasso described this work, a painting he did at age twenty-five, as an "exorcism picture." He painted it in 1907, after arriving in Paris from Spain. The title, given years afterwards, refers to a street in the red-light district of Barcelona. The subject is the parade of prostitutes in a brothel, and we as museum-goers see the scene from the viewpoint of a client making his choice. *Les Demoiselles* is a confession of Picasso's ambivalence about sex and his fear of it, a realization of its primal power. The raw emotion still sears us today. What makes the painting revolutionary is the rupture of form, the jagged and convulsive shapes. Picasso has forged together clashing sources from art history to get across his message. The figure at left, whose body looks like an Egyptian funerary statue come to life, raises a curtain, and the women display themselves. The prostitutes stare directly at us, or gaze off in savage aloofness. The faces of all three figures at left were inspired by Iberian sculpture Picasso had seen in the Louvre, and he may have painted the two mask-like African faces at right after a visit

to the Trocadéro Museum in Paris. The raw blue background was derived from El Greco. Picasso's turmoil, evident from the painting itself, is confirmed by his friend Braque who described him at this time as an artist "drinking turpentine and spitting fire."

In the same gallery are *Ma Jolie* and *Man with a Guitar*, two pivotal Cubist paintings.

A few years after *Les Demoiselles*, Picasso and Braque changed the map of art history by breaking up the single perspective of Renaissance art into the multiple viewpoints of Cubism. They painted as if different sides of a person, a place, an object were visible simultaneously, not as we see them, but as we experience and think about them. In early Cubist paintings, light and shade, the "chiaroscuro" of traditional painting, are used to unsettle form rather than fix it in space. The volumes and planes of a picture shift ambiguously forward and backward in relation to each other as the viewer's eye passes over them. (The critic Louis Vauxcelles, who also named Fauvism, wrote of the "cubes" in a 1908 painting by Braque and the term Cubism was born.) The natural impulse of anyone who stands before an early Cubist painting is to try recomposing it, to make it whole again, although this is not possible. It is this dissolving of absolutes that Cubism celebrates.

Picasso and Braque met in 1907 and lived in bohemian quarters in Paris' Montmartre, summering together in the Pyrenees. As partners in this intellectually perilous style, they studied each others' work until they were almost painting as one, "roped together like mountaineers" as Braque put it. Braque painted **Man with a Guitar** in the summer of 1911, and Picasso painted **Ma Jolie**, whose subject is a woman with a zither or guitar, in the winter of 1911–12. The shape of the musicians in both paintings is barely discernible. In *Ma Jolie*, vertical guitar strings are visible at the lower center of the painting, and the title of the picture, which is the refrain of a popular song (and also Picasso's nickname for Marcelle Humbert, his girlfriend at the time), is at the bottom. In *Man with a Guitar*, Braque has painted a nail, and an unconvincing nail at that, at the upper left. It is his joking way of pointing out that the painting is a canvas hanging on a wall, a flat surface and

not a "window," and that the illusion of depth is just that. After Cubism, once and for all, artists were free to use pictorial illusion or discard it, free to do what they pleased.

The limited color range and tones here, what historian Robert Rosenblum calls the "monkish" tans, ochres, and grays, are well suited to a cerebral and theoretical style now known as "analytic" Cubism. The surprise to the museum-goer who may have seen these paintings only in photographs is how creamy the paint looks on canvas and how seductive the brushwork is. As one of its many contradictions, Cubism turns out to be an art for the senses after all.

In a gallery nearby are Monet's late paintings. **Water Lilies** by Claude Monet (1840–1926). Monet conceived of his grand final series of water lilies as "the illusion of an endless whole, of a wave with no horizon and no shore . . . a refuge of restful meditation. . . ." He was seventy-six when he began painting the series in 1916, and his eyesight was failing because of cataracts. The project obsessed him until his death ten years later. In 1927, a year after he died, nineteen of the panels were installed at the Orangerie Museum in Paris, as planned in a commission Monet had received from the French government. In the 1950s, a number of other panels were found in his barn-like studio at Giverny, including the triptych and single panel (all painted circa 1920) now displayed in this gallery.

Monet had prepared for his late work by excavating a pond at the bottom of his estate and building the studio where he could work indoors, separate from nature, on easels set on rollers. His struggle was enormous. He destroyed numerous paintings during this period with a knife and by burning them. While working he repeatedly stepped back ten to fifteen feet to assess his progress, not merely because his canvases were so large but because he could barely see. Looking at these paintings as Monet did, first close up and then from a distance, one is astounded at Monet's sense of touch, his virtuosic brushwork, and by his uneroded instinct for the play of light.

He was a wealthy and famous artist in his last decade and might easily have settled for repeating himself. Instead, Monet pushed back the limits of his art, eliminating the conventional boundaries of a subject with a beginning and

Pablo Picasso *Glass of Absinthe*, 1914

an end. His earlier Impressionist paintings had attempted to capture how a scene looked in the light of a particular time of day. With the water lilies, the single "motif" gives way to unbounded visual sensation. The surface of the water and the seemingly fathomless depths appear unstable, unanchored by fixed perspective. The lily pads and the glimmering reflections of clouds and overhanging foliage flow together but never completely merge. Impressionism had tried to fix the elusive moment, but here the subject is *all* moments, the universal state of change.

In Gallery 7 is Picasso's **Glass of Absinthe**, a small painted bronze sculpture from 1914. This is Cubism in a playful mood. The paradoxes multiply as you look at the object, which has been rearranged according to Cubist whimsy and inventiveness. The silver strainer is both a real implement and art, and holds a sugar cube made of bronze. The glass itself is also made of bronze but painted white to look like plaster sculpture. Orange speckles of paint, a reference to artist Georges Seurat's Pointilist technique, can be read as either the shadow cast by the objects, or as the transparency of the glass, or perhaps as both. Picasso has peeled back the sculpture to show its interior. The glass of absinthe is seen from all angles, inside and out, enjoyed and possessed as an object and an experience.

Also in Gallery 7 is Picasso's **Guitar**, a sculpture from 1912. Throughout history artists either had carved sculpture out of solid matter or modeled it with their hands. Picasso constructed this guitar out of sheet metal and wire, joining together the pieces. The technique, known as as-

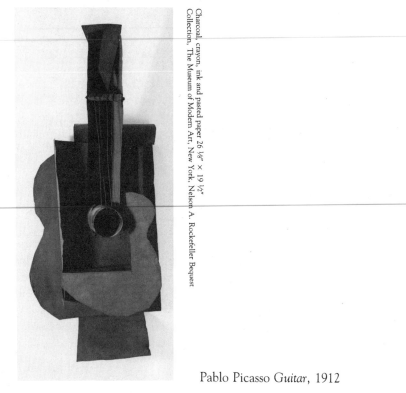

Charcoal, crayon, ink and pasted paper 26 ⅛″ × 19 ½″ Collection, The Museum of Modern Art, New York, Nelson A. Rockefeller Bequest

Pablo Picasso *Guitar*, 1912

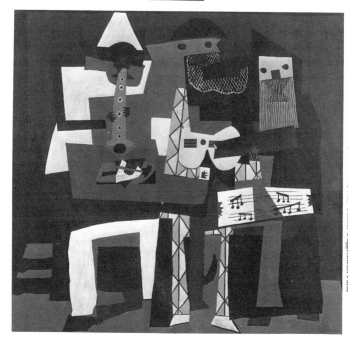

Oil on canvas 6'7" × 7'3 ¾"
Collection, The Museum of Modern Art, New York, Mrs. Simon Guggenheim Fund

Pablo Picasso *Three Musicians*, 1921

semblage, is Picasso's invention, and the guitar is the first object of its kind. Picasso's leap of imagination was inspired by his experiments with Cubism, in which pictorial perspective was broken up and reassembled, and by collage, a technique combining different materials on a flat surface. Sculptors after Picasso would have the option of an entirely new method of constructing sculpture, by welding and assembling parts. Looking at the guitar today, we admire its tautness and "rightness," and as with so many elegant solutions, we wonder that no one thought of doing it this way before.

In Gallery 8 is **Three Musicians** by Picasso. Completed in 1921, this monumental painting sums up the experiments of Cubism. Analytic Cubism, in 1911–12, had broken apart form to near dissolution. In this example of "synthetic" Cubism, Picasso rebuilds a new order of reality, as the large flat forms in this picture fall into place like well-designed architecture. The three musicians appear massive and solid, yet that first impression is contradicted as you focus on their masks and costumes, which seem

weightless and detached. Remove any element from the structure, and the trio would vanish into the ghostly realm from which they came.

The two figures at left are stock characters from the *commedia dell'arte*. A Pierrot plays a recorder, and a Harlequin plays the guitar. At right is a monk, who sings from the score on his lap. The Harlequin and monk wear strange veil-like masks. On the table is a pipe and tobacco. A dog lies beneath the musicians, its head hidden behind the Pierrot's knee but seen in a shadow on the wall, its tail peeking out beneath the Harlequin.

Art historian Theodore Reff has interpreted the picture, painted when Picasso was forty, as a farewell to youth and to friends of his bohemian days. The trio may represent Picasso as the Harlequin, and his two poet-friends Guillaume Apollinaire and Max Jacob as the Pierrot and the monk. Apollinaire had died in 1918, and Max Jacob, a Catholic convert, had recently joined a monastery and so was in a sense "lost" as a friend to Picasso. This possible scenario provides a premise for the funereal gloom of the picture, although no literal explanation can fully account for what is going on here. One feels the music of the trio must be unbearably sad, with a strong hint of mischief beneath it.

Just when the museum-goer is becoming quite comfortable with the Cubist idea that there are no absolutes in art or life, we come in Gallery 9 to the sculpture of Constantin Brancusi (1876–1957). This is an artist unprepared to give up on hard and fast truth and bold enough to present his idea of it in sculpture.

At the turn of this century, Brancusi walked most of the way from his native Transylvania to Paris, capital of world culture, which gives an inkling of the man's determination to make art. He had studied fine art in Bucharest and steeped himself in his country's folk art. After arriving in Paris he fell under the spell of African art. He apprenticed briefly with Auguste Rodin, whose example had the perverse effect of helping Brancusi go off entirely on his own. Rodin's sculpture is about the struggle of an artist to wrest form from a marble block by the act of carving. Brancusi's mature sculpture looks "unauthored": form simply *is*, with

no hint of struggle, no beginning of a process and no end, nothing to add or subtract. Like Mondrian and Kandinsky, two other renegade purists, Brancusi was drawn to Theosophy, a nondenominational religious sect that espoused a belief in universal laws beneath the veil of appearances. For Brancusi, art was a search for essence.

Bird in Space, a 1928 bronze, represents the flight of a bird reduced to essentials. Yet it is still clearly discernible as a bird rather than an abstraction. We instinctively see the bird's sharp beak in the way the top of the sculpture is sliced at an angle. It takes only a small imaginative leap for us to see **Fish** (1930) as an animate creature that is swimming. You can even sense the water through which it moves. But Brancusi's sculptures typically lead double lives, as objects that represent something and as objects that beguile us with their purity of form. *Fish* is a broad sleek piece of marble, wafer-thin at its edge, hard and polished. It is a mysterious work, mysteriously simple and irreducible.

In Gallery 10 is **I and the Village** by Marc Chagall (1887–1985). The village is Vitebsk, Russia, where Chagall grew up. The green face of the peasant is the artist himself. The beast who meets his gaze is a cow, the most sympathetic creature anyone could wish to encounter in a memory or dream. Chagall painted this picture in 1911, soon after arriving in Paris. He was influenced by painter Robert Delaunay's disks of color and by the Cubists. Nostalgia for his past in Russia was Chagall's sixth sense. He discarded the intellectual baggage of early Cubism and simply adapted its forms to give his fairytale a structure. The geometric shapes, which fit together like a puzzle, keep Chagall's topsy-turvy village and its weightless inhabitants from flying away. Fantasies are customarily fleeting, but this one is firmly anchored.

In Gallery 11 is **Street, Dresden** (1908) by Ernst Ludwig Kirchner (1880–1938), an early example of German Expressionism. Kirchner was inspired by the art of Van Gogh and Edvard Munch. He also was influenced by the Fauves but used color far more aggressively. The aim in this painting is to rupture the boundaries between art and life. Raw anxiety and the strangeness of human society are expressed

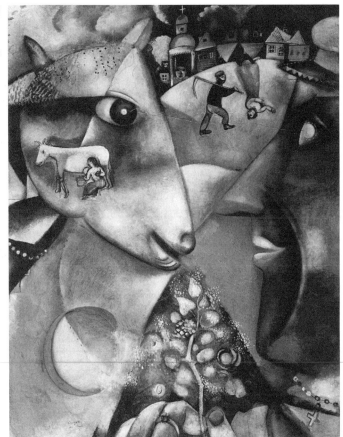

Marc Chagall *I and the Village*, 1911

by hallucinatory colors that seem to have welled up from the unconscious without the rational mind softening them first. The people in this Dresden street scene are a "lonely crowd," a race of aliens, their mask-like faces derived from the African and Polynesian sculpture Kirchner admired. Kirchner was bohemian to the core. He spurned middle-class propriety, espoused the superiority of youth, and believed in communal living and sexual freedom. He suffered a breakdown brought on by morphine addiction in his late thirties, and was plagued by illness in a life that he ended by suicide.

Expressionism turned inward, away from society. Two other movements proposed remaking society. In Futurism

(Gallery 12) and Constructivism (Gallery 13), we see two visions of Utopia.

Futurism was the brainchild of Filippo Tommaso Marinetti, an organ grinder turned ideologue whose manifesto of 1909 managed to make a love of machinery and aggression sound like a bracing Sunday drive: "The world's magnificence has been enriched by a new beauty, the beauty of speed. A racing car whose hood is adorned by great pipes, like serpents of explosive breath—a roaring car that seems to run on shrapnel—is more beautiful than the *Victory of Samothrace*." Marinetti glorified war as hygienic and advocated the burning of libraries and museums. None of the artists who followed him torched any libraries, but sculptor Umberto Boccioni did fashion the bronze figure titled **Unique Forms of Continuity in Space** (1913) as the emblem of a brave new tomorrow. It is a Cubist-inspired adaptation of the Louvre's *Winged Victory of Samothrace*, and, as Alfred Barr has pointed out, demonstrates the considerable debt of Futurism to the past that, in theory, it had wished to destroy. Boccioni died during World War I, not gloriously or in a machine, but by falling off a horse during cavalry maneuvers.

Constructivism was a movement of avant-garde Russian artists which, as the state art of the Bolshevik revolution, promised for one brief moment in history to build a new society. The notion that abstract art could transform the world may seem enormously naive in retrospect, but to many of the Constructivists the pure forms of geometry represented a new order. They intended to make geometry, which they considered free of bourgeois or any other associations, the common visual language of the proletariat. In the heady first few years after the 1917 Revolution, state-sponsored artists produced propaganda posters, leaflets, and parade decorations, stage decor, and furniture, and designed utopian monuments and buildings that were never constructed. The **Radio Announcer** by Gustav Klutsis is a maquette for a street loudspeaker system, never built, that was to broadcast Lenin's 1922 speech on the Revolution's fifth anniversary. Stalin crushed Constructivism and replaced it with social realism, and by the 1930s abstract art was a state crime.

Gallery 13 also displays the paintings of Mondrian. Piet

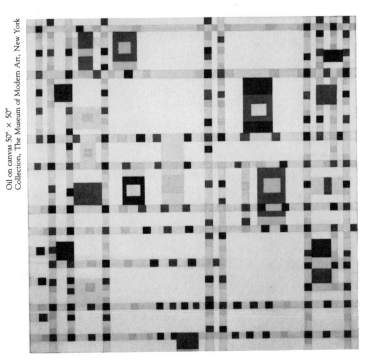

Piet Mondrian *Broadway Boogie Woogie*, 1942–43

Mondrian (1872–1944) loved nature passionately, but he loved even more the search for absolutes behind the surface of nature. He was raised a strict Calvinist and as a young man belonged to the mystical sect of Theosophy. He painted trees, cathedrals, and flowers as a young artist in Holland, and he systematically pared down the confusion of outward appearances that he called the "tragic." Ultimately he refined his paintings to include only horizontals and verticals, axes that he saw as standing for the world and everything in it. He limited his palette to the primary colors and black and white, which contain all colors. In his art, nature became solemn and radiant.

Nature's actual and less tidy charms became a kind of siren song that Mondrian, in his obsession with the ideal, attempted to avoid. Eventually he banished the color green from his immediate surroundings. His biographer Michel Seuphor, a Belgian painter who knew him in Paris, recalls an artificial tulip that Mondrian kept in a vase close to the door of his studio, its formerly green leaf painted white. Seuphor also witnessed Mondrian visiting a friend

on the Boulevard Lannes and asking to change seats at a table because he was irritated at the sight of the trees in the Bois de Boulogne. Given such asceticism, the painting in this gallery, completed the year before his death, is all the more remarkable as a pictorial equivalent of joyful noise.

Broadway Boogie Woogie by Mondrian. Mondrian spent the last three years of his life in New York, at home in a city of vertical skyscrapers and streets laid out in a grid. Curiously, and significantly for his art, Mondrian the puritan was also a jazz afficianado. In particular he loved boogie-woogie and listened to it with rapt attention on his phonograph. With his friend Harry Holtzman he frequented the clubs of Harlem to hear the pianists Albert Ammons, "Lux" Lewis, and Jim Yancey. Jazz appealed to the iconoclast in Mondrian. He was attracted to its improvisations, its "destruction of melody." Its syncopated rhythms, he said, were like his own attempts to achieve the "equilibrium of asymmetry," a kind of balancing act of off-balance form and color. In *Broadway Boogie Woogie* you can feel the pulse of the city, the rhythms of jazz. It is Mondrian's most exuberant and liberated painting, done at age seventy-two, an impassioned celebration of music and life.

In Gallery 14 are paintings and sculpture by Matisse. You might never suspect it by looking at his art, but Henri Matisse (1869–1954) was haunted by a feeling that life is meaningless. His friends nicknamed him "the professor" because of his reserved demeanor, but they also knew him as an anxious man underneath the controlled exterior. His work was his life, and he put all his energies into art completely free of worry. Matisse is the great healer of modern art. "What I dream of is an art of balance, of purity and serenity . . . something like a good armchair which provides relaxation from physical fatigue," he said. Cubism had defined space by breaking down the structure of form into fragments and then rebuilding it. Matisse's solution was to let color define space. Color and light were the main themes of his art, radiant light that he spoke of as an agent to "alleviate" spiritual fatigue. He was acutely aware of the void in Western art left by the decline of religion. To fill that void, he turned to other cultures, to primitive art and Islamic art in particular. Islamic miniature paintings and

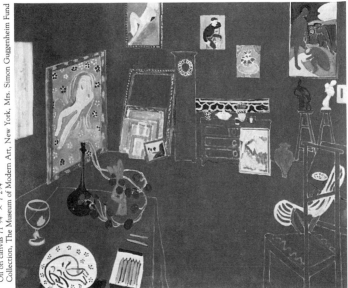

Henri Matisse *The Red Studio*, 1911

ceramics gave him the pattern of arabesque, the sinuous and enlivening curve repeated several times in the famous painting of his studio on display in this gallery:

The Red Studio by Henri Matisse. In this 1911 painting the imagination rules. The brilliant red room is shadowless. No troubles intrude. The window at left allows natural light inside the studio but nothing else from the outside world. *The Red Studio* is a memory picture, for all the paintings and sculpture seen here were done by the artist. It is also a picture about the freedom from time possible through art and imagination. The clock (at center) has no hands, indicating an eternal "now," this very moment when the mind of the artist (and by extension any viewer of the painting) roams among images of the past.

The studio is a room without walls. We are coaxed into the picture by a device of visual perspective: the outlines of a table and chair, and the large painting at left, lead our eye toward the back of the room, but there we find no juncture to define front and back walls. The paintings in the studio float in a space that is limitless, like imagination itself.

The objects in the studio refer to past, present, and future. Leaning against a stack of paintings is a small landscape from 1898, and at far left is *Large Nude* which Matisse had in 1911 recently completed. A large empty frame awaits some future painting. The present moment is accounted for too. The white plaster sculpture at right is a bust of *Jeannette*, which Matisse had yet to bronze at the time of *The Red Studio*. You can see the completed bust on display in Gallery 14, along with the painting itself.

Also in this gallery is Matisse's 1909 **Dance**. (This picture appears in another painting in the Metropolitan Museum.) Several years before, Matisse had seen a group of fishermen dancing on a beach in Catalonia, Spain. This may have given him the idea for the subject. The dancers here are female and nude, reminiscent of Dionysian celebrants upon an ancient Grecian vase. *Dance* is timeless and universal, a celebration of life itself.

Matisse painted two versions of *Dance*. In the final version, now at the Hermitage Museum in Leningrad, he exaggerated the movements of the dance and changed the colors (the dancers became a shocking red), making a violently pagan image. MOMA's earlier *Dance*, with its flesh-toned dancers and soft blue sky, is a vision of serenity and rapture.

Oil on canvas, 8'6 ½" × 12'9 ½"
Collection, The Museum of Modern Art, New York, Gift of Nelson A. Rockefeller in honor of Alfred H. Barr, Jr.

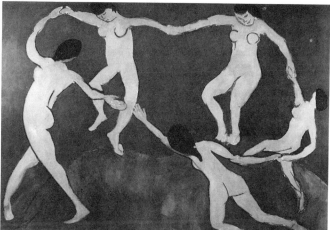

Henri Matisse *Dance*, 1909

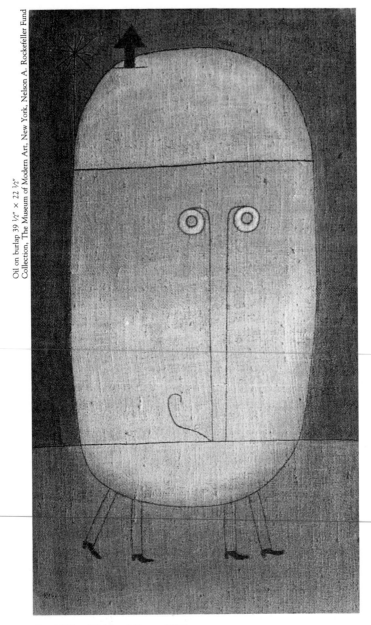

Paul Klee *Mask of Fear*, 1932

In Gallery 15 are paintings by Klee and Kandinsky.
Paul Klee (1879–1940) had been an exceptional violin-
ist as a teenager growing up in Bern, Switzerland, and one

of his greatest passions was Mozart. Like Mozart, Klee often expresses lofty feelings, and also like him, with a superbly light touch. As a mature artist, Klee struggled to give his art an underlying theoretical structure that paralleled music, but although he was a dedicated teacher and pedagogue, his greatest gift was a sublime sense of playfulness. "Just as a child while playing imitates us, we while playing imitate the forces which created and which continue to create the world," he said. Modern art would be in a sorry state without Klee's humor. It's not surprising that Klee loved children's art and went so far as to study and catalogue the juvenile pictures of his son Felix. His art remained modest in scale throughout his career. Working small proved to be a good strategy for sneaking up on the secrets of the universe. In **Equals Infinity**, Klee's painting from 1932, he fashioned a glimmering universe that is approachable and friendly if ultimately unknowable. The sign for "equals" and the sign for "infinity" are one side of an equation. The painting itself represents the other side. It's been suggested that the small colored dots in the painting might be atoms. Another way to look at them is as heavenly bodies. They form a cloudy mist, like a gleaming nebula. Floating against this backdrop are single short lines that look like unformed equal signs, detached in some random dance or unheard melody. In **Mask of Fear** (1932), the mask was inspired by Klee's interest in primitive art, and its fearfulness probably alludes to the rise of the Nazis in Germany. In **Cat and Bird** (1928), a cat is imagining a bird, and you can almost see the cat's nose twitching at the thought. The painting illustrates the power of imagination and is a metaphor for mischief pure and simple.

Wassily Kandinsky (1866–1944) was twenty-nine years old and a practicing lawyer when he saw Monet's *The Haystack* at an 1895 exhibit in Moscow. Galvanized in part by the painting, he went to Munich the next year to become an artist. He was a founder of The Blue Rider group, whose art was characterized by intense color and the equally intense feelings of the artists. It's generally agreed that Kandinsky painted the first total abstraction, a watercolor, in 1910. Today our tendency is to assume abstraction is its own justification, art for art's sake, and not

intended to "mean" anything at all. For Kandinsky, abstraction meant *everything*, even though he didn't (and we can't) interpret his images and colors as literal symbol or allegory or narrative. Like Mondrian, his aim was to evoke a hidden reality. Kandinsky believed in the occult doctrines of Theosophy, which predicted that the material world would dissolve and that a higher spiritual life on earth would replace it. The world has yet to dematerialize, although we have Kandinsky's paintings as an approximate guide to what it might look like in the event. Kandinsky, who improvised his early abstract paintings, intended that particular colors, shapes, and lines would prompt a "corresponding vibration in the human soul." His four paintings in this gallery titled **Painting No. 198, 199, 200 and 201**, all from 1914, have often been compared to the four seasons (summer, autumn, spring, and winter, corresponding in that order to the numerical sequence). Kandinsky deliberately avoided such direct interpretations, yet the comparisons are wonderfully tempting nevertheless. The mood of *Painting No. 200*, with its wispy black lines and its upward thrust of lyrical reds and yellows, is joyous if not positively springlike.

Gallery 16 is a room full of Picassos, including **The Charnel House**, from 1944–45, which Picasso apparently painted after he saw the first newspaper photographs of Nazi death camp victims.

One of the dominating paintings in Gallery 16 is **The Studio**, from 1927–28. It's a late Cubist painting which shows an artist at an easel. The theme is a favorite of Picasso's, the relation of art to reality. In one hand the artist wields a brush, represented in stick fashion, and in the other hand is a palette, shown simply as a thumbhole. The artist faces a bowl of fruit on a table and a plaster bust, which stares back. The bust has two eyes and a mouth, arranged vertically. The artist has three eyes, so much the better to see and create.

This painting is often admired for its abstract qualities, its harmony of elements arranged on a flat picture plane that denies the illusion of Renaissance perspective. Yet the narrative implicit in the picture is considerable. As in Matisse's *The Red Studio*, imagination is supreme. The paintbrush is poised at a canvas that is blank. Does the

picture inside the artist's head correspond to the painting we see, or will the artist improvise some entirely new and unforeseen image?

Dada and Surrealism follow, and it makes sense to go directly to Gallery 19 (to the left of Gallery 17). It's a small room, most of the objects in it being themselves small, and the room is conducive to a certain claustrophobia that is entirely appropriate. In this room, you find yourself enclosed quite abruptly within a dreamworld of twentieth century art.

Dada began in 1916 in Zurich, quickly spreading to New York and Paris. No one knows for certain how the movement got its name. Supposedly it was chosen at random by sticking a jackknife or pin into a dictionary through the French slang word for hobbyhorse. The playful ambiguity of the name has become part of Dada's mythology. Dada was an expression of revulsion against World War I, a childish tantrum that rejected Western civilization by declaring its own war against it. Chance and irrationality were the weapons. Marcel Duchamp, its chief mischief-maker, invented the so-called "readymades," anti-art objects such as the **Bicycle Wheel** that has been mounted on a stool like a pedestal. Here it sits, insisting that it is *not* art, but is instead a bicycle wheel. It is not even "original" but rather a 1951 replacement of a 1913 bicycle wheel. And so why have the museum curators placed it in the galleries, among real "art" objects? Its somewhat exasperating presence tends to devalue the other art in the museum, call it slightly into doubt. This softening of our expectations, a hint of bad temper or ambivalence on the part of the museum-goer, is a perfectly fine emotion to have as you look at the art in this gallery and the ones that follow on this floor.

Dada ran its course by the early 1920s and was replaced by Surrealism, which returned from anti-art to art and plunged with even greater deliberation into fantasy and the irrational. The writer André Breton had worked in a psychiatric ward helping wartime shellshock victims analyze their dreams, and he founded Surrealism with a 1924 manifesto.

One of the most startling works in the gallery is **Object**

(Fur-covered cup, saucer and spoon, 1936) by female artist Meret Oppenheim (born 1913). Its power to disconcert is compounded by what writer Robert Hughes calls its "secret life as a sexual emblem." The cup appears to be a strange but meaningless curiosity, until you realize that it is a symbol of the female genitals, meant to be brought to the mouth—a metaphor for oral sex.

Gibraltar is a 1936 sculpture by American artist Alexander Calder (1898–1976) who at the time was living in

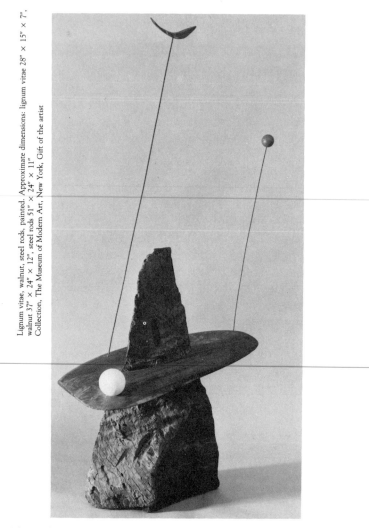

Lignum vitae, walnut, steel rods, painted. Approximate dimensions: lignum vitae 28″ × 15″ × 7″, walnut 37″ × 24″ × 12″, steel rods 51″ × 24″ × 11″
Collection, The Museum of Modern Art, New York, Gift of the artist

Alexander Calder *Gilbraltar*, 1936

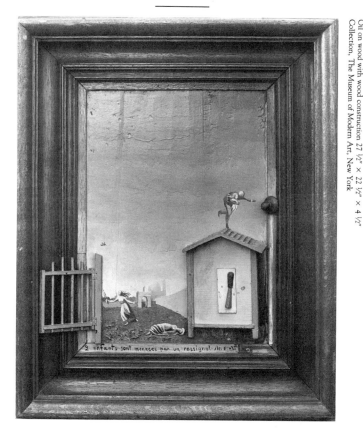

Oil on wood with wood construction 27 ½" × 22 ½" × 4 ½"
Collection, The Museum of Modern Art, New York

Max Ernst *Two Children Are Threatened by a Nightingale*, 1924

France. It shows two orbs and what appears to be a sliver of the moon clustered about the rock of Gibraltar (the "rock" is made of walnut, a beguiling transformation). Surrealism can be dark and ominous, but Calder, a cheerful enchanter, has fashioned an object out of white magic.

In 1924, German artist Max Ernst produced an object (now in Gallery 17) that became a signature work of the movement:

Two Children Are Theatened by a Nightingale by Max Ernst (1891–1976). According to the artist, the seed for this daylit nightmare was his bout with the measles as a child of six. Writing in the third-person about himself, Ernst recalled a "fever-vision provoked by an imitation-mahogany panel opposite his bed, the grooves of the wood taking successively the aspect of an eye, a nose, a bird's

head, a *menacing nightingale*, a spinning top, and so on. Certainly little Max took pleasure in being afraid of these visions and later delivered himself voluntarily to provoke hallucinations of the same kind." Although the title says "two children," the figures are actually fully developed females, perhaps caught up in sexual fear or panic. One of the figures has collapsed. It's been suggested the faceless man atop the toy house may be stealing off with her soul as depicted in the form of a small girl. The man appears intent on grasping a real wooden knob that is attached to the picture, as if to wrench open the illusionary world of the painting to reveal something else behind it. A wooden gate, also "real," leads our eye from the picture frame to the picture itself. Or, to look at it the other way around, it opens the picture up so that the vision can spill out beyond the frame to where we are.

In Gallery 18 are paintings of the Italian artist de Chirico, whom the Surrealists admired as a precursor and godfather to their movement. After a serious illness at the age of twenty-two, he became preoccupied with Renaissance architecture. Instead of rationality and order, as the architects of an earlier age had intended, de Chirico saw what he called a "metaphysical" sense of otherness.

The Nostalgia for the Infinite by Georgio de Chirico (1888–1978). "There are more enigmas in the shadow of a man who walks in the sun than in all the religions past, present, and future," de Chirico once said. Two figures stand together in an empty piazza. We must make up our own story to go along with this picture. It could be late afternoon or early morning, the first scene of a novel, or the last. Perhaps nothing yet has happened, or ever will; perhaps everything has happened, and is destined to be forgotten, or repeated. De Chirico was living in Paris when he painted this scene in 1913–14, but the looming tower, with its banners that briskly flap in a calm green sky, is based on a tower in Turin, Italy. The artist exaggerates Renaissance perspective, and forces our eye uphill to the tower and to that resplendent, still sky. This is a cityscape designed to produce agoraphobia, the fear of spaces, and to touch whoever sees it with its spell.

Also in this gallery are several "box" constructions

Oil on canvas 53 ¼″ × 25 ½″
Collection, The Museum of Modern Art, New York

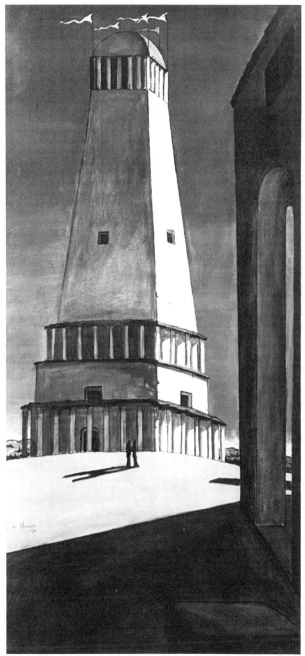

Georgio de Chirico *The Nostalgia of the Infinite*, 1913–14

by Joseph Cornell (1903–1972), an American artist who lived in the same house in Queens, New York, for forty-five years. His art often refers to remote and exotic places, but Cornell himself was a recluse whose travels were conducted inside his own mind. The museum-goer peers into the boxes as if into a small theater whose contents are precise, subtle, and resonant. **Roses des Vents** (ca. 1942–53) houses parts of maps of New Guinea and Australia, bits of rock that indicate geology, lids which partially obscure what lies below them, a star chart and twenty-one compasses. Like the human capacity for yearning, the arrows of these compasses point in an infinity of directions.

In Gallery 20 is the art of the Spaniard Joan Miró (1893–1983), who counted among his sources children's art and the cave graffiti of neolithic man. Most Surrealist art defies explicit interpretation, but Miró explained *The Hunter* in his own notes and in conversations with curator William Rubin.

The Hunter (Catalan Landscape) by Miró. Miró once said he wanted his art to "give the spectator an immediate blow between the eyes before a second thought can interpose." He was a starving artist in Paris when he painted this landscape in 1923–24. Hallucinations induced by a diet of dried figs and chewing gum helped inspire him. There is something both whimsical and ferocious about

Oil on canvas, 25 ½" × 39 ½"
Collection, The Museum of Modern Art, New York

Joan Miró *The Hunter (Catalan Landscape)*, 1923–24

this painting, with its bold pattern of sphere, cone, triangle, and line set off by bright flat areas of land, sea, and sky.

The setting is Miró's native province of Catalonia. The eye at the center of the painting is that of the artist, wide as a Cyclops'. A stick-figure hunter is depicted against the backdrop of yellow sky and the Mediterranean. The hunter has a moustache and beard, smokes a pipe, and wears a triangular knife on his sleeve. In one hand he holds a rabbit and in the other a gun, which has only just fired the huge round shot that has fallen to the ground. The hunter's heart is aflame because he so loves the hunt. His genitals are shaped like an egg with hair. The sun in the sky, above and to the right of the hunter, also has this odd egg shape. In the sky at left is a mail plane on its run from Toulouse to Morocco, displaying the flags of France and Catalonia. Above the plane is a star and rainbow.

The large sphere with a single leaf is a carob tree, and on the sea behind the tree is a boat with a Spanish flag. In the foreground is the hunter's lunch, an enormous sardine being grilled on a fire. The sardine flicks its tongue at an insect, which defecates in fear. At the far left is a triangular vine. At far right Miró has painted the first letters of "Sardine," perhaps to emphasize that, like hunting, hallucinating is hungry work.

In Gallery 21 is **Man Pointing** by Alberto Giacometti (1901–1966). In the late 1940s, the existential philosophers led by Jean-Paul Sartre adopted Giacometti as a hero whose bronze figures such as this one, pinched to the vanishing point, were the visual equivalent of their ideas on modern alienation. Giacometti, who considered himself a failure even after he became a celebrated artist, thought their philosphy boring and preferred to go his way. In effect, he made his existential choice.

In the mid-1930s he broke away from Surrealism and later referred to his earlier membership in that movement as his "Babylonian captivity." His elongated bronze figures can be seen as a curious struggle to come back from the surreal. He wanted to show how we see a human being in the first flash of animal recognition. Yet he didn't think of the figures as fantasy or phantasmagoria, rather as an attempt to get representation absolutely right. He was con-

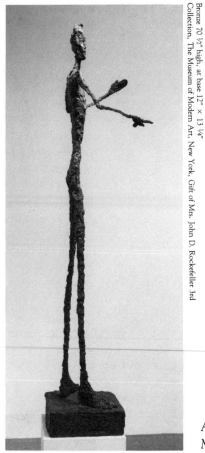

Bronze 70 ½" high, at base 12" × 13 ¼"
Collection, The Museum of Modern Art, New York, Gift of Mrs. John D. Rockefeller 3rd

Alberto Giacometti
Man Pointing, 1947

vinced that one cannot see a person clearly at close quarters and recommended nine feet as the ideal distance. Like Cézanne, he was motivated by doubt. He molded and reworked his figures obsessively before casting them, paring them down, building them up, reducing them again. "A large figure seemed to me false and a small one equally unbearable," he once said, "and then often they become so tiny that with one touch of my knife they disappear into dust." The uneven finish of the sculpture that he did commit to bronze is hard evidence of this second-guessing. The oversized feet of the figures appear to keep them from fading into thin air.

Such was his personal anxiety that from the age of twenty he always slept with a light on. Giacometti emigrated to

Paris from the Italian region of Switzerland. He was influenced by ancient Etruscan sculpture from northern Italy, in particular by its elongation of form. One way to look at **City Square**, his 1948 sculpture of five tiny figures, is as Giacometti's effort to portray very clearly how those figures inhabit the space around them. Another is to see them as modern descendants of Etruscan gods, a gathering of wraiths representing the artist's poignant feelings of uncertainty.

In Gallery 22 are paintings by René Magritte and Salvador Dali. The late nineteenth century French writer Lautreamont coined the phrase "Beautiful as the chance encounter of a sewing machine and an umbrella on an operating table," a description the Surrealists would adopt as an artistic strategy. No one midwifed such unions with the consistent success of René Magritte (1898–1967). He was a Belgian of placid personality, who liked neatness, kept appointments on time, avoided unexpected meetings, and scrupulously followed a daily schedule. One thinks of filmmaker Alfred Hitchcock, another master of disorder, who also cultivated a highly conventional private life. Magritte's art depends on its clarity and matter-of-fact style for shock value. The shock was intended to awaken the

Oil on canvas 21 ½″ × 31 ⅞″
Collection, The Museum of Modern Art, New York

René Magritte *The False Mirror*, 1928

viewer to an unconscious reality that to Magritte was as potent as surface reality. "My paintings have no reducible meaning," he said. "They are a meaning." **The False Mirror** (1928), an unblinking eye, functions as an enormous advertisement for irrationality. The eye's black pupil is like an eclipsed sun in an iris of blue sky and fairweather clouds. CBS-TV later based its corporate logo on Magritte's image, an example of life imitating surreality.

The Persistence of Memory by Salvador Dali (born 1904). Dali painted this, his most insistent dream picture, in 1931. He liked to brag that he used "all the usual paralyzing tricks of eye-fooling, the most discredited academism," which here include a skillful manipulation of shadow and slick brushwork that hides all trace of process. As in de Chirico's *The Nostalgia of the Infinite*, a painting he admired, Dali produced the illusion of rapidly receding space by placing in the foreground a box shape at an angle that pulls our eye forward. The smallness of this painting intensifies its kick, but the masterstroke is the imagery itself, which illustrates some inexplicable allegory about time marooned: ants swarming over the face of a glowing orange watch and Dali's unforgettable floppy watches which lie limp and impotent. The grayish lump curdled upon a barren shore looks as if it has crawled there to die

Oil and collage on composition board 9 ½" × 13"
Collection, The Museum of Modern Art, given anonymously

Salvador Dali *The Persistence of Memory*, 1931

from under a rock or a specimen slide. It is a profile of the artist, a tireless self-promoter throughout his career, appearing as a guest star in his own dreamscape.

Near the entrance to the third floor Painting and Sculpture galleries is **Christina's World** (1948) by Andrew Wyeth (born 1917), an artist who is heir to traditions of realism that predate modern art. Christina, crippled by polio, was a neighbor of Wyeth's in Maine. She is shown here gazing across a vast field at her home. The artist painted in tempera, pigment mixed with egg, as did medieval artists. It is an exacting medium, and it has allowed Wyeth to record with a kind of religious reverence individual blades of grass and to express Christina's wonder at the seemingly limitless panorama.

The third floor contains American and European art from the middle of this century, and Abstract Expressionism and contemporary art. Matisse's *The Swimming Pool* is in Gallery 28, and his *Memory of Oceania* is at the entrance to Gallery 29.

In 1930, at age sixty, Matisse traveled to the Pacific island of Tahiti. Light held strong spiritual significance for him, and he had long been curious about the quality of the light in Oceania. When he got there his initial reaction was disappointment. Paradise was boring and also alarming. He described the brilliant light as "too beautiful, ferociously beautiful . . . it is as if the light would be immobilized forever. It is as if life would be frozen in a magnificent stance." The stunning sunlight paralyzed his desire to work. During his visit, he made only one painting, a small study of a clump of trees.

Memory, reinforced by crippling old age, allowed Matisse to finally capture paradise in his art. In 1941, he had surgery for intestinal blockage and for much of his remaining life was confined to bed or a wheelchair. "My terrible operation has completely rejuvenated and made a philosopher of me," he said. It also freed his memories of Tahitian light, which bathes the paper cut-outs of his final years. Matisse compared himself to a sculptor cutting into stone, in the way he cut with scissors into the brightly

A nine-panel mural in two parts. Gouache on cut and pasted paper mounted on burlap, approximately 7'6" × 54'
Collection, The Museum of Modern Art, Mrs. Bernard F. Gimbel Fund

Henri Matisse *The Swimming Pool*, 1952

colored paper. For the large cut-outs, he directed assistants to arrange the shapes and paste them into place. He adopted the technique because of infirmity, yet it also represented the radical culmination of his career-long search for simplicity.

The Swimming Pool (1952) once decorated the dining room walls in Matisse's apartment at the Hotel Regina, in Nice. In Tahiti, Matisse had swum in a lagoon with "my eyes wide open," he recalled, "and then suddenly I would lift my head above the water and gaze at the luminous whole." The blue cut-outs of swimmers plunge and play, at times indistinguishable from the plumes of water they raise. The energy of these swimmers is unbounded, their motion without end. In **Memory of Oceania**, completed in 1953, the year before Matisse died, a few scant outlines in crayon suggest the presence of a human figure. One senses the blue of the sea, the gold of sunlight, the green of trees, even though objects are not literally represented. White is a rich color here. It has a vastness and depth that seems to expand beyond the confines of the picture's surface. Memory has transfigured physical reality into space and light. This image could be the dawn of a new morning, or the first day of creation.

For the purposes of this walking tour, which began with

Cézanne and the birth of modern art, Matisse will do superbly as an end point. There is so much to see that by the time visitors arrive at the Matisse cut-outs, many people are ready to breeze through the other galleries on the third floor.

Should you wish to continue, or come back on another visit, Abstract Expressionism provides the main drama on this floor. After World War II, New York became the capital of modernism. A group of painters sometimes called the New York School included Jackson Pollock, Willem de Kooning, Mark Rothko, and Robert Motherwell. Diverse as the group was, it shared a belief in the importance of the unconscious, shape and color born of free association. The Surrealists had pioneered the same territory, but with the example of such abstract artists as Kandinsky the New York painters cut loose from the use of recognizable imagery.

In Gallery 29, **Elegy to the Spanish Republic, 108**, by Robert Motherwell (born 1915) is a visual cousin to the Matisse cut-outs, for Matisse's elegance and use of flat shapes appealed to Motherwell. *Elegy, 108,* from 1967, is one in a long series of paintings begun in 1947, originally inspired by the civil war and the death of democracy in Spain. No literal representation is intended here, rather the artist wanted to create what he called a "funeral song," a universal meditation upon life and death. Black is the color of mourning, white is the color of life. The song can be heard, or at least seen, in the powerful rhythm of black on white.

Also in this gallery is **Woman, I,** by Willem de Kooning (born 1904). The new orthodoxy of Abstract Expressionism had banished the human figure from its imagery. When in 1952 de Kooning reintroduced it in this first of a series of "women" paintings, followers of the movement were shocked. According to de Kooning, his women bore a family relationship to the nudes of traditional European painting and to female idols of primitive art. The ferocious woman in this painting, with her comically lopsided grin, was also meant as a parody of the female image in mass advertising and pinup art. Although the painting portrays a figure, it is also a violent piece of iconoclasm. The brush-

work appears furious and rapid. Style is wedded to content with the force of a bombshell. In a sense, the picture's true subject is the very process of painting.

One reason the term Abstract Expressionism has stuck is that it is vague enough to encompass artists with vastly different temperaments. De Kooning and Pollock represent the side of the group devoted to heated visual rhetoric. On the other side was Mark Rothko's calm, contemplative art. Gallery 30 contains **One (Number 31),** a 1950 painting by Jackson Pollock, whose life and art are discussed in relation to a painting from the same year in the chapter on twentieth century art at the Metropolitan Museum.

Also in Gallery 30 is **Red, Brown and Black** by Mark Rothko (1903–1970), a brooding painting from 1958. Rothko, who ended his life by suicide, said that he wanted "an art that would suggest the mysterious sublime rather than the beautiful." He saw painting as an act of secular faith. He once joked that Turner, the nineteenth century romantic artist whose paintings he saw at a Museum of Modern Art exhibit, "stole [his color] from me." Rothko's art reduced the romantic impulse, the desire for union with the beyond, to cloud-like rectangles of color floating on a canvas. He was entranced by the Pompeii frescoes at the Metropolitan Museum, not for the figures or architectural elements but rather for their expanses of color. His own paintings have been compared to landscapes in which the human figure is removed. He intended viewers of his paintings to become absorbed in them. The clouds of color can sometimes appear weightless, or dense and solid, and their position in relation to each other seems to move as you look at them more carefully. Robert Motherwell once said that "without ethical consciousness, a painter is only a decorator." Whether you see a Rothko painting as sublime or decorative depends on your own point of view. The paintings themselves are ambiguous enough to allow both viewpoints.

Vir Heroicus Sublimis by Barnett Newman (1905–1970), reaches for the sublime in a highly reductive manner. One bright vertical stripe and several muted stripes divide a brilliant red "field" of color. This 1951 painting

was a touchstone for a later generation of Minimalist paint-ers and sculptors. "Less is more" became the rallying cry in the 1960s for Minimalism, a movement that some observ-ers believe ultimately demonstrated that just possibly less is less.

Also in this gallery is **Beta Lambda** by Morris Louis (1912–1962), a 1960 painting in which paint has been poured across the edges of the canvas to form glittering "veils" of color. Undeniably here is a decorative painting, bright and lyrical, and yet with its large area of unpainted canvas it effortlessly flirts with metaphysics. Is the un-painted part of the canvas empty or full? The veils of color seem to frame that question in a way that would make optimists of us all.

Gallery 31 contains contemporary art, including a sam-pling of Pop Art, which replaced Abstract Expressionism in the 1960s as the fashionable new movement. The art in this gallery is rotated several times a year, but you are likely whenever you visit to encounter works by Oldenburg, Lichtenstein, Warhol and others. Claes Oldenburg (born 1929) remains a favorite of museum-goers, subverting our expectations about form with objects taken from everyday life and changed in scale, material and texture. No one could surpass the Abstract Expressionists in earnestness, but the playful spirit of Oldenburg and others swiftly ma-rooned them in art history.

THE SCULPTURE
GARDEN

THE ancient Greeks and Romans put statues of their gods and heroes in open-air temples and public places, and at least something of that spirit prevails in MOMA's sculpture garden (located off the ground floor). Any patch of open land in Manhattan is a precious commodity, but what makes this one special is that visitors here can mingle freely and on familiar terms with the sculpture. This is a place well populated by fine art.

John D. Rockefeller, Jr., gave the land on West 54th Street where the sculpture garden now is, and the present design is by architect Philip Johnson. Johnson was inspired by Japanese and English gardens and by the layout of space in Italian piazzas.

The oldest sculpture on display is also the most imposing: **Monument to Balzac** by Auguste Rodin (1840–1917). "I think of his intense labor, the difficulty of his life, his incessant battles and great courage," said Rodin of Balzac. "I would express all that." A French society of authors commissioned Rodin in 1891 to create a statue that would stand in front of the Palais Royal in Paris. The contract called for completion in eighteen months. Rodin became obsessed and took seven years. He read Balzac's novels and the biographies of him and examined photographs and paintings of his subject. He made numerous studies of citizens in Balzac's native city of Tours in the curious conviction that their likenesses might bring him closer to Balzac. He hired a Paris factory worker who bore a physical resemblance to his subject to pose for him, and he even had Balzac's tailor make a set of clothes to fit the late

166

Bronze (cast 1954) 8'10" high, at base 48 ¼" × 41"
Collection, The Museum of Modern Art, New York, presented in memory of Curt Valentin by his friends

Auguste Rodin *Monument to Balzac*, 1898

writer's measurements. Rodin's trial sculptures of Balzac (more than forty studies in wax, plaster, and clay survive) became the record of his own labor. He sculpted Balzac nude, clothed, striding heroically, in majestic repose.

Nothing would do. Ultimately, he threw a robe over Balzac's standing figure. The cloaked figure shows Balzac as a force of nature, massive, unknowable. The society of authors rejected the final plaster version, and the monument was not cast in bronze until long after Rodin's death. Rodin, who put the plaster Balzac in his garden, was stunned by public ridicule of his sculpture. He had worked seven years, yet afterward wished he had taken even more time: "For a work, even when achieved, is never perfect, and is always susceptible to a modification that can increase its beauty."

Changing one's mind, seeing form freshly, is often at the center of art. Among the other outdoor sculptures are **The Backs** by Henri Matisse, four bronze reliefs of the female back. Matisse did the bronzes over a long period, in 1909, 1913, 1916, and 1931, modifying each time and simplifying at last to near abstraction.

Sculpture like Rodin's *Monument to Balzac*, a heroic figure placed upon a pedestal, became an endangered species in our century. **Cubi X** (1963) by David Smith, is a modern descendant of figurative sculpture. Smith's sculp-

Painted steel 7'7 ¾" × 37 ⅞" × 12'1 ¾"
Collection, The Museum of Modern Art, New York, Mr. and Mrs. Arthur Wiesenberger Fund

Anthony Caro *Midday*, 1960

168

ture consists of stainless steel geometric shapes poised one atop the other and can be seen as anthropomorphic. But abstract form has replaced the explicit depiction of a human figure. As figurative sculpture once promulgated grand ideas, *Cubi X* plays with issues of form. Its sense of balance and gesture are enticing, and its sparkling steel surface gives its shapes an unexpectedly weightless appearance.

In *Cubi X*, the pedestal of figurative sculpture has shrunk to a mere vestige. In **Midday** (1960) by Anthony Caro, the traditional base, supporting upright sculpture, is gone. *Midday* is steel painted bright orange, the color of its title. You might read this horizontal sculpture as abstract landscape, but however you interpret it, one quality that comes through is irrepressible energy. A section of I-beam balanced on one edge has the acrobatic lift and bounce of something animate.

Geometric Mouse (1975) by Claes Oldenburg is a looming steel contruction with round mouse ears and two rectangular openings that look like eyes. Oldenburg has worked a roguish sort of metamorphosis upon man's favorite rodent. By its scale and nearly abstract shapes, the sculpture announces itself as a monument. It's a long way from Rodin's *Balzac*, the lesson being that in our age we must take our heroes where we find them.

ONE EAST 70TH STREET (AT FIFTH AVENUE)
NEW YORK, NY 10021
TELEPHONE: 212-288-0700

HOURS: *Tuesdays–Saturdays, 10–6; Sundays, February 12, Election Day, and November 11, 1–6. Closed Mondays, December 24 and 25, January 1, Thanksgiving Day, and July 4.*

ADMISSION: *$2 Tuesdays–Saturdays (students and senior citizens 50 cents); $3 Sundays. Children under 10 not admitted, and visitors under 16 must be accompanied by adults.*

GETTING THERE: *By bus, downtown on Fifth Avenue or uptown on Madison Avenue. By subway, Lexington Avenue train 6 to 68th Street.*

MUSEUM SHOP: *Art publications, postcards, greeting cards.*

TALKS: *Introductory talk Tuesdays–Fridays at 11.*

SPECIAL EVENTS: *Sunday afternoon chamber music at 5. To reserve a seat, send a self-addressed stamped envelope to The Frick Collection. No charge for concert tickets (beyond Sunday admission fee), but requests are accepted only if letter arrives on the second Monday before a concert.*

THE FRICK
COLLECTION

T HE coke and steel tycoon Henry Clay Frick (1849–1919) moved his art collection to New York from Pittsburgh to get away from the smoke of the factory town that made him wealthy. By building a mansion that he would bequeath as a public museum, he also had his eye on immortality. "The article on Frick in the *Encyclopaedia Britannica* runs to twenty-three lines," S.N. Behrman once observed. "Ten are devoted to his career as an industrialist, and thirteen to his collecting of art. In these thirteen lines, he mingles freely with Titian and Vermeer, with El Greco and Goya, with Gainsborough and Velázquez. Steel strikes and Pinkerton guards vanish, and he basks in another more felicitous aura. The old boys take him cozily under their wings; they carry him along."

They carry us along, too. The Frick Collection is the favorite art museum of many travelers and native New Yorkers. Its Old Masters and its smallness are but two reasons. Another is that we feel, as we stroll around, as if we have landed on Frick's cozy golden shore. And a museum-goer is never pressed by crowds here, because of a policy that staggers admission to two hundred visitors at a time. On weekends, there is sometimes a wait in a reception hall that was added when the building was expanded in 1977.

At age twenty-one, Henry Frick borrowed money from the bank of Thomas Mellon and Sons in Pittsburgh to expand his coke operations. The credit investigator's re-

THE FRICK COLLECTION TOUR

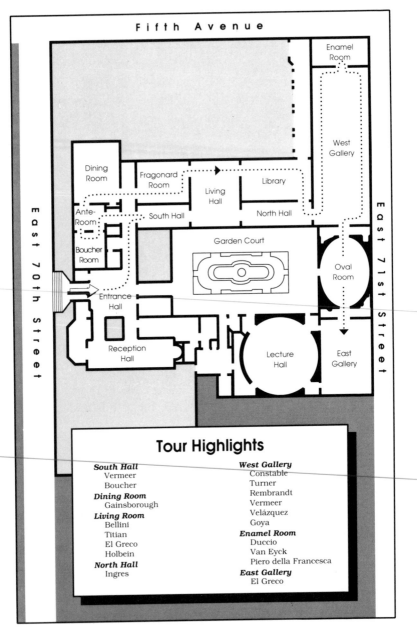

Fifth Avenue

Enamel Room

West Gallery

Dining Room

Fragonard Room

Living Hall

Library

Ante-Room

South Hall

North Hall

Boucher Room

Garden Court

Oval Room

Entrance Hall

Reception Hall

Lecture Hall

East Gallery

East 70th Street

East 71st Street

Tour Highlights

South Hall
Vermeer
Boucher

Dining Room
Gainsborough

Living Room
Bellini
Titian
El Greco
Holbein

North Hall
Ingres

West Gallery
Constable
Turner
Rembrandt
Vermeer
Velázquez
Goya

Enamel Room
Duccio
Van Eyck
Piero della Francesca

East Gallery
El Greco

port on young Frick also noted his peculiar interest in art: "Lands good, ovens well built; manager (Frick) on job all day, keeps books evenings, may be a little too enthusiastic about pictures but not enough to hurt. . . ." Frick could be as shrewd and tough as any of the era's robber barons. He was an uncompromising enemy of labor unions, notably during a strike at Pittsburgh's Homestead steel factory in 1892 when his force of Pinkerton guards fought a bloody pitched battle with armed strikers. By the turn of the century, Frick had begun devoting most of his energies to his pictures. He first installed his collection in a Manhattan mansion rented from George Vanderbilt. In 1914 Frick built his neoclassical palace on East 70th Street at Fifth Avenue, motivated in part by his rivalry with former business partner Andrew Carnegie who owned a house farther uptown. His own mansion, Frick said, would make "Carnegie's place look like a miner's shack." After Frick died his widow lived here until her own death in 1931, and the collection opened as a museum four years later.

Frick once called railroad stocks the Rembrandts of investment, and his taste in art was suitably blue chip. The trustees of the collection added to it in the decades after his death in the same conservative vein. The arrangement of the paintings avoids chronology and strict historical grouping but rather seems determined by imperial whim. This flair for mix-and-match display is another reason why visitors love to roam the place.

From the entrance hall, walk a few paces to the South Hall. Here you will be greeted by a band of medieval angels, playing up a triumphant storm in **The Coronation of the Virgin** by fourteenth century Venetian artists Paolo and his brother Giovanni Veneziano. Mary was never crowned in the New Testament, but the apocryphal nature of the scene does little to dampen the inspiration of these angels who play on period instruments in this splendid devotional panel.

Nearby you will find two of the collection's three Vermeers, the third being located in the West Gallery.

All three show the hushed, light-filled interiors that Johannes Vermeer (1632–1675) was so devoted to, and all were done from the mid-1650s onward. Most likely Ver-

meer had begun by then to use a camera obscura, a primitive camera-like device that projected an image on canvas which could be traced to produce the illusion of space. You can see evidence that Vermeer used the device in **Officer and Laughing Girl**, the earliest of the three. The looming figure of the officer is out of scale with the girl seated nearby, an incongruity that can probably be explained by the way a projection lens bloats foreground objects. Vermeer, a voyeur of unguarded moments, illustrates the rites of flirting couples in both paintings now displayed in the South Hall. In **Girl Interrupted at Her Music**, a young woman looks up and catches the artist at his game.

The Frick Collection's view of Western civilization runs deep, and runs shallow too. Henry Frick was raised on a farm in western Pennsylvania. Having triumphed over his humble beginnings, he was drawn to art of the European upper classes, in particular the eighteenth century French court, with its decorative painting and improbably ornate furniture to match. The assertion of class is one of the themes of the collection, played out in the paintings of Boucher and Fragonard and British artist Thomas Gainsborough.

In the South Hall is the doll-like **Madame Boucher**, a 1743 portrait by François Boucher (1703–1770) of his wife. He often used her as a model in his paintings for the French court of King Louis XV. Boucher's touch with a brush is meltingly delicate and exact. There is no frothier artist than Boucher, but it's a wholly seductive portrait even so.

The frothiest is yet to come, in the Boucher Room which is a short walk from the South Hall.

Madame de Pompadour, mistress of Louis XV, commissioned Boucher to paint the eight panels titled **The Arts and Sciences** (dated 1750–53) for a room in a chateau at Crécy, near Chartres. Children, most of them pudgy cherubs in costume, are depicted playing grown-up in such civilized pastimes as architecture, poetry, and music.

In the West Vestibule, immediately to the right of the Ante-Room on your map, is the **Four Seasons** from 1755,

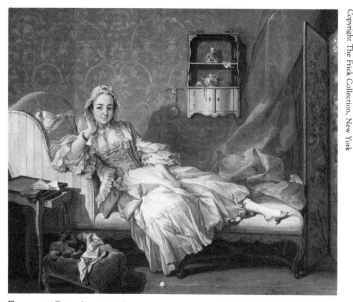

François Boucher *Madame Boucher*, 1743

another series of Boucher paintings commissioned by Madame de Pompadour. Here, the adults of high society play like children—without a care, or thought, to bother them in the decades just before the French Revolution.

From either the Boucher Room or West Vestibule, enter the Dining Room for a glimpse of what the aristocracy of England was up to in the eighteenth century.

No one could surpass Thomas Gainsborough (1727–1788) at painting the elite as they wished to be seen. His success as a society artist was also his curse, as he himself complained in a letter to a musician friend midway through his career: "I'm sick of Portraits and wish very much to take my Viol da Gamba and walk off to some sweet village where I can paint Landskips [sic] and enjoy the fag End of Life in quietness and ease. But these fine Ladies and their Tea drinkings, Dancings, Husband huntings and such will fob me out of the last ten years. . . ." Among the portraits in this room by Gainsborough and his contemporaries is his **Grace Dalrymple Elliott,** from about 1782, a woman of statuesque beauty and notorious reputation. Divorced by her husband, she had numerous lovers, including the Prince of Wales, who may have had this portrait done.

Thomas Gainsborough *The Mall in St. James' Park*, ca. 1783

The centerpiece of the room is Gainsborough's **The Mall in St. James' Park**, done about 1783 but not sold until after he died. Gainsborough never stopped yearning to paint landscapes, and he satisfies that urge here by placing fashionable strollers in an idealized park. To help him paint this upper-class paradise, Gainsborough apparently studied a model of the scene he had arranged on a table, using dolls as substitutes for people.

The Fragonard Room, with its fourteen decorative panels, is located across the West Vestibule.

The Progress of Love by Jean-Honoré Fragonard (1723–1806). A student of Boucher, Fragonard became the fashionable artist of his day. His misfortune was that the market for his rococo style began to pass even before the paint was dry on these panels. Madame du Barry, Louis XV's last mistress, had asked Fragonard to do four panels for her chateau in Louveciennes near Paris. And so between 1771 and 1773, Fragonard painted illustrations to "the progress of love in a young girl's heart"—**The Pursuit, The Meeting, The Lover Crowned,** and **Love Letters**. When he was done they were rejected, apparently because they didn't fit the new and more reserved neoclassical

design of the chateau. During the French Revolution, Fragonard fled with them to his home town of Grasse and put them in his cousin's house where he added several more panels. Out of fashion after the Revolution, Fragonard stopped painting. In 1805, he and other artist-lodgers were evicted from their quarters at the Louvre, and the next year he died in obscurity.

The Progress of Love has been called a *Midsummer Night's Dream* of romance, with statues as alive as people and human lovers who resemble dainty porcelain figurines. And like porcelain, Fragonard's fantasy world is exquisite but highly fragile.

Also in the Fragonard Room is the bust of the **Comtess**

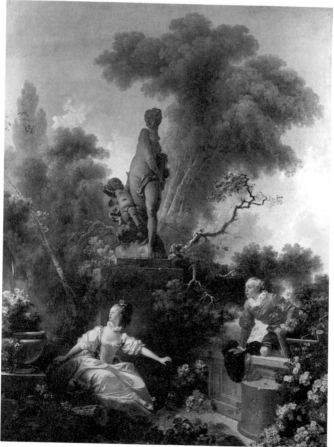

Jean-Honoré Fragonard *The Meeting,* ca. 1771–73

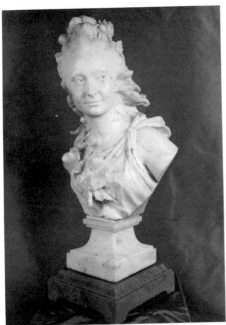

Jean-Antoine
Houdon *Comtesse
du Cayla*, 1777

du Cayla by Jean-Antoine Houdon (1741–1828). The countess, looking refined and serene, is depicted as a bacchante with grape leaves about her neck. According to Greek mythology she should be a drunken and orgiastic reveler, but the role appears not to have ruffled her composure one bit.

The next gallery is the Living Hall, which contains some of the Frick Collection's greatest paintings.

St. Francis in the Desert by Giovanni Bellini (1430–1516). The great enigma of this painting is the unknown object of Saint Francis's ecstasy. In 1224, the Francis of history spent forty days in fasting and praying at Mount Alverna in Umbria, northern Italy. According to legend God blessed his simple faith by sending a seraph, or angel, who imprinted the wounds of Christ upon Francis's hands, feet, and side. In this painting from about 1480, the early Renaissance master Bellini has departed from tradition by omitting the seraph from view. Yet Francis is clearly transported by some vision or intense inner emotion. Faint marks are visible on his hands. Perhaps he is at this mo-

ment receiving the stigmata from the seraph, whose presence, it has been suggested, can be seen in the strangely lit laurel tree at upper left that appears to be rustling. Or perhaps the miracle has previously happened, and Francis, who wrote a famous poem praising the sun, is greeting the sunrise.

Bellini has placed the saint in a marvelous landscape, one of the early landscapes of the epoch. It is a scene lit by faith, reflecting the Franciscan reverence for God's hand in the creation of nature and animals. It is also a persuasive Renaissance image. Bellini, who painted this for a private patron rather than for the Church, expresses a detailed and panoramic curiosity about the world that is new in art. He has also filled the picture with softly glowing light. The artist had learned how to use oil with tempera from the Flemish painters. He captured the effect of light by applying color in layers. To this Flemish technique of glazing, he has added an Italian mastery of distance and perspective. In the middle distance, a shepherd turns to look at Saint Francis with a sense of wonder that is matched by our own as we look at this painting today.

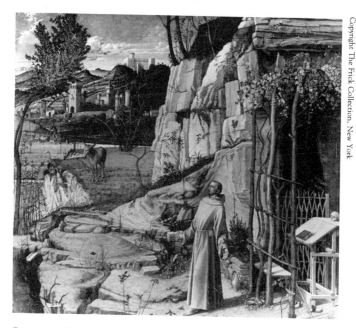

Giovanni Bellini *St. Francis in the Desert*, ca. 1480

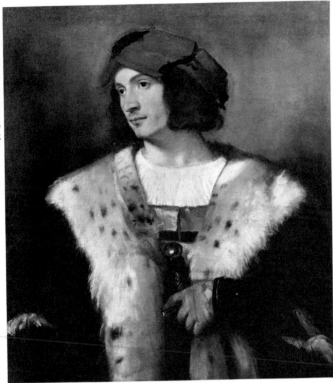

Titian *Portrait of a Man in a Red Cap*, ca. 1516

Flanking the Bellini painting are two portraits by Titian (1477/90–1576). **The Man in the Red Cap**, painted circa 1516, is an unidentified young man who has the dreamy look of a Hamlet who has yet to meet his crisis. By contrast, **Pietro Aretino**, painted circa 1548–early 1550s, looks just as we might expect a worldly fellow would who built his fortune with a poison pen. Aretino wrote slanderous satires and verses, and Titian, who was a personal friend, portrays him with both sympathy and sharp insight. Princes and churchmen paid Aretino not to write about them, and here he wears his riches on his back like some shrewd and corpulent hedgehog.

Across the Living Room is a portrait of **Saint Jerome** by El Greco (1541–1614), one of at least four versions the artist did. Jerome, an early scholar and hermit saint of the Church, translated the Bible into Latin. El Greco follows

convention by showing him in the scarlet of a cardinal. Atop the massive red robes the artist has painted the face of an inspired zealot, whose expression seems to say that he divines the word of God through hard study if not direct communication with the Almighty.

Flanking Saint Jerome's portrait are the portraits by Hans Holbein (1497/98–1543) of **Sir Thomas More** and **Thomas Cromwell**, paired on the gallery wall as they once opposed each other in life. More was beheaded by Henry VIII, largely through the urging of Cromwell, who later fell from royal grace and was himself beheaded. Holbein painted More in 1527, a year after the artist arrived in England from Germany. It was eight years later that More as Lord Chancellor was executed for refusing to approve Henry's divorce, yet he already has the stubborn look of a principled man. (In his meticulous care for physical detail, Holbein notes the five o'clock shadow on More's face.) The

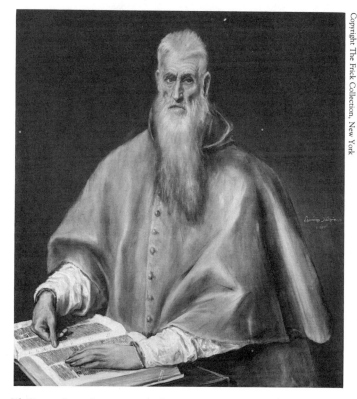

El Greco *Saint Jerome*, ca. 1590–1600

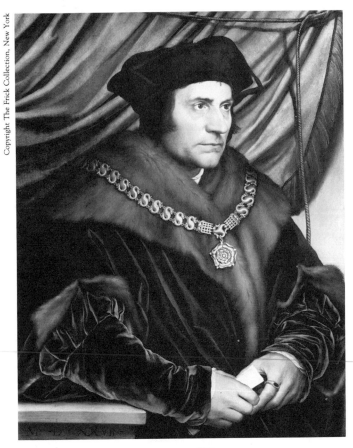

Hans Holbein *Sir Thomas More*, 1527

portrait of Cromwell, the son of a blacksmith who became Lord Great Chamberlain, is undated. Cromwell's sidelong glance speaks volumes about the intrigues of a schemer.

The Library might be called a People Like Us gallery, with its line-up of female aristocrats by Romney, Reynolds, and Gainsborough. Gainsborough portrayed **Lady Sarah Innes** in about 1757, early in his career, before his facile style had fully developed. The pose of this young heiress, who married a captain in the Light Dragoons, is rigid and unconvincing, yet her face blooms with eagerness to get on with life. Like the artist himself, she's still innocent.

Also in this gallery is **Salisbury Cathedral from the Bishop's Garden** (1826) by John Constable (1776–1837),

a picture which seems to affirm that God truly is in His heaven and all is right with the world. **Van Goyen Looking Out for a Subject**, from about 1803, by Joseph Mallord William Turner (1775–1851) contrasts with Constable's peaceable landscape. The picture shows a seventeenth century Dutch artist in a wind-tossed boat searching for a likely scene to paint. That's the literal depiction, but we can also interpret this as a portrait of Turner's own restless spirit that spurred him to become one of the great masters in the rendering of color and light.

In the North Hall is Ingres' well-known portrait of a countess.

Comtesse d'Haussonville by Jean-Auguste-Dominique Ingres (1780–1867). "A portrait of a woman!" Ingres once

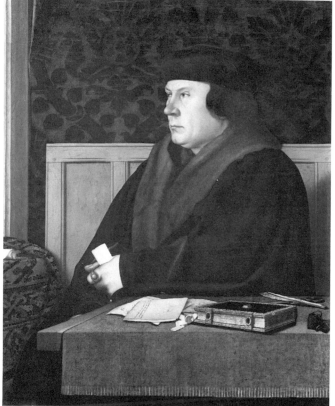

Hans Holbein *Thomas Cromwell,* undated

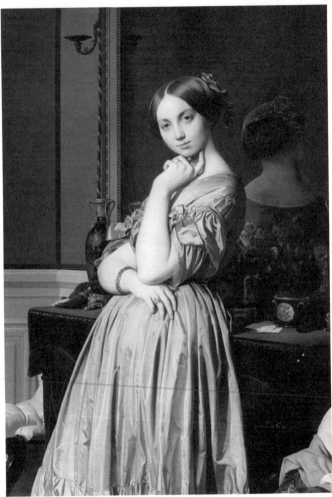

Jean-Auguste-Dominique Ingres *Comtesse d'Haussonville*, 1845

declared. "Nothing in this world is more difficult, it can't be done." For Ingres, the nineteenth century virtuoso of drawing and line, the illustration of classical mythology was the only true calling of an artist. His specialty was delineating material and flesh, and evoking noble emotions. He loathed portraiture, but decided to portray the former Louise, Princesse de Broglie, during a period when his grander commissions had dwindled. Begun in 1842, the portrait bedeviled him for nearly three years and was the product of numerous studies and much frustration.

Louise d'Haussonville had married Victor, the future

Comte d'Haussonville, at age eighteen. In her later memoirs, she describes herself as socially ambitious, innocent, icy, and beguiling. She published five books, which her husband required her to write anonymously, and among them was a biography on the Romantic poet Byron. Ingres portrayed Louise, who was then twenty-four, with a psychological immediacy that goes beyond his history painting. She was a woman and not a Greek goddess and ultimately that proved the greater inspiration.

Next is the West Gallery. Like other wealthy art collectors of his day, Henry Frick had his mansion designed to include a large picture room. This space looks like a museum gallery: it was meant to impress visitors in Frick's own day and still does today.

Among the paintings on the wall at left as you enter is **The Harbor of Dieppe** by J.M.W. Turner, painted in the 1820s, and farther along, **The White Horse** by John Constable, one of his first large-scale exhibit pictures painted in 1819. The two artists sum up opposite impulses in English Romanticism, Turner's passion and turbulence versus Constable's serenity and contentment. Turner, with his brilliant light that shocked most critics, is sometimes compared to the poet Byron in the forceful appeal to the senses. Constable was a painter of Wordsworth-like landscapes, contentment revealed in light and shadow. Turner traveled across Europe to paint exotic cityscapes and nature at its most transcendent. Constable took a trip to the Lake District in England, was upset by the breathtaking views, and returned to his home county of Suffolk where, in his words, he found his art "under every hedge."

Before seeing the rest of the West Gallery, you can take in the adjacent Enamel Room.

The Enamel Room takes its name from Henry Frick's collection of sixteenth and seventeenth century enamels from Limoges, France, and the display includes a lavish example of the craft by Jean de Court titled **The Adoration of the Shepherds.**

A number of splendid religious paintings in the museum are here, art that encapsulates a large swathe of the Christian epoch in a gallery that takes but a few paces to stroll around.

Among the paintings is **The Temptation of Christ on the Mountain** by the Sienese master Duccio di Buoninsegna (1255–1319), a panel that once belonged to a large altarpiece that was painted between 1308 and 1311. In the Gospel according to Matthew, Satan tempts Christ with "all the kingdoms of the world and their glory" if He will worship him. This is medieval art at its most vigorously didactic, a lesson of faith delivered with single-minded dramatic flair. The toy-like kingdoms at Christ's feet are there for the taking, but Christ banishes a seething devil who slinks off like a beaten animal.

In Duccio's medieval altarpiece the world is depicted simply, according to the demands of the religious message. A century later, the Flemish artists opened up their paintings to the visual splendor of the material world. **Virgin and Child, with Saints and Donor** was one of the final paintings of Jan van Eyck (active 1422–1441), possibly finished by the younger painter Petrus Christus. The kneeling donor who commissioned the altarpiece is a

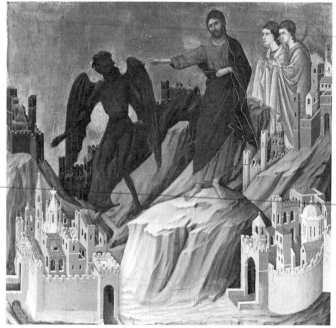

Duccio di Buoninsegna *The Temptation of Christ on the Mountain*, 1308–1311

monk named Jan Vos, prior of a Carthusian monastery near Bruges, who looks piously awed to find himself among such holy companions. Behind him is Saint Barbara, who was imprisoned in a tower that is represented in the middle distance. To the other side of the Virgin is Saint Elizabeth of Hungary, a queen who became a nun and gave up the crown she here holds. The jewel-like precision of this painting is meant as a reflection of God's greatness seen in the infinitely marvelous details of creation. The town in the distance is probably a fantasy, imagined by the artist stone by stone under a radiant Flemish sky.

While Van Eyck delighted in the look and feel of objects in this world, Piero della Francesca (1410/20–1492) took its measure and confirmed that everything God created fit precisely as it should. The Italian painter and mathematician was a pioneer of perspective in the early Renaissance. Piero's saint, painted on a panel and thought to be either **Peter** or **Simon the Apostle**, was once part of a larger altarpiece completed sometime in the 1450s or 1460s. The space the saint occupies is carefully defined, and his robes, raked by light, have the look of sculpture. He is a most solid saint, and his weathered face has a patient, even obdurate look which informs us that heaven may move him but nothing on this earth will.

Continuing in the West Gallery, you'll come to *The Polish Rider*, a picture that has bewitched generations of museum-goers at the Frick. No one knows exactly what the painting depicts. Scholars generally agree that Rembrandt painted it, but even that has been questioned in recent years.

The Polish Rider, painted in the mid-1650s and attributed to Rembrandt (1606–1669). The young rider, whoever he may be, is mounted upon a horse so cadaverous we are tempted to speculate how far the pair will go before the beast falls down. Yet the horse, and its master, are willing. The man sits nobly in the saddle, looking backward perhaps for a last glimpse of the setting sun. The horse moves with brute resolve, straining its scrawny neck. Horse and rider are depicted off-center in the painting, emphasizing the sense of forward motion into the gloom.

This is an allegory on the uncertainty of life's journey, that much seems certain. The rider's weapons and clothing

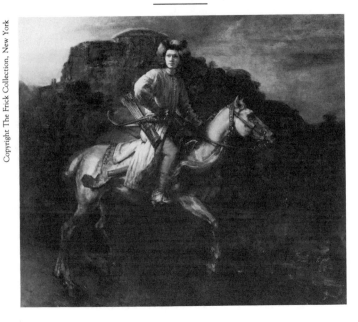

Rembrandt(?) *The Polish Rider*, ca. 1655

are Polish, although the title of the painting was given to it in the nineteenth century. Perhaps the costume is an exotic prop, and no specific meaning is intended. It's been suggested the rider is an ideal Christian soldier, off to fight the Turks. One recent theory is that Rembrandt saw a popular melodrama of the day in Amsterdam about a Mongol warrior who vanquished a Turkish despot. During the performance a horse was ridden on stage, a theatrical effect the artist may have imitated. In Holland during Rembrandt's time, artists who painted historical and literary themes were expected to show explicitly what their paintings were about. Part of the enduring popularity of this image in our own time is an ambiguity that would have been less readily accepted back then. We see the painting as neither heroic nor tragic, but instead as disturbingly equivocal.

Farther along is a **Self-Portrait** by Rembrandt, dated 1658, painted during the period of his financial collapse. The artist plays at dress-up in the costume of an Eastern monarch, but his face betrays the sadness of life. In his maturity, Rembrandt abandoned the slick smooth finish of his northern European contemporaries. He painted like a

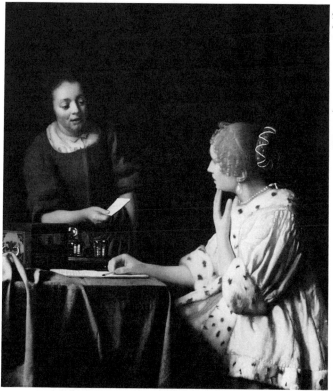

Johannes Vermeer *Mistress and Maid*, ca. 1665–70

sculptor, building up the image in loosely applied patches of pigment. The regal pose, the sheer bulk of his body, gives this self-portrait a sense of monumental nobility. One feels that Rembrandt is joking here, in a deadly serious way. Human pretense and role-playing are punctured by that proud but mournful face.

A wonderfully magical painting in this gallery is **Mistress and Maid** by Vermeer, from about 1665–70, a late work by the artist. Such details as the hands and fingernails of the mistress are incomplete, and possibly the background itself was meant to be filled in later. Something seems amiss in Vermeer's usually tranquil universe. A curious domestic drama is unfolding between the mistress and her servant. The mistress appears surprised as the maid, who seems to be speaking, gives her some communication whose contents we can only guess at. The incident might be utterly trivial, but in Vermeer's paintings the smallest

event becomes momentous. Vermeer captures the women in mid-gesture, arresting the transitory. The artist makes time stop: the scene is flooded with pearly light, as if he wanted to caress and preserve the moment even as it is passing.

An interesting contrast to Rembrandt's self-portrait in monarch's clothes is **Philip IV of Spain**, a portrait of an actual king outfitted in foppish splendor. The painter is Diego Rodriguez Velázquez (1599–1660), who did what a good court artist is paid to do: flatter his subject, but tell the truth. Philip IV was an inept king, if also a passionate patron of theater and art. His horsy jaw was the product of centuries of royal inbreeding, a hereditary mark of the Hapsburg dynasty. The gorgeously painted rose-and-white costume is historically accurate. Under Philip, Spain lost Portugal, and the Spanish treasury was wrecked, but he did defeat the French in 1644 in Catalonia. This portrait commemorates the victorious campaign and the fashionable outfit he wore during it.

Also in the West Gallery, at the entrance to the Oval Room, is **The Forge** by Francisco Goya (1746–1828). Goya had gone deaf in 1793, and this painting, done sometime between 1815 and 20, is characteristic of the vehemence and darkness of his later work. The artist depicts common laborers in an updating of a popular mythological subject in painting, Vulcan at his forge. Goya's brushwork is violent and slashing. The laborers themselves work with primitive energy, and unlike the gods of Olympus, they seem to sweat and grunt. The painting was an unusual acquisition for Henry Frick, capitalist magnate of metalworks, who shied away from depictions of the lower classes.

The Oval Room and East Gallery are part of the 1977 addition to the Frick mansion. The Oval Room contains paintings by James McNeill Whistler (1834–1903), including a portrait of **Robert, Comte de Montesquiou-Fezensac**, a preening French aristocrat who appeared as the fictional character Baron de Charlus in Proust's *Remembrance of Things Past*.

In the East Gallery is **Purification of the Temple** by El Greco, painted about 1600. This passionate little painting

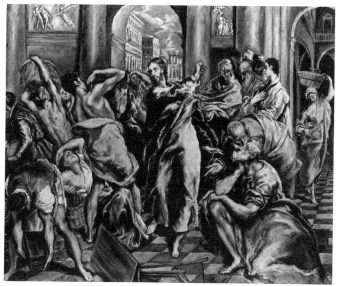

El Greco *Purification of the Temple*, ca. 1600

is all the more powerful for its compression of energy in a small space. Christ casts out the moneychangers, as innocent spectators watch in amazement. Everyone is touched by Christ's cold fury, as if by lightning. The scene from Matthew's gospel was a favorite of El Greco's, painted in numerous versions. Possibly he meant it as an emblem of the Counter Reformation and its purification of Catholicism, an image that would have pleased his Church patrons. The subject is also thumping good drama, which must have appealed to El Greco's sense of theatricality even as it takes us by storm today.

200 EASTERN PARKWAY
BROOKLYN, NY 11238
TELEPHONE: 718-638-5000

HOURS: *Daily, 10–5. Closed Tuesdays, Thanksgiving, December 25, and January 1.*

ADMISSION: *Suggested contribution of $3 for adults; $1.50 for students; $1 for senior citizens. Free to members and children under 12 accompanied by an adult.*

GETTING THERE: *By subway, train 2 or 3 to Eastern Parkway-Brooklyn Museum. By car from Manhattan, Manhattan Bridge to Flatbush Avenue; at Grand Army Plaza traffic circle, take Eastern Parkway. From Brooklyn Bridge, left onto Tillary Street, right onto Flatbush Avenue to Grand Army Plaza to Eastern Parkway. Parking at rear of building, $4.*

RESTAURANT: *Cafeteria at rear of first floor has lunch and snacks.*

GIFT SHOP: *Wide selection of ethnic handicrafts from around the world; jewelry, ceramics, glass, and paperworks by contemporary artisans. Separate children's shop has art supplies, crafts, toys, storybooks, and games from around the world.*

SPECIAL EVENTS: *Concerts, films, and lectures. Storytelling and art workshops for children. Consult museum newsletter.*

TOURS: *See newsletter or inquire at Information Desk about gallery talks.*

MEMBERSHIP: *$35 and up ($20 for students and seniors, $50 for family). Benefits include three parking passes, members' previews, newsletter, discounts at museum shops, lectures, travel programs and other special events for members, and use of library by appointment.*

LIBRARY: *By appointment only.*

THE BROOKLYN
MUSEUM

W HEN the cornerstone of the Brooklyn Museum was laid in 1895, Brooklyn was still a city rather than a borough, and its civic ambitions rivaled those of Manhattan. The initial mandate of the Brooklyn Museum was no less than to house under one roof all branches of human knowledge. As designed by McKim, Mead and White, the museum would have been the largest in the world. In fact, the Beaux-Arts structure that you see from Eastern Parkway is a monument to public idealism that faltered. Because of money problems, work stopped after the front section was completed in 1924, and the building as it stands is one-sixth of its intended size. The truncated back of the building, viewed from Brooklyn's Botanic Garden, has been aptly likened in appearance to a box factory.

If all goes well, the Brooklyn Museum will finally be finished on a more reasonable scale. A master plan calls for an addition in back designed by Japanese architect Arata Isozaki that would double the museum's size. Over the next two decades, the museum would also be renovated and a ceremonial front staircase that was unwisely demolished in the 1930s would be reinstalled. The hope is that the changes will help the Brooklyn Museum emerge from the shadows of the more famous art museums of Manhattan.

The museum's permanent collection, which is especially strong in Egyptian Art (third floor) and American Paintings (fifth floor), has been something of a secret to many native New Yorkers and tourists alike. If this is your first visit, you will be well served by beginning with these two collections.

When the museum was founded, Brooklyn was teeming with immigrants. The museum's exuberant if overzealous aim was to educate visitors through twenty-eight departments including art, electricity, engineering, housekeeping, literature, music, stamp collecting, and zoology. The focus soon began shifting to the fine arts, but one legacy of the early years is an anthropology collection that evolved into the current department of African, Oceanic, and New World Art (first floor). The galleries, just off the front lobby, are notable for displays of pre-Columbian gold and Native American art.

A Curator's Choice gallery, also off the front lobby, draws objects from the permanent collection in a series of temporary exhibits. Among the museum's other displays are Oriental and Islamic Art (second floor), eighteenth and nineteenth century Period Rooms (fourth floor), and Contemporary Art (fifth floor).

EGYPTIAN ART

BROOKLYN built its Egyptian collection upon the fortune of nineteenth century entrepreneur Charles Edwin Wilbour, who retired from his New York City printing business and went to Egypt as an amateur scholar. He sailed the Nile for fourteen years on his yacht *The Seven Hathors*, named after demigods of ancient Egypt. After the Metropolitan Museum turned down his mostly mediocre Egyptian artifacts, they ended up in Brooklyn in 1916 along with his vast scholarly library. The museum's great stroke of luck was the endowment bearing Wilbour's name. It was used to buy many of the objects in a collection that is now outstanding and ranges from prehistory to the Christian epoch.

From the third floor elevators, walk straight past the Greek, Roman, and Coptic Art Court. Turn left, then right, and enter the Egyptian galleries. To the far left as you enter the first gallery are objects from predynastic Egypt.

A **Bird Deity** from about 4000 B.C. has the head of a bird and the body of a woman. Its arms are raised, possibly in a gesture meant to protect the dead. This elegant and mysterious pottery figure and others like it come from tombs of early settlers along the Nile River. The exact function of these watchful bird goddesses is unknown, although it would seem that they express a concern for the afterlife that would be played out so elaborately in Egyptian life in the centuries to come.

Nearby is a prehistoric **Jar with Animal Decorations**,

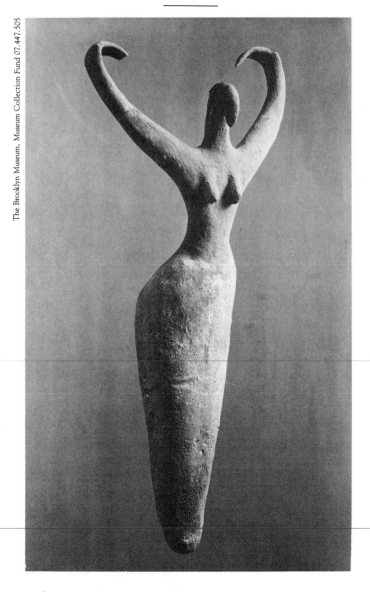

Bird Deity, ca. 4000 B.C.

from about 3200 B.C. The animals may be aardvarks or otters. The craftsman who painted them had a keen eye, if not a sense of humor, to have suggested the peculiar waddle of these creatures.

A **knife of a hunter**, from about 3100 B.C., was found in

the tomb of an unknown man. On its flint and ivory handle are animals all in a row, among them lions, sheep, dogs, jackals, and cattle. This vast miniature menagerie is carved with impressive precision and may represent some myth like our Noah's Ark story, now lost to us.

Reverse your direction and walk back toward this gallery's entrance. Old Kingdom objects are located within a three-walled space in the middle of the gallery.

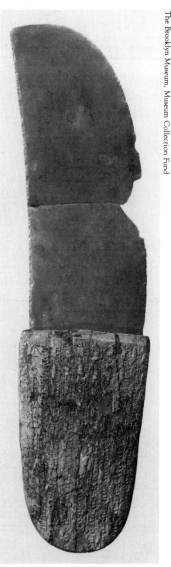

Knife of a Hunter, ca 3100 B.C.

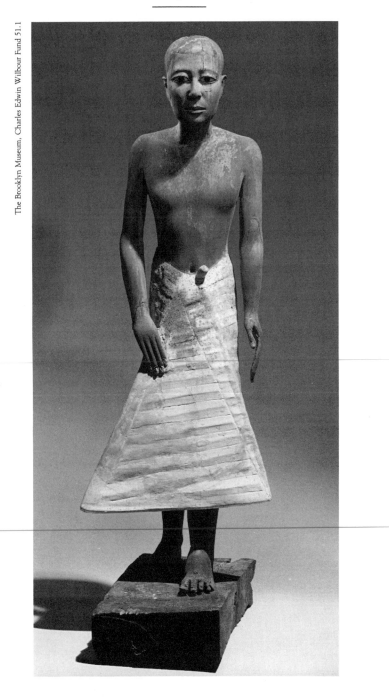

Methethy as a Mature Man, ca 2340 B.C.

Here you will find a wooden figure of the administrator **Methethy**, from about 2340 B.C. Methethy served a king named Unis as a sort of personnel manager, in charge of feeding, clothing, and looking after the tenants of the royal palace. The statuette, buried along with his body in his tomb, was made in Methethy's image so that his spirit would have a place to reside after death. Typically, early tomb portraits downplay individuality in favor of the idealized and unchangeable. This exceptional carving shows a lively, capable fellow who looks with deep concentration into a world beyond the grave that appears well within his grasp.

Continue walking in the same direction. Enter the small adjacent gallery, where you'll be confronted by a small black granite sculpture of **King Sesostris III** (ca. 1878–1843), a great soldier and ruler from the Middle Kingdom.

This temple statue, like two similar portraits of Sesostris (or Senwosret as the name is also translated) in the Metropolitan Museum, is unusual for its realism. Like other pharoahs, Sesostris was worshiped as a god. But the bags under his eyes, his distinctive downturned mouth, and his jug ears mark him as a man. The Brooklyn Museum's Sesostris is a no-nonsense strongman. The statue's feet crush nine bows, representing nine enemy tribes of Egypt. A startlingly graphic symbol of his power is his necklace, from which is suspended the scrotum of some unfortunate enemy.

Among the objects in the next large gallery, at the rear of the room, is art from the palace walls and temples of **Tell el Amarna** (the mid-1300s B.C.), the capital city of King Akhenaton. New York is especially rich in Amarna wall paintings and reliefs, and the Brooklyn Museum's collection parallels that of the Metropolitan Museum's Egyptian Collection.

Egyptian art may have flirted with naturalism before, but with the Amarna reliefs we see flesh and blood people, animals which seem to have leapt to life, and bountiful crops ripe for the plucking. Amarna art stands apart from the traditions of ancient Egypt, which emphasized the ideal, the permanent, and the monumental. The art of

6

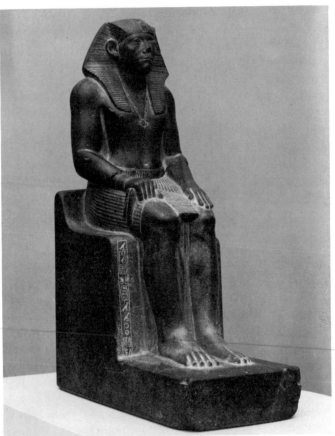

King Sesostris III, 1878–1843 B.C.

Amarna, by contrast, is intimate and fluid, and it depicts small moments and transitory events. Its inspiration was King Akhenaton, an elusive and eccentric personality in Egyptian history who established a cult to a sun god called Aton. The king was on friendly terms with his god, as seen in **Akhenaton and Daughter**, one of the reliefs in this gallery. Here Aton's beams are depicted as long arm-like rays ending in hands that tenderly caress the king and his child.

In other reliefs, the servants of Akhenaton gather wheat, feed cattle, and chase birds away from crops. A hunting scene records the flight of antelopes, one of which pricks its ears in fright. **Two Nubian Warriors**, enemy

soldiers from black Nubia south of Egypt, are so exhausted as they lean against each other that we feel they will drop in the very next moment. The reliefs from Amarna also offer a remarkably informal glimpse of the royal family. Queen Nefertiti coos over her daughter in one relief, and in another a nurse feeds one of the babies. A **sculptor's model of a royal couple** fascinates us today because it is a demonstration carving (the surface shows stray chisel marks) by a master sculptor that other court artists were meant to imitate. The carving may represent Akhenaton's young successor Tutankhamun and the boy king's wife.

Enter once again the first large gallery and turn to the right. The **Bust of a Nobleman**, a painted limestone relief from about 1250–1200 B.C., is from the Ramesside period that followed Akhenaton's regime at Amarna. After Akhenaton's death, his cult was abolished and his city demolished. Even so, artists within a generation or so of the Amarna period continued to produce images of persuasive naturalism as in this fragmentary relief of a high official. The pleated wig of this gentleman, a testament to upperclass vanity, is rendered with a superb feeling for light and shadow. The subtle illusion of volume is exceptional in ancient Egyptian art.

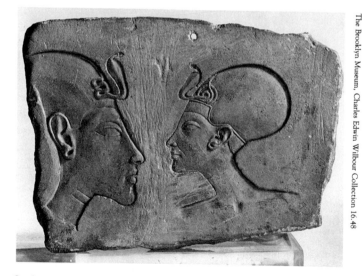

Sculptor's Model of a Royal Couple, ca. mid-1300s B.C.

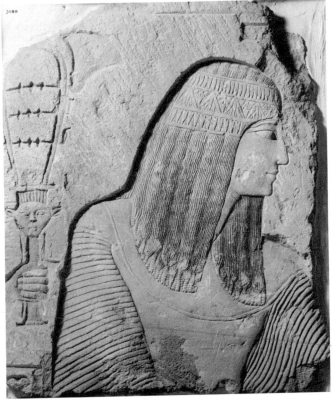

Bust of a Nobleman, ca. 1250–1200 B.C.

Nearby is a fragment of pottery from about 1300–1250 B.C., on which is painted a **Cat and Mouse**. In a role reversal, a cat plays servant to a mouse. The cat waves a fan and serves up a goose, and the lordly mouse holds a bowl and flower. The artist who sketched the scene apparently did so for his own pleasure, or to amuse some patron, rather than for a formal commission. So what we have here is unofficial ancient Egypt, improvised and off-the-cuff. The scene may belong to some lost ancient tales like our Aesop's fables. On the visual evidence, it is proof positive that the early Egyptians knew how to joke.

Art of the late period of ancient Egypt, from the eighth century B.C. to the Christian era, is in the third large gallery whose entrance is located beyond the predynastic

art. (This gallery is scheduled for renovation beginning in 1989, and its objects will probably be relocated in the Court gallery.)

School children, and adults too, are drawn to the **Reliefs from the Tomb of Nespequahuty,** carved about 664–610 B.C. Nespequahuty was an official in southern Egypt, who is shown traveling by boat to Abydos, the city of Osiris, god of the dead. Also depicted are offerings of food and drink, intended for Nespequahuty's enjoyment in the afterlife. What piques our curiosity is that these ancient reliefs are a "work-in-progress": one area was left unfinished, with sketches in paint that were meant as guidelines for sculpting. Another point of interest is the graffiti left by ancient Egyptians and Greek travelers who wanted the world to know they had played tourist.

Several portraits in this gallery span the end of Egyptian dynastic rule and the coming of Greek and Roman conquerors. **Wesir-wer's Head,** carved from hard green stone, is a small and extraordinarily vivid likeness of the chief priest at Thebes in about 360 B.C. The style is purely Egyptian, fashioned three decades before Greek rule. **Alexander the Great** conquered Egypt in 332 B.C. and is represented here by a small bust from two centuries later. The bust makes Alexander look like a mythic hero, which is how many people throughout the ancient world viewed

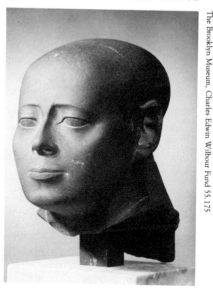

Wesir-Wer's Head,
ca. 360 B.C.

him in the centuries after his death. The so-called **Brook-lyn Black Head**, a large portrait made of black diorite from the first century B.C., was apparently done by an Egyptian artist to flatter some foreign conqueror. The identity of the man is uncertain, although it may be the Roman emperor Julius Caesar.

The gallery also contains a limestone carving titled **The Brooklyn Symplegma**, erotic art made in about 305–30 B.C. This unblushing depiction of group sex was probably meant for private viewing in the home of an upper-class Egyptian.

To conclude the tour, go to the Court gallery with its Greek, Roman, and Coptic art. The Copts were Egyptian Christians, and the Coptic craftsman who carved a **Wom-an with Cross** (4th century A.D.) has left us with a graphic symbol of a new age. The limestone figure portrays a be-liever, grasping a cross, her eyes wide with faith.

AMERICAN ART

THE Brooklyn Museum's American collection is known for its eighteenth century portraits, its scenes of daily life in the nineteenth century, and its landscape paintings. The galleries are located on the fifth floor, to the right as you get off the elevator.

Two portraits of **George Washington** await you in the first gallery. Charles Wilson Peale (1741–1827) painted Washington in 1776, when the hero of the Revolution was forty-four years old. Peale had studied art in London before the war, and here he gives Washington the conventional pose of British military portraiture.

The Washington painted by Gilbert Stuart (1755–1828) is the father of America. As historian James Flexner put it, "Should Washington return to earth today, if he did not look like Stuart's portraits many would regard him as an impostor." Washington hated sitting for portraits and cared very little for Stuart because of the artist's effusive personality. According to contemporary accounts, Stuart's nose was red from alcohol, he dressed carelessly, overindulged in snuff, and was in the habit of laughing too loudly at his own jokes. Stuart was an American who had lived in England and Ireland for much of his career and was in constant debt from high living. He returned to America in 1793 hoping to paint Washington and thereby strike it rich. When he was granted a series of sittings, he was appalled by the awkward physical appearance of his subject. Washington's poorly fitted false teeth misshaped his lower face, his shoulders were narrow, his hands unusually

large. Trained as a face painter, Stuart disliked doing full-length portraits, yet Washington's tremendous popularity required that he show the first president in the pose of a grandiose orator. The Brooklyn Museum's full-length portrait from 1796 is one of several replicas Stuart painted from his own original. So great was the demand for the first president's image that Stuart also turned out at least seventy replicas of Washington's face, portraits which the artist dubbed his "hundred dollar bills." Through Stuart's eye, George Washington became the sphinx-like immortal that we know today.

Among the colonial portraits in this gallery is **Deborah Hall**, painted in 1766 by British painter William Williams. The young woman, dressed in the finest London fashion and stiffly posed next to a pot of roses, was the daughter of David Hall, who owned a printing business in Philadelphia with Benjamin Franklin. Williams had a second career as a set designer, and the theatrical backdrop of this portrait adds to its charm and innocence.

In the next gallery, transcendent innocence is the theme of **The Peaceable Kingdom** by Edward Hicks (1780–1849), the Pennsylvania-born Quaker preacher who today is the most beloved nineteenth century folk artist. Hicks painted at least sixty versions of the pacifist message, taken from Isaiah XI in the Bible, predicting that wild and tame beasts shall dwell together "and a little child shall lead them." The Brooklyn Museum's version was painted about 1840–45. The eyes of the lion and leopard glow fiercely, but these cats are mild as house pets. In the background, William Penn, the Quaker leader, makes peace with the Delaware Indians.

In the next gallery is **Winter Scene in Brooklyn**, painted about 1817–20 by Francis Guy (1760–1820), one of the earliest scenes of everyday life in American art. This is the view Guy saw from his window of Front Street in Brooklyn. The artist variously depicts his neighbors cutting wood and shoveling coal, feeding chickens, gossiping, and slipping on the ice. In **Shooting for the Beef**, painted in 1850 by George Caleb Bingham (1811–1879), frontiersmen

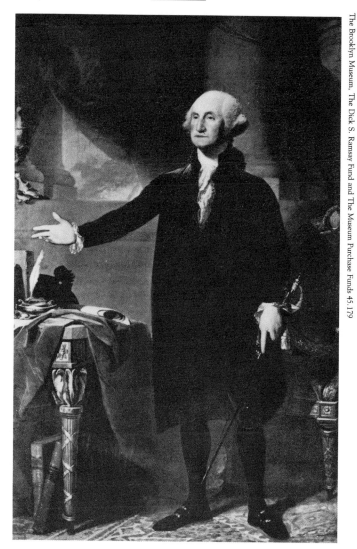

Gilbert Stuart *George Washington*, 1796

show off their prowess in a rifle contest. The Missouri-bred Bingham was a sure hand at storytelling and a skilled stylist whose specialty was capturing the effects of light and shadow.

In the next gallery, **The Republican Court** by Daniel Huntington (1816–1906) is not a great painting, but it does make fascinating social history. Like a Hollywood B-movie from our own century, this large-scale patriotic

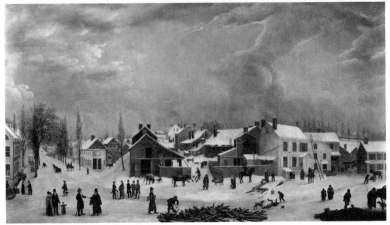

Francis Guy *Winter Scene in Brooklyn*, ca. 1817–20

painting demonstrates the timeless taste for costume melo-
drama. It was done in 1861, to glorify America's founding,
at a time when the Civil War was tearing the nation apart.
Martha Washington is pictured throwing one of her fa-
mous parties, in the bizarre imaginary setting of a cavern-
ous palace. The hobnobbing throng is a who's who of the
early republic, an American aristocracy that includes
Alexander Hamilton, Thomas Jefferson, and George
Washington. The artist undoubtedly copied Washington's
face from a portrait by Gilbert Stuart or one of the many
imitators of Stuart.

Also in this gallery are paintings by Fitz Hugh Lane
(1804–1861). **Off Mount Desert Island** (1856) is a lumi-
nous view of the Maine coast that shows nature at its most
safe and serene.

For a contrasting view of nature, all you need do is peer
into the next gallery at Bierstadt's thunderous epic paint-
ing of the Rockies.

A Storm in the Rocky Mountains was painted in 1866
by the German-born Albert Bierstadt (1830–1902) follow-
ing a trip to Mount Rosalie west of Denver. The distant
cloud-wreathed mountain is impossibly out of perspective,
depicted by the artist thousands of feet higher than its
actual position. One feels that the Creator may momentar-

ily appear from behind the peak. Such giddy awe at the vast, untamed West made Bierstadt popular with the East Coast public who saw his canvasses on exhibition and prints of his scenes in reproduction. What God wrought, Bierstadt improved upon with lavish detail and operatic scale.

Also in this gallery is **South American Landscape** (1873) by Frederic Edwin Church (1826–1900), another romanticizer of the New World. The scene is probably of the Santa Isabel valley in Colombia. Church's teacher was Thomas Cole (1801–1848), founder of the Hudson River School, whose 1846 painting of **The Pic-Nic** is a sweet American idyll.

Two portraits of ladies in black gowns stand in perfect contrast. In the next gallery is **Jane, Lady Huntington** (1898) by John Singer Sargent, the American expatriate who made his mark in England and France with society portraits of great surface flair. This female aristocrat is seen exactly as she would want to be, as confident, stylish, and unassailable. In the gallery that follows is **Letitia Bacon** (1888) by Thomas Eakins, the uncompromising American from Philadelphia. Letitia Bacon was the sister of an artist friend of Eakins. Here she is lost in thought. Or perhaps just lost. Her drooping party dress only increases our sense of this portrait as a psychological study that unmasks its subject.

1071 FIFTH AVENUE (AT 89TH STREET)
NEW YORK, NY 10128
TELEPHONE: 212-360-3500

HOURS: *Tuesdays, 11–7:45; Wednesdays–Sundays and holidays, 11–4:45. Free on Tuesdays, 5–7:45. Closed Mondays except holidays. The museum is open on most holidays. Call 360-3513 prior to holiday to confirm.*

ADMISSION: *$4 for adults, $2 for students and senior citizens. Free for members and children under 7.*

GETTING THERE: *By bus, southbound on Fifth Avenue or northbound on Madison Avenue. By subway, Lexington Avenue train 4, 5, or 6 to 86th Street.*

CAFE: *Lunch and afternoon snacks, wine, and beer.*

GIFT SHOP: *Museum publications, postcards, posters, note cards, jewelry, mobiles, designer office supplies.*

SPECIAL EVENTS: *Recorded information on current exhibits, lectures and special events, 360-3513. On weekends call 360-3525.*

TOURS: *Recorded tours for special exhibits can be rented near Rotunda elevator. Guided tours only for groups of adults by arrangement, 360-3558.*

MEMBERSHIP: *$35 and up. Benefits include free exhibit catalog, museum calendar, and discounts at bookstore.*

THE SOLOMON R. GUGGENHEIM MUSEUM

"**Y**OU may go into this building to see Kandinsky [but] you remain to see Frank Lloyd Wright," wrote cultural historian Lewis Mumford not long after the opening of the Guggenheim Museum on Fifth Avenue in 1959. Frank Lloyd Wright's spiral-shaped design was born in controversy, and to some observers it remains the ultimate example of how architecture can overwhelm the display of art. Wright and Hilla Rebay, the museum's first director, intended the design as a "dome of the spirit." Today many visitors are beguiled, if not by the building's spiritualism, then because its interior resembles an enormous abstract sculpture. Descending the gradually sloping ramp, where special exhibits are displayed on the ramp itself and in galleries off it, is a mild exercise in vertigo and an event of odd ceremony.

The founding of the Guggenheim is steeped in melodrama. In the late 1920s, Hilla Rebay von Ehrenwiesen became an advisor to Solomon R. Guggenheim, whose fortune came from Colorado copper and silver mines, and began amassing an art collection for him. Rebay, a painter and a German baroness, championed abstract art with religious fervor. She believed that Wassily Kandinsky, and other pioneer "non-objective" painters, were divinely in-

spired and spoke "the language of eternity." Besides Kandinskys, she also bought scores of paintings (now in storage) by her one-time lover Rudolf Bauer. She considered Picasso a heretic for having backtracked from non-objectivity after flirting with it in his Cubist phase but bought his paintings anyway by way of historical footnote.

The Museum of Non-Objective Painting, Rebay's original name for the Guggenheim, opened in 1939 at 24 East 54th Street. Wright was commissioned to design the present museum in 1943. It took sixteen years to get it built. During that time Solomon Guggenheim died, Rebay and Wright argued, and the project floundered in a dispute with New York City over building codes. In 1952, Rebay was forced by museum trustees to resign. When the Guggenheim finally opened at Fifth Avenue the administration had dropped its narrow ideological view of modernism. In the decades since, the collection has expanded into most corners of the twentieth century, although its nucleus remains the modernist pioneers.

The museum plans to construct a ten-story addition to its building, which may be completed within the next few years. Until then, only a small part of the permanent collection is on display in galleries off the second and fourth ramps. A natural starting place is the Thannhauser collection, which you enter from the second ramp.

The Justin K. Thannhauser Wing displays a collection within the collection. As an art dealer in Munich, Paris, and New York in the first half of this century, Thannhauser was in on the birth of modern art. He lent his private collection to the Guggenheim in 1965, and at his death in 1978 the collection went to the museum with the provision that it be shown all together. The Thannhauser collection is strong in Impressionist and Post-Impressionist art, including works by Cézanne, Gauguin, Toulouse-Lautrec, and Degas, and also the art of Picasso. **The Hermitage at Pontoise**, painted in about 1867 by Camille Pissarro (1830–1903) is actually pre-Impressionist, coming some seven years before the first group show which launched the movement. Here Pissarro, already in his late thirties, demonstrates a polished handling of light and space in a style influenced by Corot. **Mountains at Saint-**

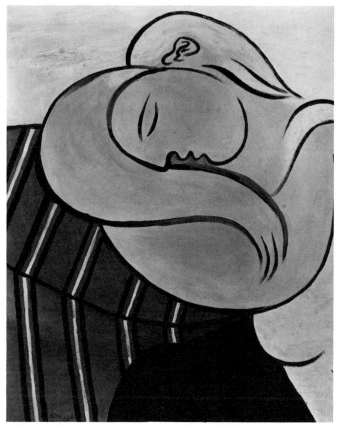

Pablo Picasso *Woman with Yellow Hair*, 1931

Rémy was done by Vincent van Gogh (1853–1890) in July, 1889, within about a month of his *The Starry Night*, which is in the Museum of Modern Art. Van Gogh could see these small, craggy mountains from the hospital at Saint-Rémy, where he had admitted himself after a mental seizure. The brushwork is swirling and ecstatic. The artist paints not merely what he sees but what he feels, and his vision of pulsating nature comes across with elemental power. **Woman with Yellow Hair** (1931) by Pablo Picasso (1881–1973) is a yellow-upon-lavender evocation of sleep and dreams. The artist's blonde model and mistress Marie-Thérèse Walter is pictured asleep. Years later she commented that when she posed for Picasso he would instruct

213

her, "Don't laugh, close your eyes." Picasso fell under the spell of Surrealism during this period, yet this painting eludes simple classification. As Shakespeare's Puck conjured up fantasy from the night, Picasso seems to have fashioned this langorous image of love and beauty from thin air.

The Guggenheim's pioneers of modernism are located off the fourth ramp. The works displayed are subject to change, but the following are some of the highlights you are likely to encounter.

Among the collection's early paintings is **The Football Players** (1908) by Henri Rousseau (1844–1910) in which rugby players bounce about with the gentlemanly aplomb of ballet dancers.

In **Man with Crossed Arms** (1899) by Paul Cézanne (1839–1906), the anonymous sitter looks at first glance solid as a mountain, undeniably fixed in pictorial space. Yet instead of traditional modeling by gradated light and shadow, Cézanne has built up form by using patches of color, broken brushstrokes, and flat planes. The searching gaze of the man in the portrait is a kind of equivalent to Cézanne's own questioning attitude toward visual reality, his adventurous and ambiguous way of seeing.

The Cubists saw the world as relative and changeable, not absolute and fixed. **Accordionist** by Pablo Picasso is from summer, 1911 (the same date as the Museum of Modern Art's *Man With A Guitar*, painted by Georges Bracque who pioneered Cubism with Picasso). The musician in the portrait is seen (or rather glimpsed) from multiple viewpoints, as the artist saw him over time or in his memory. Traditional pictorial space is here broken apart and reconstructed. Thanks to Cubism, the process of making art became in itself a subject of art. Russian-born Alexander Archipenko (1887–1964) was one of many artists liberated by the revolution of Cubism. **Medrano**, a bewitching sculpture from 1913, refers by its title to the name of a circus in Paris. The figure is a dancer, and the artist has used geometry (and considerable whimsy) to capture the movement of her body. Cubism helped Marc Chagall (1887–1985) to anchor his fantasies by giving them structure. In **Paris Through the Window** (1913) the fantasy (a

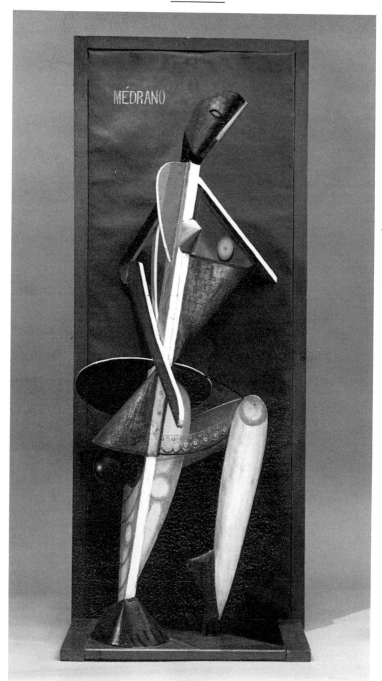

Alexander Archipenko *Medrano II*, 1913

parachutist in mid-plunge near the Eiffel Tower, a cat with a human face, a two-faced man) is no more literal in its meaning than a tipsy sort of dream. Chagall arrived in Paris from Russia in 1910. This is a fabulous homage to the City of Light.

The Guggenheim collection includes a cache of Klees and Mirós. **Landscape (The Hare)** (1927) by Joan Miró (1893–1983), is a surreal hallucination which the artist has said he painted after he saw a hare dash across a field at sunset. In the painting, the animal appears mesmerized by an apparition that may be the sun or a streaking comet. In **Dance You Monster to My Soft Song!** (1922) by Paul Klee (1879–1940), a small child-like figure calls the tune for a bloated monster, and we as museum-goers can only applaud this bright, comic scene of fear cut down to size.

At the Guggenheim, you can follow the odyssey of Wassily Kandinsky (1866–1944) to a purely abstract art, beginning with the idyllic and clearly representative **Landscape**

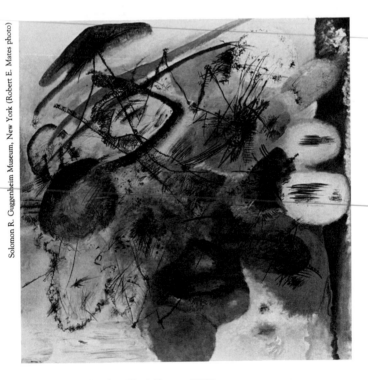

Wassily Kandinsky *Black Lines*, 1913

at Murnau with Locomotive from 1909. Kandinsky wanted his art to express a spirituality he believed lay behind the world of objects, but feared his own art might be interpreted as merely decorative. For this reason, he clung to the remnants of images even as he was letting go of literal meaning altogether. In **Sketch for "Composition II"**, a painting from 1909–10, you can discern human figures, a horse and rider at center and what may be a drowning person at lower left. **Black Lines** (1913) is entirely abstract. We can only guess at the spiritual meaning Kandinsky intended, although it may help to know the artist wanted to evoke an "inner sound," a visual equivalent of music, from line and color. In this painting, the "sound" produced by black lines and by puffs of bright red, orange, green, and blue is so exuberant it can barely be contained within the borders of the canvas.

945 MADISON AVENUE (AT 75TH STREET)
NEW YORK, NY 10021
TELEPHONE: 212-570-3600

HOURS: *Tuesdays, 1–8; Wednesdays–Saturdays, 11–5; Sundays, 12–6. Closed Mondays and national holidays.*

ADMISSION: *$4 for adults; $2 for senior citizens; free on Tuesdays after 6; free for members, children under 12 when accompanied by adult, and college students with ID.*

GETTING THERE: *By subway, Lexington Avenue train 6 to 77th Street. By bus, Fifth Avenue downtown or Madison Avenue uptown.*

RESTAURANT: *Lunch and Tuesday evening supper, cocktails. Service in sculpture court in summer.*

SALES DESK: *Books, museum catalogs, posters, postcards, slides, note cards.*

SPECIAL EVENTS: *Recorded information on special exhibits, 570-3676. For schedule of film and video (included in admissions fee), call 570-0537.*

TOURS: *Tours of the permanent collection, located on the third floor. Tuesdays, 1:30, 3:30, 6:15. Wednesdays–Fridays, 1:30, 3:30. Weekends, 2, 3:30. For information on group tours of special exhibits, call 570-3652.*

MEMBERSHIP: *$50 and up annually. Benefits include invitations to members' receptions for two special exhibits, museum bulletin, calendar, discounts on art publications. Call 570-3641.*

WHITNEY AT PHILIP MORRIS: *Park Avenue at 42nd Street (878-2550); Mondays–Saturdays, 11–6; Thursday evenings until 7:30. Sculpture garden hours are Mondays–Saturdays 7:30 a.m. to 9:30 p.m.; Sundays 11–7. Free admission.*

WHITNEY AT EQUITABLE: *Seventh Avenue between 51st and 52nd Streets (554-1113); Mondays–Fridays, 11–6; Thursdays to 7:30; Saturdays, 12–5. Free admission.*

12WHITNEY DOWNTOWN AT FEDERAL RESERVE PLAZA: *33 Maiden Lane at Nassau Street; Mondays–Fridays, 11–6. Free admission.*

THE WHITNEY
MUSEUM OF
AMERICAN ART

GERTRUDE Vanderbilt Whitney, a woman of immense inherited wealth, found the lure of bohemia irresistible. She was the great-granddaughter of shipping and railroad tycoon Cornelius Vanderbilt and wife of Harry Payne Whitney, whose fortune came from oil and streetcars. A great patron of American artists, she was herself a competent sculptor who met and was influenced by Auguste Rodin. During World War I, she opened up her Greenwich Village studio to artists as a salon in the French tradition. The Whitney Studio Club, which she formed in 1918, showed such artists as Edward Hopper, Charles Sheeler, Reginald Marsh, John Sloan, William Glackens, and Stuart Davis.

In 1929, the Metropolitan Museum rejected Whitney's offer of her American art collection, and as a response to this snub she founded her own museum one year later. After moving twice, the Whitney Museum settled in its present building, designed by Marcel Breuer, in 1966. Since then, the Whitney has opened several branches. True to its origins in the Studio Club, the Whitney remains the leading salon of contemporary American art in its changing exhibits.

It also owns the most comprehensive collection of twentieth century American art. A small sampling of the permanent collection, some seventy objects, is always on view in the third floor galleries.

On the ground floor, **Calder's Circus** provides a robust welcome for the visitor. The American artist Alexander Calder (1898–1976), who was trained as an engineer, began to construct this miniature circus in Paris in the 1920s. He used little more than rags and wire and a lot of humor. He added to the cast of characters over the years and played ringmaster in performances for friends and chosen audiences both in France and this country. Supplementing the display of the *Circus* is a 20-minute video of Calder performing it. (The video runs at 11:30, 1:30, 3:30, 5:30 and 7:30.) Looking like a beardless Santa, Calder manipulates a tiny strongman, a sword swallower, a belly dancer, a lion, and a trapeze artist who flips in midair and effortlessly locks arms with a partner. Anything seems possible in Calder's *Circus*, most notably the proposition that life itself is child's play. If you catch even a hint of this playful spirit, you'll understand his later sculpture, including the airy mobiles that were his invention. A number of Calder's later works are on the third floor, and disparate in form though they may be, they are also of a piece. Great artists create their own self-defining universes, and Calder's universe is a friendly and reassuring place.

Georgia O'Keeffe *The White Calico Flower*, 1931

Edward Hopper *Early Sunday Morning,* 1930

The art in the third floor galleries is arranged both chronologically and by style, beginning with the 1916 portrait of **Gertrude Vanderbilt Whitney** by Robert Henri (1865–1929), a leading American artist in the rebellion against the dominance of European art.

What could be more American than the fascination with industry? In **River Rouge Plant** (1932) by Charles Sheeler (1883–1965), a Ford assembly line factory is glorified as a modern cathedral, the Depression notwithstanding. Slick and precise as the new technology it celebrates, the painting was based on photographs by Sheeler. In contrast with Sheeler's purposely impersonal and unemotional art, **The White Calico Flower** (1931) by Georgia O'Keeffe (1887–1986) is deeply meditative, a celebration of the richness in simple things. O'Keeffe looked closely and with great care at this artificial flower of calico. She has painted it as her mind saw it, in close focus, and in a large scale that emphasizes feeling. The result brings to mind the poet William Blake's poem about seeing heaven in a wild flower and holding eternity in an hour.

No painter before Edward Hopper (1882–1967) had quite noticed the loneliness of a Cape Cod house in sunlight, or of Manhattan architecture in the early morning. In **Early Sunday Morning** (1930), a row of Seventh Avenue storefronts and apartments looks like a bare theater set, although we can feel the presence of the apartment dwellers offstage. The light upon the building is cool, hard,

factual. Hopper began his career, as many American artists in the early part of this century did, as an illustrator. His style is like that of a narrator who tells a story by leaving much unsaid. When we see Hopper's laconic, deceptively straightforward art, we seem to hear a deep silence. George Bellows (1882–1925) was another sort of American narrator, gregarious and chatty, cheerfully two-fisted in his 1924 painting of the **Dempsey and Firpo** heavyweight bout. Bellows (who appears at far left in the painting) covered the famous fight for the New York *Evening Journal*. Dempsey was knocked through the ropes by Firpo in the first round but came back to knock out Firpo in the next. "I don't know anything about boxing," Bellows once said. "I'm just painting two men trying to kill each other."

Until the middle of this century, Europe had dominated modern art. Then came the swashbuckling Abstract Expressionists, wearing their over-lifesized emotions on their sleeves, expressing feeling by the *act* of painting. Action Painting, as it became known, can be neatly summed up in historian Leo Steinberg's phrase, "all nouns held in abeyance." **Door to the River** (1960) by Dutch-born Willem de Kooning (born 1904) is a controlled explosion produced by an artist who relishes the speed and movement of his brush. Several nouns can be identified in this picture, swiftly described: a blue river at left, a doorway, and bright yellow sunlight. Jackson Pollock (1912–56) discarded brushwork altogether and instead flung paint directly onto canvas, an improvisational technique he had mastered by the late 1940s. Commentators often note the aggression of the act. Yet in Pollock's **Number 27 (1950)** with its decorative pattern of greens and yellows, what comes through is its lyricism. This is a small painting, compared to the enormous Pollock canvases in the Museum of Modern Art and the Metropolitan, and a sweet painting at that.

Among the sculpture in the Whitney's permanent collection is **The Brass Family** (1927) by Alexander Calder, a witty portrait in brass wire of circus acrobats. The galleries will likely always have on view sculpture by David Smith (1906–1965) and Louise Nevelson (born 1900), even though the particular works may change. In Smith's Cubi series, the artist burnishes the surface of stainless steel with

Jasper Johns *Three Flags*, 1958

a turbulent motion that emulates Abstract Expressionist painting. Nevelson places pieces of scrap wood inside boxes, the boxes themselves forming wall-like constructions that have been aptly compared to altars. Light and shadow is important in a Nevelson sculpture, as is an indefinable sense of religious hush, as if the artist's mysterious assemblages come to us from some lost civilization.

Three Flags (1958) by Jasper Johns (born 1930) is perhaps the Whitney's best known image of modernism. It is many-dimensional, quite literally, for the three representations of American flags pop out at the viewer in three-dimensional rectangles of canvas. The object, not quite a painting, and not quite a sculpture, presents the familiar icon of a flag but subverts its meaning. The stars and stripes are a kind of interesting aesthetic exercise: this is an art object that comments ironically upon art. In its amiable, ambiguous way *Three Flags* is a precursor to Pop Art. Whatever pleasure the museum-goer gets from knowing its pivotal place in art history, the more immediate delight as you stand in the gallery is to look closely at the surface of *Three Flags*. The meticulous, even sensual, brushwork is its own reward.

In the collision of mass culture and high art, Pop Art was born. **Little Big Painting** (1965) by Roy Lichtenstein

(born 1923) is a Pop lampoon of Abstract Expressionism, mimicking its great slurping brushstrokes. Lichtenstein's benday dot technique is borrowed from comic-strip and commercial art, and the smooth surface of the painting suits his cool, detached wit. The seriousness and passion of one generation has yielded to the knowing laughter of the next, making *Little Big Painting* a fitting punctuation to the Whitney's third floor galleries.

SOURCES

GENERAL

Art in America.

ARTnews.

Atlantic Brief Lives. Louis Kronenberger, ed. Boston: Little, Brown, 1971.

History of Art. H.W. Janson. New York: Abrams, 1977.

Lives of the Painters. John Canaday. New York: Norton, 1969.

Looking at Pictures. Kenneth Clark. New York: Holt, Rinehart and Winston, 1960.

Merchants and Masterpieces. Calvin Tomkins. New York: E.P. Dutton, 1970.

The Museum Age. Germain Bazin. New York: Universe Books, 1967.

The New Yorker.

The New York Times.

The Oxford Companion to Art. Harry Osborn, ed. London: Clarendon Press, 1970.

Palaces for the People. Nathaniel Burt. Boston: Little, Brown, 1977.

Phaedon Encyclopedia of Art and Artists. New York: E.P. Dutton, 1978.

The Romantic Rebellion. Kenneth Clark. New York: Harper & Row, 1973.

Signs and Symbols in Christian Art. George Wells Ferguson. New York: Oxford University Press, 1954.

The State of the Art. Arthur C. Danto. New York: Prentice Hall Press, 1987.

Traveler's Guide to America's Art. Jane and Theodore Norman. New York: Meredith Press, 1968.

The Visual Arts: A History. Hugh Honour and John Fleming. Englewood Cliffs: Prentice-Hall, 1982.

THE METROPOLITAN MUSEUM

American Paintings: A Catalogue of the Collection of the Metropolitan Museum of Art. Vol. 1 and 2.

The American Wing at the Metropolitan Museum of Art. Marshall B. Davidson and Elizabeth Stillinger. New York: Knopf, 1985.

The Ancient Near East. William Hallo and William Kelly Simpson. New York: Harcourt Brace Jovanovich, 1971.

Art of Pre-Columbian Gold. Julie Jones. New York: Metropolitan Museum of Art, 1985.

Audioguide cassette recordings narrated by Philippe de Montebello and Metropolitan Museum curators. Acoustiguide Corporation.

Book of the Courtier. Baldesar Castiglione. Translated by Charles S. Singleton. Garden City: Doubleday, 1959.

Classical Sculpture. George M.A. Hanfmann. Greenwich: New York Graphic Society, 1967.

The Climax of Rome: The Final Achievements of the Ancient World. Michael Grant. Boston: Little, Brown, 1968.

The Decline and Fall of the Western Empire. Edward Gibbon. New York: Republished by Dutton, 1974.

El Greco of Toledo. Jonathan Brown et al. Boston: Little, Brown, 1982.

European Vision and the South Pacific. Bernard Smith. New Haven: Yale University Press, 1985.

Greek and Roman Art. Dietrich von Bothmer. New York: Metropolitan Museum of Art, 1964.

The History of Impressionism. John Rewald. New York: Museum of Modern Art, 1973.

Inquisition and Society in Spain. Henry Kamen. Bloomington: Indiana University Press, 1985.

Jackson Pollock. E. Frank. New York: Abbeville Press, 1983.

Jackson Pollock. Francis V. O'Connor. New York: Museum of Modern Art, 1967.

Jackson Pollock. Deborah Solomon. New York: Simon & Shuster, 1987.

The Metropolitan Museum of Art Bulletin. Vols. 25–44.

The Metropolitan Museum of Art. Howard Hibbard. New York: Harper and Row, 1980.

The Metropolitan Museum of Art. Carlo Ludovico Ragghianti, ed. New York: Newsweek, Inc., 1978.

The Metropolitan Museum of Art Guide. Works of art selected by Philippe de Montebello, director. New York: Metropolitan Museum of Art, 1985.

Northern Renaissance Art. James Snyder. New York: Abrams, 1985.

Painting: 1905–1945 and 1945–1985. Selections from the Collection of The Metropolitan Museum of Art. William S. Lieberman et al. New York: Metropolitan Museum of Art, 1986.

'Primitivism' in 20th Century Art. William Rubin, ed. Boston: New York Graphic Society, 1984.

Recent Acquisitions. New York: Metropolitan Museum of Art, 1986.

Rembrandt: His Life, His Paintings. Gary Schwartz. New York: Viking, 1986.

Rembrandt: Life and Work. Jakob Rosenberg. Greenwich: New York Graphic Society, 1964.

Renoir. John House et al. London: Exhibit catalog published by the Arts Council of Great Britain, 1985.

The Robert Lehman Collection: A Guide. George Szabo. New York: Metropolitan Museum of Art, 1975.

Romans and Barbarians. Department of Classical ¿iNk School. Exhibit catalogue, Los Angeles: County Museum of Art, 1965.

Pablo Picasso. Hans Jaffe. New York: Abrams, 1987.

Picasso: Fifty Years of His Art. Alfred H. Barr, Jr. New York: Museum of Modern Art, 1946.

Picasso in the Collection of the Museum of Modern Art. William Rubin. New York: Museum of Modern Art, 1971.

Piet Mondrian: Centennial Exhibit. New York: Solomon R. Guggenheim Foundation, 1971. | Y⁶

Piet Mondrian: Life and Work. Michel Seuphor. London: Thames and Hudson, 1956.

Rodin. Albert E. Elsen. Garden City: Doubleday, 1963.

The Shock of the New. Robert Hughes. New York: Abrams, 1981.

The Skies of Vincent van Gogh. Charles R. Whitney. Reprint in *Art History*, Vol. 9, 1986.

Van Gogh: A Self-Portrait. W.H. Auden, ed. Greenwich: New York Graphic Society, 1961.

OTHER MUSEUMS

American Painting from the Armory Show to the Depression. Milton W. Brown. Princeton: Princeton University Press, 1970.

Duveen. S.N. Behrman. New York: Random House, 1952.

The Frick Collection: Guide to the Galleries. New York: The Frick Collection, 1979.

The Frick Collection: Handbook of Paintings. New York: The Frick Collection, 1985.

The Frick Collection: An Illustrated Catalogue. Princeton: Princeton University Press, 1969.

Sources

From Bonaventure to Bellini: An Essay in Franciscan Exegesis. John Fleming. Princeton: Princeton University Press, 1982.

Giovanni Bellini's St. Francis in the Frick Collection. Millard Meiss. Princeton: Princeton University Press, 1964.

The Guggenheim Museum Collection Handbook. Vivian E. Barnett. New York: The Solomon R. Guggenheim Museum, 1984.

The Guggenheim Museum: Justin K. Thannhauser Collection. Vivian E. Barnett. New York: The Solomon R. Guggenheim Museum, 1978.

Hilla Rebay: In Search of the Spirit in Art. Joan M. Lukach. New York: Braziller, 1983.

Kandinsky at the Guggenheim. Vivian E. Barnett. New York: Abbeville Press, 1983.

Twentieth Century American Art: Highlights of the Permanent Collection. New York: The Whitney Museum of American Art, 1981.

The Whitney Museum of American Art. Patterson Sims. New York: Norton, 1985.

ACKNOWLEDGMENTS

The author thanks the following people for their help:

Guy Bauman, Pamela Berger, Brendan Boyd, Stephen Campbell, Jennifer Carlson, Colin Cochran, Cynthia Ellis, Kate Ezra, Susan Galassi, Tom Gallagher, Lisa Giragosian, Martha Hackley, Bernice Heller, John K. Howat, Julie Jones, Emily Kies, Steven Kossack, Richard McDonough, Alfreda Murck, Douglas Newton, Michael Padgett, Richard Pierce, James Romano, Beth Rosenberg, Laura Rosenstock, Ann Macy Roth, Steven Schlough, Jessica Schwartz, Mary Shepard, Cornelius Vermeule, Charles R. Whitney, Florence Wolsky.

INDEX

New York's Great Art Museums *was designed by Dede Cummings.*
It was typeset in Goudy Old Style by Dartmouth Printing Company.
It was printed on Finch Opaque, an acid-free paper,
by Bookcrafters.